PORTRAITS FROM THE DESERT: BILL WRIGHT'S BIG BEND

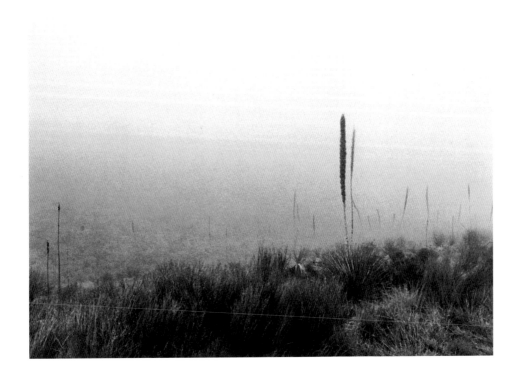

PORTRAITS FROM THE DESERT

BILL WRIGHT'S BIG BEND

University of Texas Press Austin

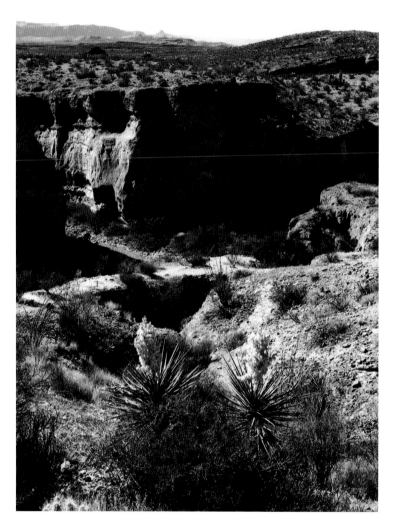

FIRST EDITION, 1998

Requests for permission to reproduce material
from this work should be sent to
Permissions, University of Texas Press,
P.O. Box 7819, Austin, TX 78713-7819.

♾ The paper used in this publication
meets the minimum requirements of
American National Standard
for Information Sciences—Permanence
of Paper for Printed Library Materials,
ANSI Z39.48-1984.

LIBRARY OF CONGRESS
CATALOGING-IN-PUBLICATION DATA

Wright, Bill, 1933–
 Portraits from the desert : Bill Wright's Big
Bend / by Bill Wright. — 1st ed.
 p. cm.
ISBN 0-292-79115-1 (cl. : alk. paper). —
ISBN 0-292-79116-x (pbk. : alk. paper)
1. Big Bend Region (Tex.)—Pictorial works.
2. Big Bend Region (Tex.)—Biography.
3. Photography, Artistic. I. Title.
F392.B54W75 1997
976.4'93—dc21 97-9402

Frontispiece: Sotol. Big Bend National Park. 1982.
Above: Tuff Canyon. 1994.

Contents

Things separate from their stories have no meaning.

They are only shapes. Of a certain size and color. A certain weight.

When their meaning has become lost to us they no longer

have even a name. The story on the other hand can never be lost

from its place in the world for it is that place.

And that is what was to be found here. The corrido. The tale.

CORMAC MCCARTHY, *The Crossing*

Acknowledgments

I T IS IMPOSSIBLE TO CREATE a book such as this without the help and friendship of many persons. I suppose I will start at the beginning, with my friends Terrell Hamilton, Sidney Pitzer, John Shelton, and Bill Tate, with whom I made my first trip to the Texas Big Bend. Unfortunately, Terrell did not live to see our experiences recorded, but Sidney, John, and Bill have been invaluable in fine-tuning my memory of those events that are now so far in the past. I have anguished over the death of my friend Nancy Mendenhall, who, with her family, accompanied Alice and our kids on an early trip, and my prayers have been for her, Elliott, and their children, Craig, Catherine, and Cheryl.

Bob and Peggy Trotter have been faithful friends and Big Bend companions since they moved to Abilene in 1965 and have been with me on many trips since that time. Lawyer Frank Calhoun, with whom I have climbed many mountains and floated many streams, contributed in numerous ways to this book and to my life. His lovely wife, Suzanne, is learning to love the land as we have learned to love it. I am grateful to my former partners in Southwest Photographic Workshops: Frank Armstrong, Jay Forrest, and Allen Rumme. Their photographic knowledge and love of the Big Bend made our shared times there great learning experiences for me as well as for our students. Bob Dickenson accompanied me on many trips while he was still a bachelor attorney in Abilene, and his recollections of conversations and events were very helpful. Johnny Newell, the late Gulf oil jobber in Alpine, introduced me to hidden secrets of the land through his wonderful road logs and personal visits. I miss his humor and his brilliance. My longtime friend, photographer, and rancher Clifton Caldwell, and his wife, Shirley, have been steady companions on many of my trips. He has generously shared his friendships with area ranchers as well as opening his own beautiful Mitre Peak Ranch to me for my own photography.

I am indebted to David Haynes, Bill and Sarah Bourbon, Bill and Ann Whitaker, and Marise McDermott for reading my manuscript and checking it for errors of fact and clarity. I could not have accomplished this book without Melissa Boehm and Beverly Guthrie, my trusted assistants. Certainly my editor, Shannon Davies, was instrumental in the project as was designer George Lenox and the staff at the University of Texas Press.

Of course, I could not have begun such a narrative without the assistance of the many local people I have met and talked with during my trips to the Big Bend. David Alloway with the Texas Parks and Wildlife Department;

J. P. and Marijon Bryan; Bill and Laurie Stevens; Hallie Stillwell; Buck New-some; Etta Koch; Emily More; Aunt Roberta and Uncle Joe; Angie Dean; David Sleeper; Janet Sullivan; Barbara Baskin; Terry and Diana Taylor; Ellie Meyer; Marianne Stokebrant; Bill and Lisa Ivey; Bruce and Don Maxwell; Elvira Sanchez, the hostess of Cibolo Creek Ranch; Lineaus Hooper Lorette; Mimi Webb-Miller; archaeologist Tom Alex and the Big Bend National Park ranger staff; librarians at the Center for Big Bend Studies and its then di-rector, Earl Elam; Enrique Madrid, the philosopher of Redford, Texas, and his wife, Ruby; Marion Walker and Frances Howard, the famous sisters of Candelaria; photographers Bank Langmore, James Evans, Todd Jagger, and Bryce Jordan; Roy Flukinger; Tom Southall; Lois Howard of the Marfa museum; and many, many others whose names I have lost or forgotten. To all of you, my thanks and my hopes that this project will not be the end of our great times together in the world's most wonderful outback.

PHOTOGRAPHIC NOTES
The photographs in this book were made with a variety of equipment over a period of many years. I have used at various times a 4 × 5 view camera, a Leica M6, and several models of Nikon, from Nikkormats to the latest F5. The medium format landscapes were made with a Hasselblad 500C/M. I have used many different films over the years, including Kodachrome 25, 64, and 200, and several different Ektachromes as well as Fuji Velvia and Provia. The black-and-white images were made on Kodak Tri-X, Plus-X, and T-Max 100 and 400. The color work was processed by various color labs, including Holland Photo in Austin, Meisel Photochrome in Dallas, and Capelight in Massachusetts. The black-and-white images were made in my own lab in Abilene, Texas.

Introduction

THIS IS A BOOK ABOUT CHANGE: personal, geologic, and cultural. It is also about people: the tough, the artistic, the practical, the dreamers. About the never dull, occasionally tragic, but often hilarious stories of their lives. I have been traveling to the Big Bend area of Texas for almost half a century, and in that time, as my own perceptions have sharpened, I have seen economic development cover the pristine landscape; I have seen delicate formations eroded by the wind and the rain; and I have felt myself change, physically and mentally. When I first came to what is now Big Bend National Park in 1950, I was a senior in high school on an Easter vacation trip with four friends. During college days I made camping trips to the area to photograph and explore the undeveloped and little-known desert mountains. After my marriage to Alice and my return to Abilene upon graduation from the University of Texas at Austin, I continued my trips to the park and the Trans-Pecos area of Texas, bringing our children and our friends with their own small children. Our children have grown and married, and now we are introducing our grandchildren to this incredible area, the last outpost of the Texas legend.

Paralleling my visits to the Trans-Pecos region has been my growing interest in photography. I developed my first contact print in my bathroom at twelve years of age. My mother had learned of a man who had a darkroom, and she inquired if I might see him develop a picture. I was taken to his house one evening, and we went to a small darkroom in his garage. He put a negative in his enlarger, and soon I was watching a photograph appear in the developer. It was magic. At the first opportunity my mother secured the necessary chemicals, and I closed the door to my bathroom and, taking one of my mother's negatives, made a contact print. The magic was with me and has never left.

My first real camera was a Kodak 35 that long ago was traded off for a more advanced model. In high school I was a photographer for the school yearbook, and I took a class in photography from Willie Mae Floyd, who gave me the opportunity to work in a real darkroom, instead of the bathroom sink and bathtub.

Sometime during high school I came into the ownership of a 2¼ × 3¼ press camera. The first photograph I took in the Big Bend was made with that camera at the entrance sign to the park. The black and white negatives and most of the photographs of those high school days have since disappeared, perhaps during the process of moving or in one of my periodic spasms of organization.

My first real instruction in fine art photography came in the 1970s when my older son, David, and I met a Dallas photographer, Chris Regas, who invited us to his home and gave us a weekend course in developing, printing, and print presentation. It was one of the photographic turning points in my life. His were the first world-class images I had ever seen. During those days our local art museum did not show photographs, and the local camera club was composed of amateurs of about my level of experience. With his patient demonstrations I was revitalized and redirected.

In 1978 I followed the example set by many documentary photographers and traveled to New York City to photograph the streets and feelings of America's most famous city. Then I produced my first exhibition and held my first one-man show. Later that year I spent a month in Nepal photographing the mountain villages around the base of Annapurna. Experiencing this still exotic country was another turning point in my life. The strange non-Western culture, the physical experience of hiking ten to fifteen miles a day at elevations of up to 18,000 feet and sampling exotic food such as tsampa kept my body sending distress signals. Psychologically, the isolation from all that was familiar and supportive in my life made a profound differ-

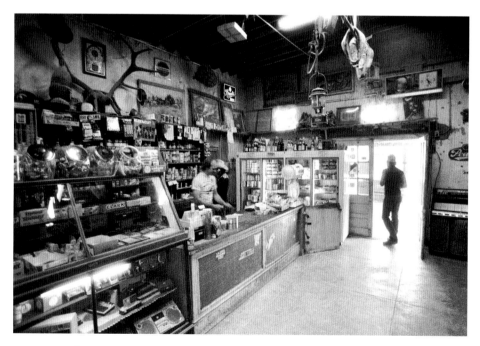

Lajitas Trading Post, 1986.

ence in how I viewed the world. From that moment on, for me, the world was never the same. Nor were my photographs.

I became less interested in landscapes and began to photograph people and inquire about their situations. I began to read anthropology seriously and to consider myself primarily a documentary photographer, interested in the beauty and uniqueness of people's lives. I also became aware that this richness of human culture is not restricted to exotic locales, and I began to realize that the Big Bend of Texas had an equally interesting collection of strong-willed people who measured their lives by their own standards and who loved the land with frontier independence. I began to photograph them and collect their conversations. I started out with the people that I knew best—Mimi Webb-Miller, Bill Stevens, Hallie Stillwell, Johnny Newell, and others—but the project soon developed a life of its own. I found that I was expanding my friendships and meeting people I would never have otherwise encountered. The richness of this experience is something that will stay with me forever.

Somewhere along the way I began to photograph the land again. I have come to understand how much the land around us affects the landscape of our lives: how seeing a sunrise every morning affects the rest of our day, how walking alone in a desert canyon after a rainstorm, watching the runoff subside, infuses a fresh spirit in the most unfeeling among us. The geographer Yi-Fu Tuan describes noise as auditory chaos and reminds us that unless we live next to a waterfall the countryside is quiet, and that the sounds of nature reduce the tension and anxiety that cities create with their noisy, never-ending commotion. Looking from a solitary one-room adobe toward the circling crown of the Chisos in the evening with the gentle murmur of a desert breeze the only sound establishes without question the accuracy of Tuan's observation.

So here it is: the Texas Big Bend as I have experienced it.

Ernst Tinaja #1, Big Bend National Park, 1987.

The Beginning

I WILL NEVER FORGET the agony of that morning, now so long ago. I stood in my parents' bedroom in the early light. The curtains were translucent. My mother and father roused from their sleep. There I stood, suppliant before the bed, awaiting the final decision. Any moment four of my friends would arrive in Sidney Pitzer's dad's pickup in front of my house to take me with them on a trip to the new Big Bend National Park.

It was Easter vacation in 1950. I was a senior in high school and had never ventured that far from Abilene on my own. My friends and I were planning a spring trip to the new national park in West Texas, but my father was noncommittal. "I'll see about it," was all he would say. All the others had firm commitments, but I was out on a limb, not knowing what his decision would be. So I stood there, agonizing, awaiting the verdict, terrified he would say no.

It took a long minute for him to collect himself from sleep. He thought silently for a while. Then, "Okay, go ahead." I left quickly, before restrictions and admonitions could be given. I bundled my gear out front, and fifteen minutes later the old pickup was headed west on U.S. Highway 80, crammed with our camping equipment and food scavenged from our respective kitchens, my friends laughing and talking. I felt free for the first time in my life.

If freedom is, as Kris Kristofferson wrote and sang, just nothing left to lose, I was certainly free then. We were traveling in a primitive fashion. This truck was unlike the fancy four-door, extended-cab, luxury pickups of today, and there were five of us in it, which meant at least two had to ride in the bed, exposed to the elements. Sid's dad had fashioned a metal framework that fit over the bed. Draped with a tarp, it provided some protection from the sun. I watched the road reel off from the open end of our pre–deluxe camper rig.

I cannot remember the first time I heard of Big Bend and the park that was established there. The motivations for that first trip are lost in the biochemical jungle of my memory. I *do* know that my lifelong love affair with the desert and my strange attraction for the Big Bend began right there, right then, on that visit.

But at that time the Big Bend had little to recommend it to the typical tourist. Texas south of present-day Interstate 10 and west of the Pecos River is desolate country. The towns are small and far between. The folks who live there are toughened by the sun and the hardscrabble life. Geographically, the area lies within the great Chihuahuan Desert, which, with

the Great Basin, the Mojave, and the Sonoran, constitute the four major desert areas in the United States. Most people consider the "Big Bend" to be the area comprising the Texas counties of Presidio, Brewster, and Jeff Davis. It was first called that by Lieutenant William H. C. Whiting, a U.S. Army officer who was one of the first American explorers of the region, in 1848.

Big Bend National Park was authorized by an act of Congress in 1935, but much had been done prior to that time and much remained to be done afterward to make the park a reality. The year I was born, 1933, a bill was introduced in the Texas Legislature by Alpine state representative Everett E. Townsend and Abilene state representative R. M. Wagstaff to create the Texas Canyons State Park on fifteen sections of land along the river in the area of Santa Elena, Mariscal, and Boquillas Canyons. Soon legislation was introduced to increase the size of the park, and the name was changed to Big Bend State Park. At this stage, the park consisted of 150,000 acres of unsold public free school land, which was transferred to the Texas State Parks Board.

From the first, there was interest in cooperating with Mexico to create an international park, preserving the similar land south of the Rio Grande. During World War II the international aspect of the project lost momentum, but the idea may yet be revived. Legislation to transfer Big Bend State Park to the United States for a national park was introduced into Congress in 1935. One of the provisions of the bill prohibited the use of any federal funds for land acquisition. Nine years later the basic acreage was acquired and Big Bend National Park was officially established, but the purchasing of additional land for the park continued. With strong support from Governor W. Lee O'Daniel, in 1941 the Texas Legislature appropriated $1.5 million and purchased 700,000 more acres, which were then transferred to the federal government by Governor Coke Stevenson. The park, with scant facilities, was finally opened to the public on July 12, 1944. Geologist Ross A. Maxwell was appointed the first superintendent.

Because of the war and its aftermath, development in Big Bend National Park was slow. It was yet to be extensively photographed, written about, and interpreted by travel writers and park publicists. For us it was a land of mystery—in its history, geology, and biology. Then, we couldn't imagine a land where bats pollinated flowers, where a great river seemingly ran uphill through the canyons, where a Green Heron, stalking food in the slow backwaters of the river, shaped a bit of leaf and cast it as a lure for minnows on a slow day.

And the Big Bend people we read about had personal histories as remarkable as the land and its animals and plants: Captain C. D. Wood, who with his partners established a candelilla wax extraction plant at Glenn Springs that was raided by Mexican renegades during the Pancho Villa era; the prospectors; and the ranchers, who were colorful figures in the area long before the park was established. There was J. Frank Dobie's story of buried treasure to be found on the flanks of the Chisos where the first rays of the Easter sun illuminated the outcrops. It was a land made for adventure, and we wanted to learn about it and see it for ourselves.

The park is substantially different from other North American desert environments. The characteristically high elevation of the Chihuahuan Desert distinguishes it from the Sonoran, the Mojave, and the Great Basin in climate and ecology. The hot summers and cool winters of the Texas Trans-Pecos region of the Chihuahuan support flora that include creosote bush and tarbush, honey mesquite and the distinctive drooping juniper, which is said to be found in the United States only in the Chisos Mountains. David Alloway, a naturalist with the Texas Parks and Wildlife Department, talks about the strange lechuguilla, a sharp, shin-high member of the agave family, as still being used by the Tarahumaras of Mexico to poison fish and to tip their arrows. Geologist and naturalist Bill Bourbon reports that during the spring migration, over 200 species of birds migrate through this area, more than in any other single place in the United States. In all, over the years, 450 bird species have been identified. According to scientists at the Chihuahuan Desert Research Center, there are more different species of cactus in the Chihuahuan than in any other American desert.

In 1950 the five of us were interested in science. We were proud of our rock, fossil, and insect collections and were active in the Abilene High School Science Club. Terrell Hamilton was our expert birder, and he told us of the rare Colima Warbler that frequented the exotic and difficult slopes of Boot Canyon, high in the crown of the Chisos Mountains, which form the central mass of Big Bend National Park. Bill Tate and Sidney Pitzer were interested in engineering. They both shared a great love of the outdoors and the backpacking possibilities it afforded. John Shelton, a year older than the rest of us, was to be our protector if we encountered bandits. I was anticipating the chance to photograph the desert mountain landscape and the flowers, which would be in bloom if the rains were timely.

We five would not be bothered by the lack of facilities in the new park. We were adventurers, pioneers. Of course we would camp out: no

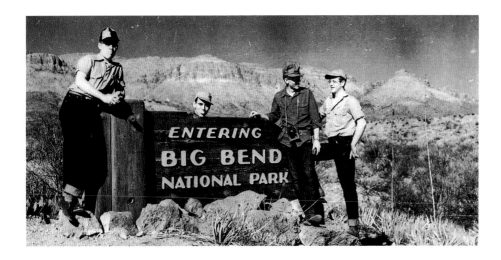

Left to right: Bill Tate, Sidney Pitzer, John Shelton, and Terrell Hamilton posing at the entrance to Big Bend National Park, Texas, 1950.

tourist reservations for me and my friends. We had our army surplus back-packs and canteens.

Marathon, Texas, was the jumping-off point then, as it is today. We filled the pickup with gas and headed south on what is now U.S. Highway 385. We stopped at the park entrance sign and took our first photographs. I had my parents' 8 mm movie camera and still can make out the faded Kodachrome figures as they posed behind the sign. At the time we were all ignorant of much of the area's history and oblivious to the remains of Indian occupation that predated the first western settlement in the Big Bend. Persimmon Gap, as the northern entrance to the park is called, was along the old Comanche Trail. Stagecoaches used this pass, and a way station was located here.

When we checked in at the ranger station, we were advised of the no-firearms rule. Sidney, a law-abiding straight arrow kind of guy, had brought a 30-30 rifle. The weapon was given up to the park ranger, to be returned as we left the park.

We set up our camp in the Chisos Basin the first night. The development there was scarcely more than the old Civilian Conservation Corps shacks, erected during the construction of the park. They were rented to those desiring a roof over their heads. Today they are gone, replaced by a neat stone motel with inside showers. The remainder of the development was the horse concession, a small coffee shop, and the park ranger's office. There was no telephone service. In those days you were really on your own, and that was just the way we wanted it.

Our first objective was to climb Casa Grande, a great square block of stone, towering like a giant's single white molar from the gum of ringing mountains overlooking the Basin. It was created by an eruption of two different volcanoes, far back in geologic time. Carrying our canteens of water and the movie camera, we started up it. The only other mountain I had ever climbed was Sierra Blanca, or "Baldy," in Ruidoso, New Mexico, where the altitude was higher and cooler. Dripping sweat, we struggled to the summit, shooting lots of film along the way. We ate our candy bar lunch and chucked rocks down the interior canyon walls, listening to them echo like rifle shots, startling birds and a solitary whitetail that paused, curious at our shouts.

The trip down was magnificent: hundreds of feet of scree, like a giant's slide of stone poker chips. We ran down with an alacrity reserved only for the young. Making great leaps, falling, sliding, we came to rest at the foot of the slide. Sidney's boots were almost shredded, all of us were skinned and scratched, and we thought, "How can it be better than this?"

The next day we tackled the South Rim Trail, planning to spend the night at Boot Canyon, the home of the Colima Warbler. Our plans were to rent burros from the horse wrangler, Burt Beckett, and carry our supplies while we skipped along the trail enjoying the scenery. No such luck. The price of a burro was twenty-five dollars a day, and none of us could afford that luxury. So we packed it.

My old movies of the trip remind me of how awkward it was. No sophisticated backpacks, just the old army surplus packboards. We carried all they would hold on our backs and the rest in our hands. At first light we started up the trail. We were alone out there—the horse concession hadn't opened, and the "tourists" were surely still asleep. As the sun rose above the East Rim of the Chisos, the heat began to tell on us. We slugged down the water and stopped about every thirty minutes for a rest. Bill Tate's feet began to bother him, and we slowed down to accommodate his limp. Secretly, I was grateful. I could be macho without having to prove it. With many rest stops we made it to the South Rim, the most magnificent view in the park and the hardest to get to. We spent the rest of the day photographing and bird-watching. We climbed to the top of Mount Emory, the highest peak in the Chisos, finally establishing our camp for the night near the old cabin at the head of Boot Spring. We were up early the next morning, looking for the Colima Warbler. If we saw it, we didn't know it. We kicked around around for a while longer, bushwhacking around the springs looking for wildlife and finding it. As we were turning over dead logs and rocks, we suddenly

leaped back in shock. Squirming in every direction were tiny rattlesnakes, just born. They scattered everywhere. Terrified that we would find their parents, or that they would find us first, we quickly retreated from the area. The sun was settling toward Santa Elena, and we knew we had a long walk back to the Basin campground. We needed no more encouragement.

Our next adventure was the trip to Santa Elena Canyon. We started early, driving the unpaved road to the old trading post at Castolon and the canyon entrance. The day was cloudy and rain threatened. We drove slowly down the dirt road. Suddenly a dark form slithered across the road in front of us: a bull snake. Sidney slammed on the brakes, and all of us jumped out of the truck. Terrell pinned the snake with a stick and held it tightly with a grip behind the head. Being unaware of the park rules against hijacking snakes, we decided to keep it for a while, so we dropped it into a tow sack that, now emptied of the tire tools it had held, became a "scientific" herpetological container. Sidney protested mightily. He was certain that the snake would get loose in the cab. We drove another mile or two, with Sidney getting more and more insistent that we release the hostage. Finally we did, and the snake slithered away. Today I know that a snake displaced from its territory could die and, after examination, should be replaced where it was found. But we were young and ignorant at the time. We continued to haze Sidney for the next hour, until a fresh concern claimed our attention.

The road dipped over a low hill and through a dry wash. We looked back to see a three- or four-inch-high wave of water advancing down the previously dry streambed. A light rain had begun to fall. Should we turn back before we were marooned by a raging torrent? The unpaved road began to get slippery, and the pickup was slithering from side to side like the snake we had previously apprehended. Fearing a slither off the road into a drainage ditch, we walked alongside the truck while Sidney drove, pushing the pickup toward the center of the muddy road and making slow time. It was impossible to turn around, so we continued toward Santa Elena and camped near the mouth of the canyon.

It was a miserable night. Secretly we were all nervous about being marooned by the rising waters. Huddled in the back of the pickup, we drank canned peach juice and ate dry crackers for supper. With five of us under the tarp, it was crowded and impossible to sleep. The next day we departed, hoping that the road was passable. The stream was flowing but not too strong or deep, so we barreled through and pitched our tents again in the Basin. It was our last night.

Sidney started the fire, and we dug into our remaining provisions, finding an assortment of canned goods. We decided to make a stew of all of it. Canned tomatoes, pinto beans, creamed corn, chili—everything went into the pot. When it came to a boil we dished it up, dug in, and gagged. Inedible! The bizarre mixture was salted too much, peppered too much, everything too much. We carried it to the bushes and tossed it all out for the coyotes.

That night we attracted more than coyotes. Bill Tate was awakened from a sound sleep by something walking over the top of his bedroll. Cautiously opening his eyes, he saw, illuminated by the moonlight, a foraging skunk. No doubt it had been attracted by the fragrant odor of our discarded meal. Bill slowly pulled the bedroll over his head and waited. The moments seemed like hours. Finally, he felt the little feet move across his belly and off the bedroll. He quietly peered out from under the covers and found that the visitor was gone. The crisis had passed.

In the morning we packed our gear and headed north. We had climbed the highest peak and hiked the cool, shaded canyons, shouting our hellos to the echoing cliffs and watching Cliff Swallows peer from their mud nests. In the dry arroyos we saw Scaled Quail weave their way through the creosote bush and lechuguilla, then blur blue at our intrusion. Each canyon led to another mountain. Each mountain crested toward another canyon. The place was wild and mostly undiscovered. It was what our vision of Texas was all about. It had been a grand expedition, and we knew that we would be back.

Arroyo near Terlingua, 1985.

A Friend

JIM BELL WAS STANDING by the Jeep at the junction of an unpaved county road and U.S. Highway 80 on a hot, cloudless day in 1962 in Sierra Blanca, Texas. Both man and machine were covered in light tan alkali dust, like two cheap plastic toys molded from the same material. My dad pulled the Ford across the eastbound lane and came to a stop beside the shapes. While Dad and Jim exchanged greetings, I got my gear out of the trunk and threw it in the back of the Jeep. Dad said good-bye and pulled back onto the highway, heading west for California, and Jim and I started south for Indian Hot Springs and a week of geological exploration together.

Jim was a tall, thin, near-genius guy, with an independent streak as wide as a Big Bend canyon. While we were growing up in Abilene, he was my best friend, and the friendship only strengthened after college. During our high school days in the 1950s, we would escape on weekends and camp out along the upper reach of Elm Creek, which meandered from its source in the limestone caprock of the Callahan Divide through the McDaniel Ranch and finally joined the Clear Fork of the Brazos north of Abilene. We chipped fossils from the exposed Cretaceous outcrops, ate rabbits and armadillos, and generally tried to behave as if we were mountain men of the past. From these early explorations we both gathered a deep appreciation for nature, the mutual dependency of its creatures, and the long and tormented history of the earth, as the geologic ages came and went beneath our geologist's hammers.

Our fathers were wary of our relationship because we had the ability to overstimulate each other with plans for adventures far beyond our means. They finally agreed that we should be separated. I remained at the University of Texas, and Jim transferred to Sul Ross State University at Alpine, which was closer to the hallowed Big Bend ground. When Alice and I got married during our senior year at the University of Texas, Jim was the best man. Since we were all broke, Jim paid for the wedding with his wrist watch.

Alice and I returned to Abilene in 1955, and my father and I established a wholesale gasoline business there. After holding various jobs, Jim began working on his master's degree in geology at the University of Texas. His master's thesis research was in the Indian Hot Springs area of the Big Bend, where he was studying the unique faulting of the region just south of the river in Chihuahua.

One day, about ten years later, I received a letter from Jim. I have it still:

Rancho Bano de Tina, Chihuahua

We arrived late, Milton and I, in the Cajones locality Saturday because he had gone to town for mail and gasoline. The usual letdown from idling away a scorching hot breezeless morning and the anticipated disappointment of no personal mail prevailed even after our arrival at the outcrop. I was unsure of the stratigraphy and the structure, both of which depended on correct identification of the rock unit; that single outcrop held the key to my problems. Interest dully glimmered when a few familiar, but non-diagnostic, fossils were uncovered, and the feeling of depression began to slide into the background. We started climbing up the steep, blocky limestone hill, scratching and pecking slowly upward, heads lowered and searching only a few feet in front of us. Preoccupied by the search, I suddenly, unexpectedly, found myself high on a cliff, several hundred feet above the ancient, flat, river-beveled plain. The view was startlingly magnificent.

To the north the Quitman Mountains stood out, craggy and majestic: a royal manifestation of sheer brutal, noble, ruggedness. About forty miles to the northwest, huge dust clouds began boiling up over the bleak starved desert, moving slowly southward. The sun was low now and through the dust its rays diffused into unknown hues of brilliant red that mingled with the darkness of the distant mountains. It became cool and windy on my perch; the wind had a refreshing hint of moisture in it that must have come from the thin scuttling clouds. Just over my head, two silent Cliff Swallows spread their wings and hovered in the stiff wind like microhawks. They must have been resting, or taking in the wondrous view, or whatever it is they do when their minds are not on feeding; they can't catch insects hovering like that. It occurred to me that few men my age ever have the chance to be in the raw, brutal, unpredictable and beautiful Trans-Pecos. The unlimited space, seemingly unscarred, untouched by man made me feel small and unimportant, and yet aware that I'm part of Nature's scheme. But what was I supposed to do? Just stand there forever? A few feet by my side I noticed, for the first time, a pitaya cactus in the full glory of bloom. I felt a kinship with that piteous cactus, but inferior; its desperate struggle to produce its flowers had taken most of its life-sap, and for a good distance above its roots, the plant appeared to be dead. Was I too supposed to give everything I could, doing only what I can do in strict obeyance to Nature's orders: to live? To reproduce? No. No . . . I'm a man.

My strivings have to be equal in comparison, but I have to struggle uphill with my rock, like the myth of Sisyphus. Is not the struggle eternal and the bloom only temporal? Have all men, like me, no matter what the environment — paused in the stock exchange or sitting before the loan desk in the living tomb of a bank, wiping the factory smudge off a perspiring brow; standing dog-tired in the yellow concourse of Love Field — have they thought and felt the same things? Perhaps. Shocked and amazed at my thoughts, I felt paradoxically enlightened but . . . unsure of what I must, what I can do . . .

. . . and you, Bill. What flickers through your mind when you take your shoes off in a sterile, hostile motel room? The hunting's pretty good here and there's some delicious wild honey that goes fine on flour tortillas. Not much else to do — take a few piping hot baths in Indian Hot Springs — but why don't you come down for a day or so and help me in the field before August ends?

> *General Delivery*
> *Sierra Blanca, Texas*
> *July 28, 1962*

Jim always had a way with words, and the letter fired my imagination and inflamed my desire to return to the outback. Dad was going to California to call on our truck stop customers, and I arranged with him to drop me off at Sierra Blanca, Texas, where Jim was to meet us in his Jeep. He was drinking a beer, unshaven, and looking like a refugee from the cast of *The Treasure of the Sierra Madre*. Dad headed for California, looking after business; Jim and I went south to the river.

The dust swirled up from holes in the floorboards of the ancient Jeep. Behind us a long plume of light tan dust marked our route to the circling Red-tailed Hawks above. Both of us immediately broke into a sweat, and we stopped frequently to replenish our "electrolytes" with iced-down Mexican beer.

Jim explained the area we were to explore. Indian Hot Springs around the turn of the century had been a very famous spa. Believing in the medicinal properties of the springs, people traveled here from Europe and New York and other great turn-of-the-century metropolitan areas. Bathhouses were built over the naturally occurring springs, and small adobes, now abandoned, were built to house the clients.

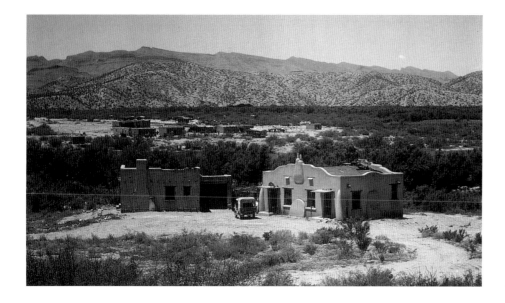

Hot Springs, Texas, 1962.

Indian Hot Springs was the location of one of the last attacks by a separated band of Victorio's Apache warriors. Military records indicate that members of the Tenth Cavalry were stationed at Indian Hot Springs during border troubles with Victorio and other Apache bands. On October 14, 1880, members of his band deserted Victorio at Tres Castillos before the Mexican forces, under the leadership of General Joaquin Terrazas, surrounded Victorio, who was killed in the attack, along with some eighty-seven Indian warriors. This renegade band of Apaches made their way back across the Rio Grande and, on the morning of October 28, 1880, attacked the army camp before breakfast. They killed five soldiers and pillaged clothing, equipment, and horses. They then escaped.

Jim had set up camp in an old adobe building that had once sheltered clients of the hot springs. I took the guest cot, which was erected in the sample room, where Jim kept his fossils and rocks collected for the project. Each morning we would load into the Jeep after a hearty breakfast of fried eggs and oatmeal, cross the river, and head into the canyons of Chihuahua, where Jim photographed, measured, and collected the fossils that would help him in his analysis of the structure.

At night we would come in hot and sweaty, covered with dust from traveling the dry arroyos and the lechuguilla-spiked hillsides. We would light a gasoline lantern and walk to the abandoned spa, where concrete tubs that once held the rich and famous still had the naturally hot spring water flow-

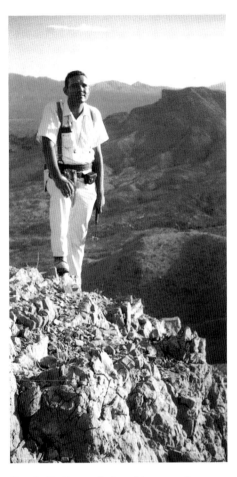

Jim Bell, Sierra de Los Pinos, 1962.

ing through them. As I soaked in the curative waters, I read James Joyce's *A Portrait of the Artist as a Young Man* by the light of a Coleman lantern.

Looking up at the incredibly clear night skies punctured by brilliant holes of light, I thought about the book, my life, and its meaning. At twenty-nine I was just coming to grips with these metaphysical ideas that were beyond my experience. Jim was thoroughly practical and could blow a hole in a weak argument faster than you could slap a horsefly on your neck. But for all his practicality, he also had his dreams. He had seen his father almost die in a gas well explosion and then lose his job as a drilling mud representative when the oil industry collapsed. Jim dreamed of financial and emotional independence, and he was working hard for both. I was joined in a young business with my highly successful father and struggling with similar issues. How could I establish for myself a territory in which I could excel?

I lay there under the stars at night, thinking of Stephen Dedalus's plight, then, burned by the sun by day, thinking of mine. For me it was death, burial, and resurrection to a new life, all rolled into one incredible week. Physically cleansed by day, intellectually stimulated by night, I felt I had passed a towering guidepost along my life's journey.

Jim went on to submit his thesis, "Geology of the Foothills of Sierra de Los Pinos, Northern Chihuahua, near Indian Hot Springs, Hudspeth County, Texas," and then received his master's degree from UT. Soon he was hired by a group to manage a mine prospect near Torreon, Mexico. Several months into the job he suffered a severe attack of appendicitis while at his prospecting camp miles from any town and was too sick to ride his burro off the mountain. He finally made it into town after walking twenty miles holding on to the burro's tail, and a local doctor removed the appendix in the rural clinic.

I loved hearing Jim tell that story. He could embellish it with Mexican lingo and his cultivated Texas drawl. I liked him to tell it while wearing his hat . . . it seemed to transport him immediately to that phantom mesa, with the wind coming up and him in pain. What a tale!

Jim finally landed in the oil and gas business in Graham, Texas, working as an independent geologist, married a fine woman with two beautiful girls, and found some oil.

One day as Alice and I were photographing in Abu Dhabi, in the United Arab Emirates, I received a phone call from Texas. Jim had died of an undiagnosed case of hepatitis that he had contracted somewhere in his travels. Upon my return to the States, his wife asked me if I would mind scatter-

ing his ashes in Big Bend National Park, a place both of us loved and where we had many times traveled together. On my next trip to the park, Alice and I left the other members of our group, had lunch in the Basin, and together walked the Window Trail to the famous pour-off of the Chisos Basin. It was a cool start and we made good time, stopping to photograph the profusion of flowers along the trail.

We were alone. I never mentioned to Alice the burden I carried in my pack. Somehow, I felt this was a private moment between Jim and me. I am sure she assumed it was photographic equipment because that is what was usually there. We went to the Window, gazed through it to Castolon, Santa Elena, and Mesa de Anguila in the distance. As we turned to go, I asked Alice to go ahead and start up the trail, saying that I would catch up in a minute. I opened the box. A little breeze began as I spread the ashes. They swirled around me, landing on my clothes and in my hair and disappearing through the canyon opening to the desert below. I returned the empty box to my pack and started up the trail to meet Alice. We walked in silence. Alice is extraordinarily perceptive, and I believe she must have sensed my need for privacy. We startled a doe with her fawn, and they bounded off to a clump of trees and turned their ears toward us. I was thirsty now, and we had not brought water. A stupid thing to do in the desert, but I had been preoccupied with my mission. I knew better. After a bit, a family group came bouncing down the trail, meeting us as we ascended. We greeted them and were offered water. We took it gratefully.

With the passage of time I realize what a mythic figure Jim was in my life, manifesting the thrill of exploration, of learning, of independence. I know that life was not utopian as he lived it, but as he told it, and as we saw it, it seemed romantic and desirable. While I was building a business and a family with the responsibilities and tedium that accompany such civilized behaviors, Jim seemed free, traveling in the land we loved. I return each year to the desert to reestablish that connection.

Canyons

AFTER ALICE AND I RETURNED to Abilene from college in 1955, my friends and I began to journey each Easter to Big Bend Park to canoe the rapids and hike the trails. Most of us were married with young children, and the trips together with our families were what are now referred to as "bonding experiences." One of the most memorable was the Easter trip of 1970.

We gathered our families and gear and headed west with plans to canoe through Mariscal, the most beautiful of the Big Bend canyons, in my opinion. People rarely went through Mariscal because of the difficulty in traveling to the remote location where the canoes are launched and, then, the long drive to shuttle the vehicles to the downstream takeout area. The canyon is located at the nadir of the river's great bend, and the drive to the launch area takes several hours over difficult, unpaved roads. I had made the Mariscal trip many times and was looking forward to the adventure.

I decided to graduate from the trustworthy Grumman canoe I had used in the past and do the rapids in my new, more sophisticated C-1, or decked canoe. The C-1 has a place for one person and a lip around the cockpit where a splash skirt is fastened. The canoeist uses a single-bladed paddle both for the power stroke and as a rudder for directional control. Experts, when upset in the rapids, can "roll" the boat like a kayak. It is a class of craft used in Olympic competition. I was not a contender for Olympic-class competition, but I thought I would enjoy the more maneuverable craft. Also, the rapids of Mariscal are not that severe: active enough to give us a thrill when the water level was normal but dangerous only during high water.

Our group departed Abilene on a Thursday after school dismissed and drove as far as Midland, where we planned to get an early start the next day. Friday morning we drove to the park and along the river road that led to the launch site for Mariscal Canyon. It was a clear, warm April morning, and the river was flowing with enough water to float the canoes without difficulty. There would be no dragging through the shallows on this trip.

As usual, I was playing the role of expedition leader and directing the departure. My father and mother had accompanied our group, and Dad agreed to spot the car for us downstream on the far side of Mariscal Mountain. He vicariously enjoyed our adventures and loved participating to the extent that he was physically able.

We had a large group this Easter: Dr. Bob Trotter, his wife, Peggy, and their children; our sons, Mitch and David, and our daughter, Alison; David's friends Tommy Lester and Gregg Cooke; Abilene attorney C. G. Whitten and his son, Blake; and several other couples and their children.

The launch site swarmed with activity. Everyone was loading their gear into the canoes, making sure that all was waterproofed in case of a flip in the rapids. One by one, the canoes departed under my watchful eye, with instructions about what to do if they were about to capsize in the rapids: "Don't lean upstream," I said. "The canoe will fill with water and you will be in big trouble in a hurry! If you hang up on a rock, lean downstream while you try and dislodge yourself. Kids, don't stand up in the canoe. Get on your knees when you are heading into fast water. Balance your load . . . tie in the waterproof boxes."

The last of the canoes pushed off from the bank, and I stepped to the water's edge and into my new C-1. I immediately capsized. My river hat began to float downstream, and I made a lunge for it while trying to hold on to the soggy canoe. The others disappeared, laughing, around the bend. I squeezed the water out, reassembled my gear, and pushed off. My dad, watching from the bank, loved every minute of it.

Following along at the rear of the group, I took my time in the easy-to-paddle C-1, remembering my first trip through the canyons a dozen years before.

We had come at Easter then also. Three friends and I had decided to head for the Bend and try our hand at Mariscal. We borrowed two canoes from the local Boy Scout troop and headed west.

Our car looked as if a small airplane had crashed on the roof and continued to cling there precariously. It had two aluminum canoes tied to the top along with cooler boxes, food cartons, oars, and other paraphernalia. To the occupants of a car from California that pulled in beside us at a service station in Monahans, Texas, we must have appeared demented, carrying canoes deep into the desert. They stared at our roped-up collection of gear and regarded us as a new generation of Okies, fleeing a modern-day dust bowl and heading for the promised land. They surely did not know of the canyons of the Rio Grande a few hours to the south, where the next day we would launch our canoes and brave the river rapids, exploring what were, at that time, the least-traveled areas of Big Bend National Park.

After that first trip we came each year at Easter. We canoed through Mariscal, Boquillas, and Colorado Canyons, always a bit afraid to attempt Santa Elena, the one with the famous rock slide rapids that had "eaten" a number of canoes in the past. Later, after the children were old enough, these became family trips. We would gather with a large group of friends and head for the Big Bend with our canoes strapped to the tops of our cars or on

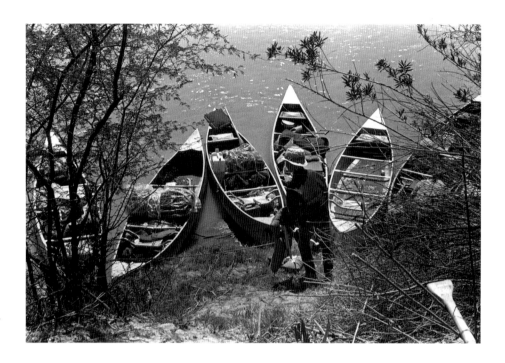

Mitchell Wright with the canoes loaded
for a trip through the canyon.

trailers, our vehicles full of groceries, cooler boxes, bathing suits, bird books, cameras, and all the equipment that goes with that kind of an outing.

We always had adventures on the river: sighting a rare Peregrine Falcon, seeing the large catfish roll at the surface of the river under the Cliff Swallows' nests, exploring the side canyons leading into Mexico. It was still fun, I thought, to bring people to the park and help them find the private places that few people know about and that fewer still are adventurous enough or fit enough to explore. On those first trips to the park to canoe through the canyons, no outfitters made it easy for you with package deals, rubber rafts, and experienced guides, creating a trip where all you have to do is settle back, enjoy the scenery, and sip a beer or two.

My attention returned to the present as my faster C-1 caught up with the group. We made camp at an arroyo joining the Rio Grande from Mexico at a location we call the Big Break of Mariscal. One branch of the old Comanche Trail passed into Mexico from that point. Another branch of the trail crossed the Rio Grande at the Lajitas crossing, several miles northwest of the national park. On the west side of this arroyo is a large boulder covered with Indian petroglyphs—designs that are chipped into the stone, as opposed to pictographs, which are painted images. This marvelous piece of

culture is seldom revealed because it is usually covered with sand and is
exposed only after floods. This is a place where we customarily camp, often
on the Mexican side, where there is a nice *vega*, or grassy flat, that is quite
comfortable. This day the petroglyphs were clearly visible in the illuminat-
ing light.

We pitched our tents on the Mexican side of the river and hiked up
the arroyo, exploring the tributaries and the plant life near the water. As
luck would have it, a group of Mexicans was processing candelilla wax
nearby. The candelilla plant, relatively common in this area, is gathered for
the wax that coats the slender, leafless stems. The Mexicans very courte-
ously showed us how the operation worked and gave us samples of the wax.
They even allowed us to photograph them at work.

The Mexican gatherers search all day in the surrounding desert for
the candelilla, which they pull up by the roots and load onto burros. In the
evening they return to camp, and workers dump the plant into a cauldron of
boiling water and sulfuric acid, fueled by dry candelilla stalks supplemented
with mesquite wood and anything else that will burn. The acid removes the
wax from the stems; then the molten wax is removed from the surface of
the water with a skimmer and allowed to dry. The plant stalks are taken
out, dried, and used for fuel. After cooling, the wax is broken into chunks,
loaded into burlap bags, smuggled across the Rio Grande, and sold to proces-
sors in the United States, where the price is higher than in Mexico, where
the government controls the price.

On an earlier trip, the camp had also been in operation, and we
stopped to photograph this local industry, then continued down the river
and camped on a conveniently level spot near the water but high enough to
be safe if the river should rise during the night. Shortly after making camp,
an Abilene friend, Gerald Galbraith, and some other Abilene friends who
were traveling with him came roaring toward our camp in their canoes,
stopping only long enough to give us details of a serious accident. They had
stopped at the wax camp also, and Gerald had fallen through a deceptive
crust of ashes into hot coals and seriously burned his leg. He was in great
pain, but there was nothing we could do. His group paddled all night to their
cars, which had been positioned downstream, and then drove him more than
a hundred miles to the hospital at Alpine. Fortunately, they arrived in time
to ward off serious damage, and he made a good recovery.

We remembered Gerald's accident as we photographed the candelilla
wax operation and returned to camp for our evening meal and lots of lively

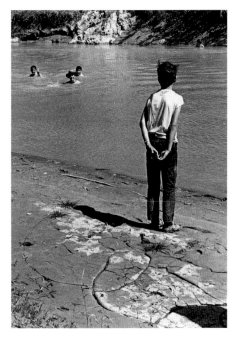

*My younger son, Mitchell, too young to
swim in the river, watches from a safe
distance as the older kids cool off after
a day of canoeing the canyons, 1971.*

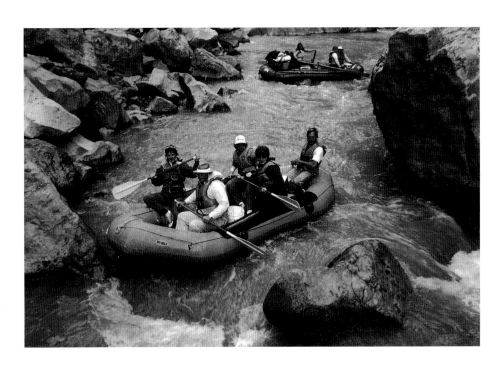

My daughter, Alison, leads a raft during a canyon trip, Santa Elena Canyon, 1984.

conversation around the campfire. One by one we drifted off to our individual bedrolls and went to sleep. We were camped on a vega about ten feet above the level of the river.

About one-thirty in the morning I was startled by screams coming from the area where the boys had camped. We were all sleeping in the open, not wishing to erect tents, and I could hear the sounds of bodies thrashing about on the ground. Grabbing a flashlight, I rushed toward the noise while the other adults began to look around, wondering about the cause of the commotion. Gregg Cooke, our son David's guest, was having a nightmare. He was yelling, talking, thrashing around in his bedroll, and fighting some unseen monster. I was terrified that he was going to roll off the embankment into the river. Fortunately, he woke up, calmed down, and we all went back to sleep.

About three-thirty, I awoke again. There was a very strange crackling sound coming from the direction of the "kitchen." I lay in my bedroll wondering if our campfire had somehow caught the grassland on fire. About that time I felt a few drops of rain falling on my face. I realized that the crackling (by now almost deafening) was the sound of two plastic blow-up tents being erected by Bob and Peggy Trotter. They wrestled with those

tents for an hour, keeping everyone awake. The sprinkles passed almost as swiftly as they had come, but the night was destroyed. Finally, we all got up, fixed breakfast, and pulled out about two hours earlier than we normally would have done.

As we were loading our canoes, Peggy Trotter shouted, "Look what I found!" We scrambled to a small ledge about four feet above water level, where, embedded in the rock, were the fossil remains of a twelve- to fourteen-inch fish. It looked beautiful in the split shale and gave us an incredible sense of time and place—so very different from a museum specimen, isolated from its mother stone. We could visualize the bottom of the ancient ocean that once covered the area, long before the land was uplifted and the river cut its path to the sea. It made the fossils for sale in rock shops seem abstract and somehow out of place. We admired the fish, photographed it, and covered it again with heavy stones, hoping to preserve it from other canoeists, who might attempt to chip it out. I am sure that by now erosion has carried it to another fish-resting place in the Gulf of Mexico.

At the end of Mariscal Canyon and about a mile from the takeout, we encountered a stiff wind blowing straight into our faces. The canoes with two persons paddling, one on each side of the boat, made steady progress into the wind, but suddenly I understood the need for more training in the C-1. Every time the bow would move a little to the right or the left, the wind would catch it, and I would go into a 360-degree turn. I couldn't control the boat with the single paddle. The canoes pulled far ahead, and I struggled, cursing the single paddle and swearing I would replace it with a double-bladed kayak paddle, if I could ever get off the river. Eventually I spun to the takeout, where my friends had been waiting. I was exhausted, but the trip was completed.

THE LOWER CANYONS of the Rio Grande, beginning with Reagan Canyon just below Boquillas, always fascinated me, and finally I got the opportunity to see them. In October 1970 the Sierra Club sponsored a trip led by Temple attorney Bob Burleson, president of the Texas Explorers Club and a longtime traveler in the Big Bend and northern Mexico, a true expert on the area. Bob had written the guidebooks that all of us used for the other canyons; they were full of information about the geology and plant life, along with historical references that made each trip an educational experience.

The group on this trip consisted of several other folks from around the state and four of us from Abilene. Also along were Stan Chladek and his

wife, Emma, who, in 1965, won the International White Water Champion-
ships in Prague, Czechoslovakia, to become canoe champions of the world.
Now, five years later, Stan was finishing a research fellowship in biochem-
istry at Texas A&M. During vacations he and Emma applied their skills
to the wildest rivers the Southwest had to offer.

We started down the river on a Sunday morning at Stillwell Cross-
ing, a historic landmark on the Adams Ranch where early settlers drove
their Mexican cattle across the Rio Grande to Texas markets. We planned
to spend six days traveling one hundred miles from the eastern edge of Big
Bend National Park to near Langtry, Texas, where the law west of the Pecos
is much the same today as it was seventy-five years ago when Judge Roy
Bean was in love with Lily Langtry and Robert Fitzsimmons fought Peter
Mahar on a Rio Grande sandbar. The remote area between the national park
and Langtry is largely unexplored and completely isolated.

Because, even by 1970, so few people had entered the area, we felt
the trip might accomplish several purposes. We hoped to discover, and docu-
ment with photographs, undisturbed evidence of early humans to report to
the Texas Historical Commission. The legends we had heard told of people
who had lived in the rock shelters along the river long before the early his-
toric Jumanos were visited by Cabeza de Vaca near present-day Presidio.
In addition, we wanted to photograph the fragile beauty of one of Texas'
last true wilderness areas. Late summer and fall rains had brought the
parched earth into bloom. The vegas above the river were brilliant green.
The mountains were packed with color and flowers. And finally, of course,
we had come to confront nature. We wanted somehow, in the stillness of
the desert, to reaffirm ourselves, to escape for just a little while the press
of civilization, to catch our breath, to think, to let things fall into place, to
sort things out.

We were not disappointed. In six days we saw the beauty of the
canyons, the still, quiet waters of a sluggish river that time and again
changed into a thrashing white roller coaster in rock-choked rapids. There
were rain and cold. At the most difficult rapids we portaged the canoes.
There were blisters and strained muscles, but there were also deer and
Prairie Falcons, Ruddy Ducks, and Cliff Swallows. Cacti and flowers in a
hundred varieties were everywhere. Quickly we saw evidence of human
occupation.

The first evening above camp we found the "ring middens"—the
burnt, cracked rock of ancient cooking fires—of a continuous series of

campsites stretching almost a thousand yards along the river. Acres of fire-blackened rocks and flint tools were scattered about, indicating several hundreds of years of repeated occupation. Later we climbed to rock shelters along the way and found mortar holes and grinding rocks in abundance. In several locations petroglyphs were carved into the limestone walls; the stone implements had lain on the cave floor untouched for centuries. Amazingly, the carvings were unmarred by vandals. We photographed them and left them as we found them, to stir the curiosity of some future visitors.

Three days into the trip we came to our first big challenge: Hot Springs Rapids. Stan Chladek stood on a boulder and pointed his finger toward a scattering of boulders almost obscured in the foam. "I think we'll make it about there," he said. "Then slip into the eddy behind that large rock . . . then on through."

"Good luck," I said. "We'll be ready downstream if you capsize." He and Emma replied with a smile and a handshake.

Confidently, they walked through the salt cedar that lined the Rio Grande and up the river to their sleek C-2 white-water racing canoe. With efficient precision they belted down their splash skirts and settled to their knees, lowering the canoe's center of gravity. Stan took the bow position, where his strength would be most effective. For a moment they back-paddled in the current, taking one last critical look at the churning water ahead, then they executed the power stroke. The canoe leaped forward as if jet-propelled. "You've got to be going faster than the water," Stan told me later. "Otherwise you have no control." The rapids surged to meet them at exactly the place they had pointed out to me earlier. Twisting, slithering, and sliding, the yellow canoe turned neatly behind the rock and slipped into the eddy, then shot forward with a renewed burst of speed and power across the remaining boils and suck holes. Camera shutters clicked from a dozen different rocks as the Chladeks waved their arms in a sign of victory from calmer water a hundred yards downstream.

Abilene insurance man Jack Callaway teamed with Houstonian David Cornell to make the same run. "Here they come," shouted someone as their seventeen-foot Grumman canoe came into view from behind the salt cedars. They gathered speed. Paddles flashed in the afternoon sun. "Watch the haystack, Jack!" Our advice was drowned by the thunder of the water. Suddenly, the canoe seemed to stand on end as the swirling current caught it in a watery squeeze. Then it was upside down and two men were

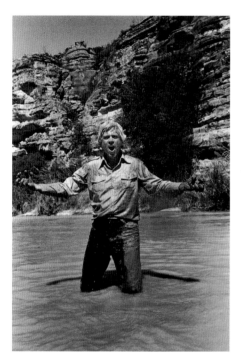

Frank Calhoun in a traditional mud fight in the Lower Canyons, 1977.

swimming for their lives. Downstream moments later we helped them to the top of the riverbank to catch their breath on the grass-covered vega.

The name of the game was action. On the fifth day I asked my partner, Owen Cook, if he was ready for a shot at the white water. Ahead of us was a vicious series of rapids called Lower Madison Falls. "I'm ready," he said, and we pulled ashore fifty yards upstream so we could analyze our route. Stan and Emma showed us the way. "Be sure and miss that boulder," he said. "The force of this water can wrap your canoe like a pretzel around the stone. And be careful if you swamp. A canoe full of water in this current would crush a man if it pinned him on a boulder."

We borrowed their slotted crash helmets for protection and started out. It happened quickly. One instant, a wall of water; the next, a fish-eye view of the Rio Grande, with our swamped canoe floating ahead of us. It would take us a long time to even approach the skill of our friends the Chladeks.

The next day, action again. We rounded a bend in the river, and I saw a strange object half submerged on a sandbar. "Pull to the left, Owen," I yelled. "Let's see what's up ahead." As we came closer, I could see the body of a man. The currents swept us by in a flash. We yelled upstream for the others, and they made their way slowly to the corpse.

There was nothing to do but leave him in the river as we had found him and report to the sheriff two days later when we reached a telephone. Was it the body of a fisherman or of a Mexican attempting to enter the country illegally? No one knows for sure.

At noon Friday we arrived at the Davenport Ranch below Dryden, Texas, where our cars and canoe trailers were waiting. It had not been a trip for amateurs. Without the proper preparation and equipment it could have been disastrous. A person injured or ill along this stretch of river can be evacuated only by helicopter or floated out by canoe. But it can be a safe trip if adequate food and supplies are taken, life jackets are worn, and the other rules of river running are followed. The Lower Canyons of the Rio Grande provide the most exciting window to nature that any state has to offer.

Agave along Lost Mine Trail, 1994.

The Photographer

IN 1995 I WAS TRAVELING toward Alpine on my way to the Big Bend and thinking of the early photographers who had documented the area. W. D. Smithers had roamed the border, and his photographs were in the immense collection at the Harry Ransom Humanities Research Center of the University of Texas. Frank Duncan had worked the Marfa territory and left an extensive body of work. But the man who had documented Big Bend Park from its earliest days was Peter Koch. I knew that he had died some years before, but I had heard that his wife was still alive and that she probably lived in Alpine. I called her from my car phone as I was entering Alpine and asked if I might stop by and see her.

Etta Koch was glad to have a visitor and gave me directions to her house just outside of town. We sat on her screened-in porch and talked about the days when she and Peter had first come to the Big Bend.

Pete was born in a German community in Romania and had emigrated from there with his parents when he was a child, growing up in Cincinnati. Etta was born in Ohio. Pete was working for a newspaper, the *Cincinnati Times-Star*, when she met him through a friend. They started going together and then married. Etta said that not only was Peter a professional photographer but every weekend he would also take off for the country to photograph the natural history of the area for his own pleasure.

"I had asthma at the time," Etta said, "so Pete said, 'We'll go west. I want to photograph the desert.' So that's how we came. In 1944 we loaded up in our travel trailer and started west with our three kiddos."

Along the way, Pete met a person with the Park Service at a party in the Smoky Mountains, where he had been photographing, and as they talked, Pete revealed his interest in photographing the American West. The Park Service person suggested that he stop by Big Bend, a newly opened national park. Pete said sure, since he was photographing the West. So he and Etta and their three girls drove to the park, arriving on February 22, 1945.

When they got there, Pete met the superintendent, Dr. Ross Maxwell, who asked him if he would take photographs of the park for publicity purposes. Since it was still wartime, it was difficult to obtain film. Dr. Maxwell offered to supply some film for Pete's personal use if he would do the job for the Park Service. That was the agreement: he would take publicity photographs of Big Bend National Park and get some film for his own work. Etta Koch believes that Pete's photographs were among the first taken of the area as a national park.

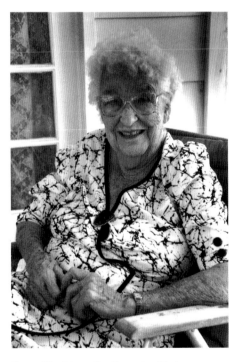

Peter Koch's wife, Etta, in Alpine, 1995.

They intended only to stop over to take pictures, but when they came over the divide and saw the Basin, it took their breath away. Pete told Etta that very first night to write her folks that they were here to stay indefinitely.

It developed that Dr. Maxwell needed a secretary. He had advertised the position and employed a person by mail. Etta had been a secretary for years, and Maxwell asked her to fill in until the new woman arrived. But when the new secretary found out how far the location was from a city, she withdrew her application, and Etta kept the job. She and Pete moved out of their trailer into the Civilian Conservation Corps barracks and became permanent residents. They stayed in the park for thirteen years.

"There were four Park families living there at the time we arrived," Etta told me. "The superintendent, the chief clerk, the maintenance man, and a ranger family . . . just four families," she said. At that time, before the new headquarters were built, all families lived in the CCC barracks.

The entertainment for the family centered around the unexplored Chisos Basin. Etta and the girls climbed all over the place. "I just took the trails," Etta reminisced. "The children would climb Casa Grande. They'd climb up the back of it to get on top. Our daughters loved the park. Especially since they could hike and climb the mountains."

Betsy Clark, Etta and Pete's daughter, later told me that there weren't many other children their age to play with at that time. They had their schoolwork, though. They took the Calvert Course by correspondence for the third and fourth grades. When the school age population rose to seven children, the park got a schoolteacher. Betsy was the only person in the class for the fifth, sixth, seventh, and eighth grades. Etta sent her to Marathon to finish out the eighth grade to make sure she would be up with the other children before entering high school.

The living conditions in the park then were much different than they are today. Modern facilities now make it comfortable for park staff and visitors alike. Betsy remembers the time before refrigeration when Pete fixed a little shelf in a tree near their trailer to store their bacon. He would cover it with a wet burlap sack to keep it cool. It would last about a week, and then they would wait for the truck to come from Marathon with fresh supplies. The truck made the trip once a month, bringing them a pound of bacon and a dozen eggs. The rest of their food was canned goods and oatmeal. They didn't have candy; their sweets were apricots and fruit.

The first summer they were there, the Park Service drilled a water well. Betsy said they all have good teeth from drinking the water from that well. During those early days, there were lots of springs and the creeks were running. The residents could drink the natural water anywhere. Now, visitors are cautioned to pack their own water because of possible contamination in the streams and springs.

The girls had permission to ride the Park Service burros when they were not being used. In the early days of the park, the rangers allowed the burros to graze outside of their small pasture. Betsy would see one walking by, jump on his back, and sit there while he grazed along. Occasionally, the children got permission to ride the fire guard's horses. It was a special treat to ride to the South Rim and visit the fire guard at the Boot Canyon shack. Sometimes they would stay with him for a couple of weeks. Pete once pointed out the rare Colima Warbler to the girls, but they were not impressed. They preferred to ride the horses.

After they had been in the park a year or so, Pete began to travel, lecturing with his photos, in the role of a freelance publicist for the park. He made three two-hour-long silent color movies of the park, and he would narrate them as they were screened. He traveled in the eastern United States, lecturing and showing his films. It was the first time the Big Bend had been advertised in the East. Slowly the tourists began to come, as information about this new national park spread.

Pete decided to move Etta and the trailer down from the Chisos Basin to a location at a lower altitude, where it would be warmer during the winter. Dr. Maxwell suggested that Etta and the girls could stay at Hot Springs in the old rock house on the hill. That year they lived in the rock house from September until March.

Etta remembered the legendary Maggie Smith, who was running the general store in Hot Springs at the time. Maggie's store was a crossroads of the area, and she sold supplies on credit to people on both sides of the river. She also filled every possible occupational role, from postmaster to midwife. After the Park Service took over, they let Maggie stay a year or so and then closed everything, including the store.

Today the store is preserved, and visitors looking inside through the guard screen can see painted murals on the walls. Etta told me that she had drawn several of them. She said that she didn't know if they were still there but that Pete had painted the cactus and she had decorated it with little red

buds. I asked her about the horse heads in some of the rooms of the rock cabins that still remained.

"I didn't paint the horses," she continued. "They were done by one of the River Riders' wives. These patrolmen used to ride along the river and keep the immigrants from crossing the border. It was like today's Border Patrol on horseback. The only one whose name I recall is Aaron Green of Marathon. I don't remember the woman's name who painted the horses. She evidently lived in the cabin after we left."

Pete was an aggressive photographer, determined to photograph every corner of the park. Once, Betsy recalled, he made a raft of agave stalks with two inner tubes for flotation and a big milk can to carry his film, a wool blanket, and his camera. He had a canvas seat in the middle and his legs dangled in the water beneath. He could float along and then, in the shallows, stand up with the raft around him and walk along the shore. He named it the Broken Blossom.

Etta dropped him off in Lajitas, and he floated through Santa Elena on the agave raft taking pictures and exploring the canyon. The family was terrified that he would not make it because all they knew of the canyon at that time was that a man had died at the "rock slide" near the upstream entrance. When the prearranged time came to meet him at the mouth of the canyon, he wasn't there. A day passed. Etta was frantic. Had the great rock slide claimed another victim? Finally, a day later, he came floating out, pleased with the photographic opportunities he had discovered.

"He was a man to take risks," Betsy once told me. "They just tickled his fancy. I went with him to a lot of places that he had never been before. I remember sliding down through a prickly pear patch on the side of Pullian Peak one night. It was hot and I had a headache. It was an awful trip, but he was tough."

Pete just wasn't interested in photographing people during his time in the Big Bend. Perhaps he had gotten an overdose of that during his photojournalism days. He would use his family for props in his photographs of the park, but not as primary subjects. He would drape a snake around Betsy's neck to provide a sense of proportion, but he didn't take many family pictures.

Often, the family would load up in their 1938 Chevrolet and go down to the desert. When Pete spotted something he wanted to photograph, he would take off across the flats and set the camera up, waiting for the sun

to rise or the clouds to move. Betsy said that he would sometimes wait for hours for the light to be just right.

Etta smiled as she remembered those days, and I could tell the memories were good ones. She went on to say that after Pete left the park and opened his own business in Alpine, she had continued to work for the Park Service. He illustrated a book of wildflowers for Barton Warnock. He also worked his postcard route. These cards and the park brochure photographs were the first images of the park I had ever seen, and the standard by which I would judge my own work for many years.

For the most part, Pete was a landscape photographer, revealing the natural world to attract the tourists that would bring activity to the park. As a young photographer, I was strongly attracted to this tradition and longed to replicate it. But that was something difficult to do with 35 mm equipment, and I had no knowledge of the technical expertise practiced by the great landscape photographers of the day. I struggled with my small images and wondered why the prints did not have the snap and detail of the grand images I had seen.

The landscape genre continues to intrigue me, and I still feel compelled to investigate the special places, forms, shapes, and textures of nature. The power that the landscape holds in the minds of people is manifest in the millions of photographs of trees, mountains, and streams taken by tourists with their automatic cameras. It is so with me. In an exhibition of Chinese art at the Sackler Museum at Harvard University, I read that the Chinese word for landscape is *shanshui,* meaning mountains and water, and that the Chinese consider landscape painting the philosophical search for principles that underlie the harmony of the universe. Perhaps the feeling is an innate characteristic within us all.

I thought Pete Koch a legendary figure. He never knew what an influence he had on a young photographer from Abilene.

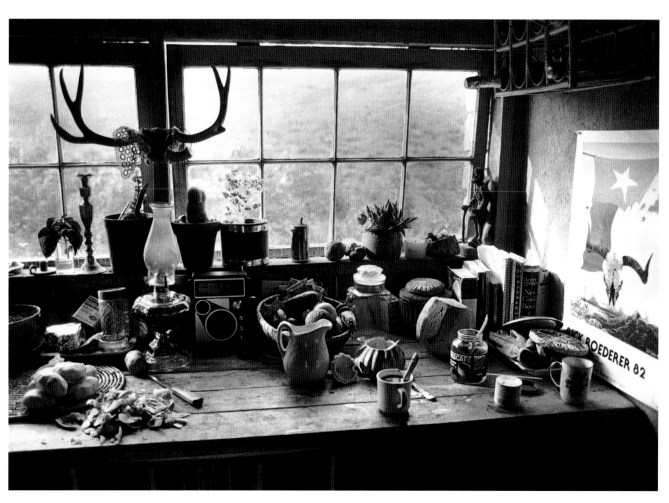

Rancho el Milagro, 1982.

Searching for Presidio San Carlos

CHAPTER 5

NINETEEN NINETY-FIVE was the year Ole Grey was to be baptized—"Ole Grey" being an affectionate term for my four-by-four Land Cruiser. Loaded with photographic gear, books, and field guides, she and her predecessors have crisscrossed Big Bend backcountry roads for decades. Today, however, was to be a first. We would ford the Rio Grande at Lajitas, the place where the old Comanche Trail carried Indian raiders between countries, then on to the Chihuahuan village of San Carlos. The objective: to locate the remains of the presidio constructed near there by the Spanish in 1773.

This morning in January, photographer and educator Bryce Jordan and I were having our final coffee in the hotel restaurant and bolstering each other's courage. It seems most of the advice we received about using the Lajitas low-water crossing was negative. "There is a growth industry here in pulling stalled trucks out of the river," one optimistic adviser said. "Of course, some of them just floated downstream a ways, then grounded. When a rise came down, that's the last we'd see of 'um."

The restaurant manager recommended we take the Lajitas ferry—a rowboat—across and secure the services of a professional who works for the golf course and who advertises his services as a tourist guide to the village of San Carlos. Unfortunately, he was busy that day. But that was fine; we wanted the excitement of exploring the area on our own.

The Lajitas–San Carlos area is a historic place. Early Spanish manuscripts speak of its importance as a crossroads in the far-flung province of Nueva Vizcaya. It was a primary crossing for the various Indian tribes that roamed across the river, recognizing no sovereign territories. In the past it was a principal port of entry into the United States, where thousands of head of Mexican cattle were trailed to market. The actual boundary between Mexico and the United States is only a political construct, something for the sheriffs, Border Patrol, and drug enforcement agencies to deal with. The culture of the area is virtually seamless. People move freely back and forth across the Rio Grande, which marks the border between Texas and Mexico. No effort is made to control local traffic here. So, as with those early raiders, the Comanches, who crossed at will to steal from settlers in both countries, today's raiders—drug traffickers and other outlaws—cross the imaginary line between the two countries with their own brand of plunder.

Life on the border has complex undercurrents of local gossip, historical determinism, and blissfully ignorant tourists, whose economic support is the lifeblood of the communities. Spanish is the language and visitors the

crop to be harvested. As my late friend, historian Rupert Richardson, once stated: "A tourist is worth as much as a bale of cotton and twice as easy to pick!" Most visitors stop at the river—not because of the water, but rather for fear of entering an undeveloped area devoid of customary services where the English language is often not understood.

As Bryce and I were preparing to leave the restaurant, I noticed a familiar face at the "locals" table. It belonged to Janet Sullivan, a classmate of mine from the Texas Parks and Wildlife Department guide course that I had taken the previous January. She lived in a trailer down by the river and knew everyone in the area. The last time I saw her, she was flagging traffic for a road construction crew between Lajitas and Presidio. She was a short, striking woman with long, straight blond hair and a face deeply tanned from her years outdoors. I walked over, reintroduced myself, and asked if she would like to drive over to San Carlos with Bryce and me. I knew she spoke Spanish much better than I, and she probably knew folks in San Carlos who could help us find the old presidio. She was agreeable, and we loaded up and headed out. I remembered from the workshop that Janet had a degree from Texas A&M in parks and recreation management and was working on a master's degree in wildlife communications. She would be able to help us appreciate the diverse plant life along the way.

I had previously made the crossing with my friend David Alloway, who had explained the procedure. "Take the road to the river behind the Lajitas trading post. You will come to a shallow slough creating a small island at low water levels; cross the slough and follow the tracks across the no-man's-land island and into the water, continue straight in the river for twenty yards or so, then take a right turn and head for the tracks leaving the water on the Mexican bank."

Following David's directions, we came to the slough and plunged ahead, with Bryce looking apprehensively out of his window at the water that immediately covered the running boards and almost came inside. We crossed the small island and cautiously entered the main body of the Rio Grande. The bow wave seemed gigantic and gave a false impression of depth. Looking straight ahead, it seemed we were going under.

The directions were precise and we slowly made our way across and up the Mexican bank. Ole Grey had her baptism, and our faith in her was well founded. We drove through the river cane and sand to the intersection with the road that connected San Carlos and Paso Lajitas, the small Mexican community across the river from Lajitas, Texas.

When Presidio San Carlos was established, Mexico was under Spanish rule, and there was concern about the organization of the frontier defenses. In 1765 the Spanish king sent the Marques de Rubí to the frontier to conduct a survey of the defenses and recommend changes to better protect the Spanish settlements from the ravages of the Apaches.

As a result of Rubí's recommendations, the Spanish government ordered Lieutenant Colonel Hugo O'Conor to select new sites for the frontier defenses, and he chose to move the presidio San Miguel de Cerro Gordo (now Villa Hidalgo, Durango) from the banks of the Arroyo de Cerro Gordo, about two hundred miles south of the Rio Grande, to a new location near the spring of San Carlos. Historian James Ivey described the establishment of the presidio in a report for the National Park Service.

O'Conor returned to the site of San Carlos in May 1773. He brought military engineers, who evaluated the physical location and gave their approval for the new construction. The location at San Carlos to which the troops from Cerro Gordo would be transferred was on a "flat and roomy hilltop above the permanent stream of San Carlos, about six miles from the Rio Grande. The area had abundant pasture land and farmland and a good supply of timber."

The garrison at Cerro Gordo was relocated to San Carlos during October 1773 and was known as San Carlos de Cerro Gordo. After certification by the engineers, construction began immediately. The garrison gathered building materials and began planting the fields by April 1774. By 1775 the garrison had probably completed construction of the presidio and begun the routine of border protection and other military duties.

In those times a presidio was a place of safety. The military garrison was theoretically able to protect the area settlers from the Indians and the occasional bandits who might venture that way. The San Carlos presidio was part of a line of presidios extending from San Vicente, on the east side of the Chisos Mountains, west to present-day Presidio, Texas, and the junction of the Rio Grande and the Rio Conchos. Other presidios were established along the frontier all the way to California and southeast to the Gulf of Mexico. After several years, the San Carlos presidio was relocated to the Conchos south of Presidio because the location at San Carlos proved to be too far from the villages it was designed to protect.

The small community of San Carlos continued after the presidio was relocated. Preliminary archaeological surveys in and around San Carlos Canyon reveal ruins indicating that the occupation of the area was probably

continuous from the time the presidio was established to the present day. In the old days the Mexican village of San Carlos was an important town, crossroads of the trail to Presidio and another to the Lajitas crossing of the old Comanche Trail into Texas.

During the famous Chihuahua–El Paso Pioneer Expedition of Colonel Jack Hays, the inhabitants there provided food and shelter to the lost and starving company after they had wandered through the rugged Big Bend country en route to El Paso. In his biography of Colonel Hays, James K. Greer quotes Hays explaining to the authorities in San Carlos why the armed expedition had crossed into Mexican territory: "We were compelled by hunger, the strongest necessity that men could urge." The villagers treated the men well and directed them toward Presidio.

The village had survived through the years because of farming on the floodplain of the Rio Grande and its tributaries and, more recently, because many of its inhabitants commute the fourteen miles to Lajitas to work in the hotels, returning to their families on their days off. There is only a slight income to the community from tourism. A few hardy visitors come from Lajitas to see the beautiful canyon and the nearby spring. On an earlier trip I had explored San Carlos Canyon, but I hadn't known anything about the presidio.

Were the walls of the old presidio still standing? Bryce and I were determined to find the site before the adobe walls melted back into the desert or were destroyed by treasure hunters, as had happened to the presidio at San Vicente. We would measure the remaining reality against the myth.

As we started up the narrow road, I asked Janet how she had happened to come to the Big Bend country.

"I started coming out just camping as a parkie, back around seventy-seven," she said. "Didn't know anything about anything. I thought outside was just the space between the house and the car. I was doing the corporate scene. I had my own business, and when my husband and I came out here we did everything wrong. Wrong tent, wrong shoes. I didn't know what kind of food to bring. It was still a great experience. That's when I saw Casa Grande, the big mountain in the Basin. She captured my soul and she still has it. . . . I walked into the desert and I was home.

"Then my life changed. My husband and I had done the 180-degree-turn-of-direction-in-life thing [divorce], and I needed to know if I liked the

area alone. We had always come together. My husband was a really cool person, really a wonderful person, but it was just time for different pathways."

The Land Cruiser jolted along over the two-track road toward San Carlos, and behind us the dust boiled up, sucking back toward the rear window. I kept the speed up to leave it behind. Bryce was hanging on and holding the equipment. Janet was enjoying the company and the scenery. The landscape was typical Chihuahuan Desert, with lots of lechuguilla and the waving tentacles of ocotillo. Occasionally, the multifaceted green dome of a large pitaya cactus was backlighted by the early-morning sun.

Janet continued, "I came out to see if I wanted to do this alone. I was working at that time in an office. I left work on Thursday evening and had to be back at work on Monday morning. So I came out here and decided to do the Chimneys hiking trail from the Ross Maxwell Scenic Drive. Then I was going to hike on to the Maverick Road, then hitch back.

"I came to the Chimneys, and it was an easy trail. Then I continued on for Maverick. It's an old trail and supposed to be pretty easy, but I never found it. So here I am at ten-thirty in the morning bushwhacking across the

Janet Sullivan, near the town of San Carlos, 1995.

desert. Having the time of my life, looser than a goose. Lost, but not lost, because I knew where west was!"

The color in the eastern sky was beginning to be overwhelming. I slowed Ole Grey to a stop and we all piled out for photographs. Bryce unfolded his tripod and started shooting his new Mamiya 6, and I ran some film through the Nikons. Janet wandered around, examining cactus and kicking rocks. The sun gradually bleached most of the color out of the sky, and we loaded up again and continued toward San Carlos and the mythical presidio.

Janet continued with her story, picking up where she was semi-lost after the Chimneys trail. "I finally found the Maverick Road and just hollered out loud! 'I did it!!!!' Then I saw a bus coming my way and thought how lucky I was not to have a long wait. Yeah, it was a Big Bend River Tour bus, and it passed me right by! Left me standing way to hell out there in a cloud of dust.

"Then another car came by . . . maybe it was some people from Abilene, or Lubbock, or somewhere like that. . . . They were going the other way, so I said, 'Okay, I'll just catch another ride.' Then an RV passed me. Now here I am, five feet tall, one hundred and five pounds, a pack on my back, it looks like I've been hiking. And here come a couple of RV-type people . . . seniors . . . had a Florida license plate. They drive by over to the far side of the road. She's scrunched up under him, like how afraid they were, and he gunned it and went right by me. And I wasn't mad, it was just sad that they were afraid of *me.* Finally there was a bunch of kids, a church group, and they took me part way, then I hitched with somebody else. It was one of the most exhilarating experiences I've ever had!"

"You decided to come down here and stay. How did that happen?"

"Well, I met Jack and Alice. I'd never stopped at their Terlingua store in all the fifteen years I'd been coming. I was driving along and just turned around and went in and visited. I'd never met them, although I'd met a lot of people like Robin, Angie, and Jim Carrico, and so I just gave them my typical spiel: 'One of these days I'm going to move to the Big Bend. I really want to do that.'

"Well, I went back to Corsicana, and in a couple of weeks Alice called me and said, 'Did you mean that about coming to the Big Bend?' and I said, 'Yeah, I meant it.' She said, 'Have we got a deal for you.' They had a little store that they were going to try to keep open while they went out and worked someplace else. She said, 'We can't pay you, but we've got a trailer

you can live in and you can eat out of our little restaurant and if you sell anything we'll give you a commission.' So I said, 'I'm on my way.' And on the very day, exactly, that my former husband and I had planned to be here, I was here. I didn't manipulate it, I didn't make it happen, the universe brought it about."

Bryce spoke up. "How long ago was that?"

"Nearly four years ago."

We came up a short grade, and as we topped out we could see Rancho el Milagro, or Mimi's Place, as I always called it. Mimi was long gone to California, working in the movies, but her reputation lingered on among the locals of Lajitas.

The sight of the ranch brought back memories of my first trip to San Carlos. I first met Mimi on an early January morning in 1982. I was bringing some friends to the Big Bend area for the first time and had arranged the trip to San Carlos with Mimi over the telephone, agreeing to meet at Lajitas. The group consisted of my wife, Alice; Phil and Jo Shultz from Santa Fe; Nancy Scanlan, a photographer from Austin; Marni Sandweiss, the curator of photographs at the Amon Carter Museum in Fort Worth; and her assistant, Charlott Card. Phil was a naturalist and retired surgeon and Jo a former army nurse whom he met after the war while serving as a doctor with the Indian Health Service in Arizona. It was already two hours past the time we had agreed on to meet, and I was wondering if I had screwed up, planning a trip into Mexico with someone I didn't know. The temperature was crisp that morning, and dawn couldn't quite break through the low overcast. Alice and I were sitting with our friends on the steps leading up to the front porch of the house we had rented for the week. Everyone was grousing, having been awakened at five in the morning for the ride across the river, and we were ready for the promised breakfast at Mimi's ranch house on the road halfway to the village of San Carlos.

Mimi Webb-Miller's name had been offered by the hotel as a person who would take our group into the interior of Mexico to photograph the historic spring that issued from one of the most colorful canyons of the area. Luxuriant ferns and trees were promised, as well as a picnic lunch and, perhaps, a cockfight in the village.

We were told that Mimi was a recent graduate of Southern Methodist University with a degree in art history and that she was a niece of U.S. senator John Tower. Sounded steady and dependable. On the telephone we agreed on the price and the time, and here we were: cold, hungry, and

about ready to check off the whole adventure as a bad deal. Just as we were preparing to take our gear back to the room, Mimi came walking up, unconcerned, laid-back, and invited us to walk to the river, where the boatman was waiting to take us across to her waiting Suburban on the Mexican side. Anxiety somewhat subsided, and aggravation began to set in. "Did we misunderstand the time we were to meet?" I asked. "No," she responded, flashing a winning smile, "just had some difficulties getting started. Boatman was late . . . you know how it is in Mexico." Mimi was assertive and confident. She had a beat-up kind of outdoor tan and dark brown hair streaked sun-bleached blond that were definitely not from a fancy salon. She wore down-at-the-heels cowboy boots and Levi's and looked as if she had spent her entire life here on the border. Everyone began to relax, and I began to hope for the best.

Mimi Webb-Miller, 1982.

The morning light was still tentative as we drove our vehicles to the Lajitas crossing behind the old trading post. We locked them and started to the ferry that would take us to the Mexican village of Paso Lajitas on the opposite bank and Mimi's car. The "ferry" turned out to be a rowboat with a leaky bottom, and it was piloted by an uncertain navigator who spoke no English. The river looked ominous in the early light—dark-brown waters swirling in mysterious eddies at the base of a slippery bank. I tried to reassure my guests. "I've been across here many times before. No sweat. You all load in, and I will come on the second trip." Somehow I got the feeling that everyone wanted me to go first, so I eased down the sloping bank and took my position in the rear of the boat. Alice was next, carrying her longtime fear of water quietly as she sat beside me. "The river isn't deep here," I said to the group. "You can actually stand up and wade across." I was speaking to the breeze. All were eyeing the boatman and trying to convince themselves that they would be safe in this rickety boat with its Spanish-speaking captain.

We made the crossing without incident, and the boatman returned for those who remained. When we were all safely ashore on the Mexican bank, the group relaxed somewhat as we loaded into Mimi's vehicle and started up the road toward her ranch house.

Paso Lajitas was beginning to stir, with people walking to the river. We drove through the town and began our climb out of the river valley and into the mountains to the south. Mimi would sometimes pull to the side of the faint road to give me an opportunity to photograph. The road was

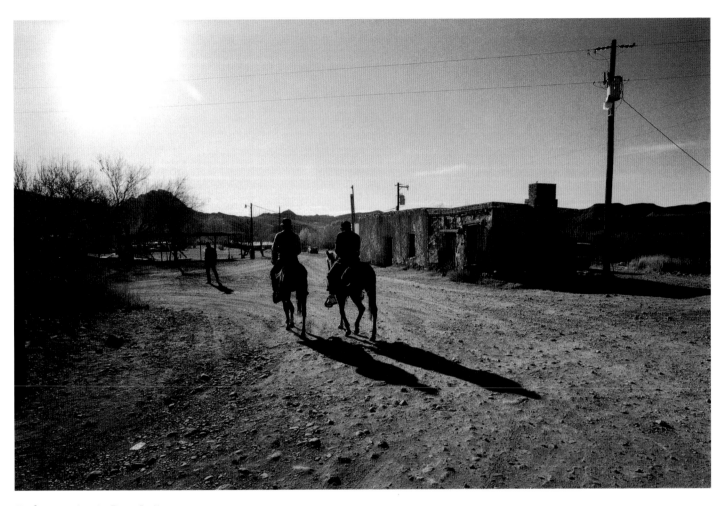

Early morning in Paso Lajitas, 1994.

definitely primitive. By now, the hungry troops were very anxious to arrive at Mimi's house, where the promised ranch breakfast was waiting.

Our plan was to have breakfast and then drive on to San Carlos to see the local celebration, photograph the cockfights, and listen to some authentic Mexican music. Then we would hike up the beautiful canyon to the spring before we returned to Lajitas.

We arrived at Rancho el Milagro, where Mimi lived. Breakfast was not ready, and the troops began to grumble. "Won't take but a moment," Mimi assured us with a smile. She proceeded to wake up Manuel, the Mexican rancher, who was supposed to have had the breakfast coffee ready. By

Manuel's children asleep at Rancho el Milagro, 1982.

now everyone was delirious with hunger and fearful of what we might get when breakfast came.

Alice inquired as to the facilities. Mimi, more accustomed to the primitive nature of the Big Bend country than my citified wife was, waved her outside, saying, "Just any bush." Alice was not charmed.

I wandered around, photographing the rancher's children asleep in their bed, the goats that were sheltering near the house, the buildings . . . anything to pass the time while eggs were cooking. Manuel was fumbling around getting dressed all the while he and Mimi were hurling words at each other. Ours was one of Mimi's first tours, and she wanted things to move smoothly. Finally, Mimi brought scrambled eggs, sausage and bacon, hot toast and salsa. We ate as if it were our last meal and loaded up for San Carlos, wondering if the rest of the day would be as unpredictable as the morning had been.

Mimi drove her Suburban with the rest of the group while I rode in Manuel's pickup. It was an experience in itself. We careened around hairpin turns and bore down the grades at full throttle. I suspected he might have laced his eggs with tequila. The old pickup truck shook, and the brakes squealed as he stomped them approaching the curves. Occasionally his foot would slide off the worn brake pedal and hit the accelerator. The truck

would lurch forward toward the turn, and he would stomp the brake pedal again. A giant rooster's tail of dust plumed behind us, and it thrashed us every time we slowed. I was terrified. I only hoped that Mimi, well ahead of us, was driving more sanely.

Finally we arrived in San Carlos. Our first stop was to visit Manuel's mother, who owned a small shop. She was a charming and distinguished woman, and while she spoke only Spanish, her facial expressions and body language suggested that we were very welcome.

I photographed her in her store and then the streets and the church of San Carlos. There was no rooster fight that day . . . so this trip turned out to be a dry run.

Mimi and her rancher companion took us to the beautiful canyon near the town, where we picnicked and bird-watched. A wonderful experience. On the return trip, Manuel drove the Suburban, having left the pickup in town for repairs. Nancy, the photographer from Austin, sat between Manuel and me in the front seat. There was no air conditioning. Alcoholic fumes blended with the soda crackers that Manuel stuffed in his mouth and snowed us with as he spoke.

The unpaved and ungraded road wasn't fit for a sharecropper farm. Alice was terrified from looking out of the window as Manuel drove as fast as the old Suburban would go. Rocking and weaving, we were close to death, through either asphyxiation or a sudden stop at the bottom of a gorge. But providence intervened. The engine began to wheeze and spit. After it hobbled into the yard at Rancho el Milagro, halfway to the border, Manuel attempted emergency repairs. He removed the carburetor and accidentally dropped a bolt down the intake manifold. We abandoned the wounded vehicle and moved our gear to another pickup that was nearby. Nancy, Marni, Charlott, and I opted for the open-air bed for this last leg of the trip. If the truck were to pitch over the side of a canyon, we could at least fling ourselves out of it at the last minute. We rattled down the mountain roads in the gathering dusk, and it seemed that my companions were at the end of their ropes. Phil Shultz was tight-jawed and ready to throw the driver to the vultures. At the outset he and Jo had been uncertain about traveling to Mexico under these conditions. I didn't know Marni and Charlott very well before the trip. Marni had just taken the Amon Carter job, and she was fresh from the bright lights of the East Coast. This was her first real experience with the Texas outback. They were beginning to wonder about me and why I had invited them to this godforsaken country and if they would survive.

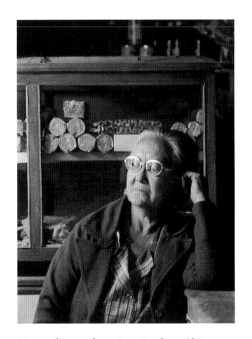

Manuel's mother, San Carlos, Chihuahua, Mexico, 1982.

About two miles from town, the pickup blew two of its tires, and there were no spares. We packed up our camera gear, abandoned a smashed cooler box, and all walked to the border. We had to rouse the boatman from his home because he had long since ceased operating for the day. My friends eagerly leaped into the boat they had been so concerned about before, and we finally landed on the Texas shore. Mimi was apologetic. I understood. Mimi had depended on Manuel, who had let her down. She later developed an excellent reputation as a location spotter for movie companies coming to the Big Bend area to film and subsequently moved to California and established her own successful company. I thought it was a great adventure. Alice thought it one she did not wish to repeat.

As we rumbled past the ranch, I could see that the big "flying red horse" Mobil Oil sign I had photographed once before had been mounted on Mimi's former house, and the property looked occupied. We passed on by.

Rancho el Milagro, 1982.

Janet continued, "I have some great friends down here in the Big Bend, I have wrangler friends and I have business friends and they are all wonderful. I lived in a little town in Central Texas for over twenty years. I never had the friends, the real friends, there that I have here. In less than four years I have found people here who are beautiful and caring, and they

love and they offer and give of themselves, and they are willing to receive your love back and share their emotional and psychic and spiritual life and share their money and want to be around you and say, 'Hey, we missed you' and mean it. That is such a beautiful thing."

"Wait a minute," I said. "I'm sure there are some bad actors down here also, like everywhere else. What is the downside?"

"There's some gossip that goes on," she admitted. "It's kinda petty in some ways. The very people that'll be petty will still defend you to out-siders. It's kinda like family. 'We'll crucify you, we'll vilify you, we'll annihi-late you; but nobody else better.' The thing is, then, if you care about the area, and you care about the people, you just go through it. It's kinda like a baptism by fire. Like other small communities, maybe this area demands it. I don't know. Maybe it's part of paying your dues. I'm not sure. But once you get through it, then you're a part of the family."

Ole Grey pulled to the top of another grade, and beyond us in the valley lay the historic town of San Carlos. I could imagine the days of Comanche raids and border skirmishes. In those early days the Spanish had in their army a Danish colonel, Emil Langberg, who recounted in his report of his campaign against the Comanches that the land near San Carlos was rich in timber and pasturelands as well as minerals. He noted that the Mescaleros had long lived in the area and had been driven out by the inhabi-tants of San Carlos and the Comanches. He also commented that the Comanche Trail was so wide and hard-packed that it was better than the Camino Real.

It was evident that the Comanche Trail from Lajitas to San Carlos had taken a different route or had suffered the effects of years of disuse, because the road we had been following was certainly no Royal Road. We drove into the clean, well-kept town and bounced over the stone pavement toward the plaza. Pulling over, I hailed some men working alongside the road and asked for directions to the old presidio. Getting wildly conflicting answers, I pressed Janet into service as a translator. Together we made out that we were to continue on past the plaza, turn left into the riverbed, then follow it to another road that led out of town to the south. We thanked them and moved on.

We came to the riverbed and turned onto its solid gravel, driving past overarching cottonwood trees with a few scattered golden leaves remaining on the stark branches. We paused for photographs of the incredibly blue sky. We came to the road, turned south, and began looking for the remains of the

presidio, which continued to be elusive. We came to a large ranch where men were loading a big wagon with hay. I pulled in the gate and drove to where they were working to ask directions.

"¿Donde esta el presidio viejo?" I asked in my best Spanish. There was a confusion of rapid-fire responses that totally exceeded my capacity to understand. Janet was swifter. "They think you are asking the direction to Presidio, Texas," she told me. Finally we got it straight, and, yes, they knew of the old ruins. With a complicated set of instructions ringing in our ears, we proceeded along the road away from town. The Chihuahuan Desert unfolded around us, a large valley with mountains in the distance. After ten or twelve miles, we all agreed that something was wrong. We turned back and drove into the ranch again to clarify the instructions. I suggested to the man with the pitchfork that it would be helpful if he could take a few minutes and come with us. Apologetically, he declined but motioned to his ten-year-old son, who was working about fifty yards away.

With some reluctance the young boy came forward, hanging back ten or twelve yards and viewing us with anxiousness. "Por favor, señor," I tried to be smooth, trilling my r's. "¿Vaya con nosotros al presidio?" The kid was terrified. His father tried to reassure him. Finally he relented and nervously climbed into Ole Grey and sat beside Janet. We determined that his name was Horacio Morales and then off we went. At each crossroad, Horacio would point, and I would turn in the direction indicated. Finally, near the road ahead, the crumbling adobe walls of the old presidio came into view.

The presidio was located on a broad open expanse of land, surrounded on the south and west by mountains and sloping toward the Rio Grande valley in the north. There is a view of the back side of Santa Elena Canyon, a seldom-seen perspective.

We pulled off the road, gathered up our cameras, and began to explore. By this time Horacio had begun to relax and tried to tell us things about the presidio that I could not understand. I would attempt to clarify and we would both break up laughing at my miserable Spanish.

Standing on the bumper of Ole Grey, I could see that the standing walls were only a small part of the total structure. The presidio had been constructed in a square with large diamond-shaped bastions in the north and south, probably for cannon positions. Most of the remaining walls had collapsed to rubble and appeared as a long linear mound that enclosed the square interior of several acres. The road ran through the middle of the structure. I wished I could have seen a plan of the whole thing; then I could

Horacio Morales, our young guide in San Carlos, in front of the ruins of Presidio San Carlos, 1995.

have related it to the walls that remained, which I took to be the chapel. There were potsherds on the ground and holes where pot hunters had been digging. Below, in the shallow valley, was the San Carlos River, which would have provided the water supply for the presidio's inhabitants.

This presidio had a short existence. It was relocated to a more advantageous site on the Conchos River south of the present Presidio and Ojinaga. There it was renamed Presidio San Carlos de Chorreras. The original presidio was later reoccupied, and a census report stated that 119 soldiers were there in 1817.

Returning to the ranch, we left Horacio with a generous tip for his services. I told him his new title was Turismo General for San Carlos, which caused him to laugh again. After entering the village we found a grocery store and purchased supplies for a picnic lunch at the mouth of San Carlos Canyon, which was a short distance from town and a favorite destination for the few visitors to the town. While we were eating, Janet continued her story.

"You said earlier that you had to prove yourself down here. How do you go about that?" I asked.

"It's mainly being willing to be in the outdoors. Willing to do without. I think I said a little earlier today, there's not a lot of money down here.

But it's not what you give up, it's just what you don't want anymore. You don't necessarily want the toys of 'society.' Of what we call the other world."

"It's not that the people have dropped out," I suggested. "People have diminished their desires."

"Yes, that's it," said Janet. "Most people have chosen to be here. It's not a dropout. The education rate is very high. There's a lot of former business people, CEO types, that choose to be here. It's like we've been there, done that, no more. So let's do this. Let's do our own thing. If you come here, do you really mean it, or are you playing a game? Some people come out here and don't know what they're in for. Don't know that it's hotter than hell in the summer and colder than hell in the winter; and there's no water and sometimes there's no electricity and you put up with the hospitality industry and you put up with close confines. No money . . . long ways to anywhere . . . wilderness . . . You got to prove you can do it. Can you be on the river? Can you hike the mountains? Can you sit out there in a tent? In a travel trailer? Can you take the gossip . . . the rumors . . . the nasty? Are you going to stick? Did your spirituality stay in it? It's a very spiritual place.

"You go through all that and suddenly, and it's almost suddenly, now you're one of us. And that's oversimplified; it's a very, very complex thing. I wouldn't trade it. Could I live in another world? I don't know anymore. I really don't know. I tried Dallas for a couple months last year, and it nearly killed me. Really and truly. I was trying to help my parents regain some money, and they finally said, 'Blow it off, forget it, go on.' It's better that you go than die if you're dying slowly by degrees. It's been tough sometimes. Just keep on going. I've developed some beautiful friendships out of it, and I've seen the same thing happen to others."

We finished lunch and sacked the trash. It was time to head back to Lajitas and perhaps get some evening shots on the road as we returned. One of the persons in town had suggested we might be interested in seeing the mines, so we decided to detour by and see what we could. Again, we drove several miles out of town on the road toward Ojinaga, but the turnoff to the mines never materialized. We agreed to check it out next time we were there, then turned Ole Grey around and headed back to the dirt road leading to Paso Lajitas.

Uncle Joe, Aunt Roberta, and the Cinnabar Miner

I WONDERED IF BANK was going to make it. He was fifteen minutes late, and time was running out. When we had talked on the telephone the day before, he said that he would meet me at the Abilene Regional Airport at 6 A.M. and fly with me to Lajitas.

It was Texas Independence Day, March 2, 1986, 150 years after Texans pronounced their independence from Mexico and later proved it at the Battle of San Jacinto. I had been assigned Brewster County as part of a proposed book: *A Day in the Life of Texas,* to be published in connection with the Texas sesquicentennial.

San Antonio photographer Bank Langmore was going along for the ride. He loved the Texas outback as much as I and rarely missed an opportunity to kick around there and photograph. I had been to the Big Bend almost every year since high school days, and, as I prepared for the flight, the memories came flooding back. This time I wanted to concentrate on photographing some of the interesting folks that, along with the history and desert, created the Big Bend mystique.

Bank finally arrived, and we loaded our gear into the plane and left Abilene behind in the breaking light of morning. The flight was uneventful, and Bank and I discussed ideas for the shoot. I had planned for my friend Mimi Webb-Miller, who had led the trip to San Carlos, to meet me at the Lajitas airstrip and chauffeur us for the day. Mimi knew almost everybody in the area, and she wasn't shy. I knew we would meet some interesting people.

We circled the Lajitas strip, a runway nestled between the buildings of the hotel and restaurant on one end and a small hill on the other. Part of the hill had been excavated after an MU-2 crashed on an attempted landing; now it was easier to approach the front end of the runway. We saw a pickup waiting, and as we landed and taxied to the end, Mimi stepped out of the pickup and came to meet us. We loaded camera gear into the battered truck and headed out.

Mimi's truck shook and squeaked as we rattled down the roads to the various locations I wanted to photograph. Our first stop was Uncle Joe's Cafe in Study Butte. "Uncle Joe" had come to the area for his health in September 1982. His heart condition would be eased by the desert climate and the easy pace of life. He was born in Oklahoma but had lived in Dallas, where he worked for a Kentucky Fried Chicken outlet. In the Big Bend, at a meeting of the local American Legion, he had met Roberta, who was deaf and mute. She had come there on vacation from her home in Illinois in October 1982 and stayed, trapped by the sunsets and the clean air. Uncle Joe

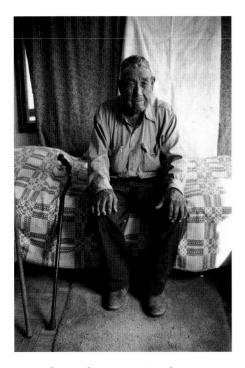

Retired cinnabar miner, Study Butte, 1986.

Photographer Bank Langmore and Mimi Webb-Miller at Uncle Joe's Cafe, Study Butte, 1986.

had found work first at a little cafe in Terlingua. Then, with Aunt Roberta, he bought the cafe at Study Butte in 1983 and began to cater to the needs of tourists, who had begun to come to the area in greater numbers.

I wanted to photograph Uncle Joe and Aunt Roberta, who had become popular among the locals as well as the visitors who stopped by the cafe for a hamburger and a game of pool.

Joe was a big man of boisterous goodwill. His hearty voice contrasted with Roberta's silence. His great hands were road maps of the work he had done, creased and lined with the struggle of a hundred jobs that somehow had led him here. Under the large canopy in front, Joe put a pool table, and he sold hamburgers, eggs, and beer on the inside. Aunt Roberta always maintained she was the best pool player in Study Butte and would challenge all comers. For several years I had made the place a mandatory stop. On this stop, I photographed Joe and Roberta in front of the store and then we moved on.

I photographed motorcyclists, store owners, artists, and cowboys that day. It was hot, and my energy began to flag. Heading back toward the airstrip, we passed the old Study Butte cinnabar mine, and I suggested that we go up and look around. The mine had been in operation as late as January 1973, when it was suddenly shut down by the owners. The circumstances

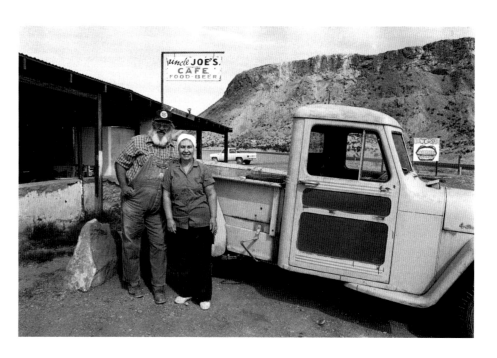

Joe and Roberta in front of their cafe in Study Butte, 1986.

were interesting. The price of mercury had been held artificially high by a tariff on imports since the 1960s. The owner of the mine, Diamond Alkali Corporation, had been checking the international prices on the London Stock Exchange, and when the U.S. tariff was removed, the price fell dramatically. "They called in the middle of the night and said, 'Shut it down. The mine is closing,'" reported my friend Bill Bourbon, Terlingua geologist and guide.

Cinnabar mines in the area had their beginnings in the early part of the century. The work was difficult there, but in spite of the shortcomings the mines still provided employment for many Mexican workers who migrated to the United States both during and after the Mexican Revolution.

Some of the old workers were still living nearby. A trailer house was situated on the edge of the mine property, and I walked up to see if anyone was around. An old Mexican man was leaning against the building in a cane-back chair, looking out across the desert. With my limited Spanish I announced myself, and we had a conversation—on my part mostly a few Spanish words and a lot of sign language. I asked if I could photograph him, and he agreed. Then another person, who happened to be there as well, said, "You should photograph his daughter . . . she is inside the trailer in the bedroom." So I said that I would like to very much, and I went inside

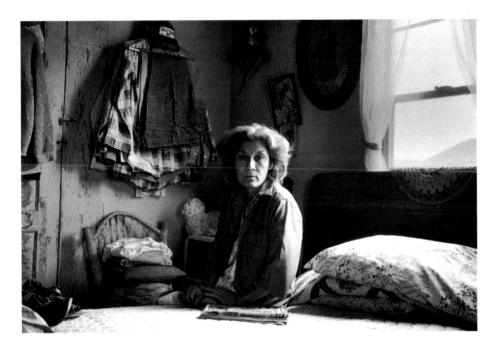

Jesuita Watters, daughter of a retired cinnabar miner, at his trailer house near Study Butte, 1986.

and introduced myself. It was a wonderful scene. The woman, Jesuita Wat-
ters, was sitting on the bed. Hung on the wall behind her were various
shirts, Levi's, pictures, and all sorts of memorabilia. I photographed her,
right there on the bed. Her hair was lovely: dark, streaked with gray. She had
a warm and engaging personality that overcame my difficulty in speaking in
Spanish. I promised her father, the old miner, a photograph when the film
was processed and printed.

 It had been a long day. Bank and I climbed into the plane and headed
for Abilene. The sesquicentennial book was never published.

 A year later I was back photographing as usual in the Big Bend. I
decided to stop in and see how my friend the old Mexican man was getting
along. He was there in the same cane-back chair, in the same position that I
had seen him in the year before. But this time, instead of gazing out at the
desert and all of the mountain vistas that earlier stretched before him, he
was just looking at the side of a pickup truck that was parked about four
feet in front of him. He had a blank, unseeing expression, and I wondered if
he was ill. I said hello, we visited. His friend was there, the same one who
was there the previous year. Again he wanted to show me something. He
took me into the trailer where the old man had his bed. Tacked to the wall
at the foot of his bed was my photograph of his daughter, which I had sent

him. The friend said, "I am so pleased that you sent him that photograph, because, to him, it is the most important thing in the world. It is the first thing he sees every morning when he gets up and the last thing he sees every night when he goes to sleep."

I was touched by the thought that an image I had made could bring that much pleasure to a person. His friend continued, "She was from Alpine, and after you photographed her she returned home. Three months later she was murdered. It is the only thing that he has left to remind him of his daughter."

Another time I came, Uncle Joe was gone, dead from a heart attack in 1989. Aunt Roberta, his wife, was running the restaurant. I stopped by for a burger and a cold beer. Aunt Roberta had changed the sign to read "Aunt Roberta's" and business was proceeding as usual.

A few years later when I came, the cafe was closed. Aunt Roberta had married a man called Gator, who ran a fossil shop next door, and they had closed the cafe and converted it into a house for the two of them. My friend and traveling companion David Haynes and I stopped by to say hello. Aunt Roberta came to the door. I introduced myself as the person who had photographed her and Uncle Joe several years before. She invited us in. David wandered off to see the fossils, photos of Gator and his alligator pit, and alligator skulls that adorned her living room. I took a tablet and pencil and began to write notes to Aunt Roberta.

"How did you meet Gator?" I asked.

"After Joe died," she wrote, "Gator came here to eat, and we talked a lot. Then, we 'started' with each other and married February 17, 1990. For a while we had the gators, but they didn't do well here. Last May the alligators had to move out because there was not enough water for them and what water we had was bad. Gator called a friend, who came and picked them up, all thirty-two of them, and took them to a gator farm until we could get another place and take them back. So we are moving to Fannett, Texas, near Beaumont, this fall."

David and I thanked Roberta for the visit and left. I later heard that Gator had been in trouble with the law. He was serving time for spousal abuse. Roberta was forgiving. She had worked to obtain his release from jail and thought he might be out in a few months.

As I photograph an area like the Big Bend over a period of years, I experience more than human change. I have seen grasses come and go, depending on the seasons. One year the flowers are abundant because the

rains came; another year they are scarce. I recognize that a certain tree that I once photographed has been cut or washed away by a flash flood. Waterfalls expand and contract. I see the land eroding, gullies widening, fallen rocks leaving scars of white against the weathered rimrock of the mountains. I come in the summer and see plants I never knew existed because before I always came during the cooler times of fall, winter, and spring.

I have changed too. When I first came to this country, I was indefatigable. No mountain was too high, no hike too long. My photographs were hurried and unconsidered. I wanted to photograph everything and do it quickly. Now, I feel myself weathering like the rock . . . new scars among the old. When I look into a mirror, I see that the gullies of my face have widened and lengthened. I take more time. I walk less and photograph less. Not that I have already photographed everything, but I take more care. I try to look deeper. I think about meanings and history . . . things that not too long ago escaped me. I try to simplify, isolate, to make sense of place and person. And finally, if one photograph of the many I have made makes sense and gives comfort to an old miner or my encounter with an old friend gives me a deeper insight, I am satisfied.

Bad News

WHEN I LOOKED AT THE boatman's face, I knew something was terribly wrong. Even differences of language could not disguise it. The three photography students with me, swept up in the excitement of crossing the Rio Grande into the little village of Santa Elena, Chihuahua, Mexico, were unaware of a problem.

Our day had begun well before sunrise in Lajitas, just west of Big Bend National Park, and my three fellow photography instructors, Frank Armstrong, Jay Forrest, and Allen Rumme, had all loaded students into their vehicles and together we started out for the park and a day of photographic instruction. Frank, Allen, and Jay were concentrating on landscape photography, and we wanted to get into the best area for a sunrise shot of the Chisos Mountains.

The air was cool, as it is in the early January mornings of the Chihuahuan Desert, but clear, and the four of us and our students had a great view of the southern end of the park from the Lost Mine Trail. Clouds hung low over the mountains south of the river, creating a wonderful layering of white and blue. After shooting in the Lost Mine Trail area for most of the morning, we descended to our parked vehicles at the trailhead and drove to the Basin for the famous hamburgers and vanilla malts that the restaurant served. After lunch we took the students to the Castolon area for photography in the ash flows that create an incredible moonscape environment. As the light began to warm in the late afternoon, we loaded our gear and departed for Santa Elena Canyon, the picture-postcard signature of Big Bend National Park. On the way to the canyon, I usually take those students wanting to photograph interesting people to the ferry that operates between the park and the Mexican village of Santa Elena. This day three students wanted to make the trip; we split from the others and drove down the river sand road to the water's edge, where the boatman waited for those wanting to cross.

The little villages along the Rio Grande have always been very hospitable, and the people are comfortable with tourists. Three months before, I had taken a couple of students into Santa Elena village to photograph. We crossed over in the rowboat, and I made a photograph of the boatman, as was my practice, and gave him photographs I had made of him earlier. The students and I walked in the streets, photographing everything in sight. I became attracted to a bright Mexican youngster, about eight to ten years old, who was roughhousing with her friends, playing and laughing. I followed her, taking photographs of her various antics. She showed me the

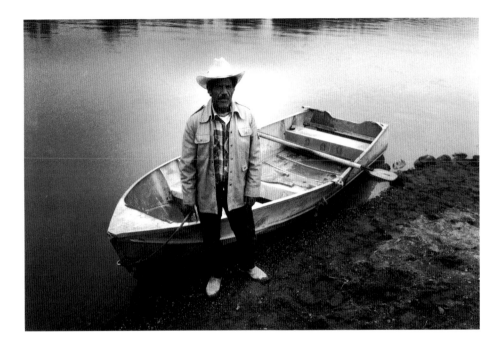

Rio Grande boatman at Santa Elena crossing, 1990.

home where she lived, which was humble. There were toys scattered about the yard, and when she started roughhousing on an old truck with her younger brother, I photographed their play. I moved on down the single unpaved street. There was a group kicking a soccer ball on the cement play-ground. The photography students were having a beer at a local cafe, and I joined them. It had been a good day.

Now, three months later, I could tell something was wrong. As the boatman slowly looked at the copies of the photographs I had made on the previous trip, his face clouded in sorrow. He withdrew the photograph of the young girl that I had followed about as she roughhoused with her friends and said, "Este niña es muerto!" I was stunned. I was able to understand that the girl had died. I indicated that I wanted to deliver the photograph to the girl's family. So I went to the house. Upon entering, I found the girl laid in a casket in the center of the room. Circling the room were the female members of her family: aunts, cousins, mother; the men were outside. Never have I wanted to speak the language so badly and tell the family I shared their sorrow. Everyone was seated, and someone directed me to the mother of the girl. No one was crying; all seemed to accept the inevitability of death. I felt like an intruder into this sorrowful scene, but I was deter-mined to deliver the photograph of the girl because I felt sure it would be

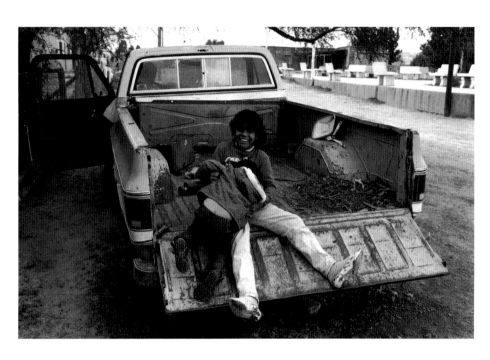

A young girl, Sylvia, plays with her little brother, Santa Elena village, Mexico, 1992.

the only one they had. I presented the photo to the mother, and she handed it back to me with a motion for me to share it with the others in the room. Slowly I moved from person to person. They held the photo and talked among themselves. Tears began to well up in their eyes. As I moved down the row of women, I was terribly uncomfortable. Unable to communicate adequately in Spanish, I could nevertheless tell they were very grateful I had made the effort to come back to deliver the photograph to them. I learned that the girl had died of meningitis. She had become ill, and there was no doctor in the small town. When her condition worsened, the family drove her all the way to the clinic in Ojinaga, where her condition was found to be critical. Despite the efforts of the doctor there, she died.

Before I left I gathered the family around the coffin and photographed the remaining family members with the dead girl, intending to bring that image back on my next trip. About a year later I returned to the Big Bend for another photographic workshop. I went to the river, saw the boatman, gave him his photograph, and again showed him the photographs I had taken the year before. When I came to the photograph of the young girl in the casket, he said, "You know, her father died about three months after you left." I was staggered. "What happened?" I inquired. "El corazón—it was his heart," he replied. Whether the response meant grief or occlusion, I

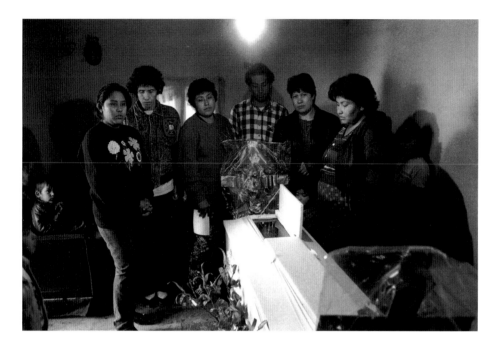

Grieving relatives gather around casket of Sylvia, Santa Elena village, Mexico, 1993.

could not determine. I crossed the river, resolving to deliver the photograph containing the picture of the father to the family. As I walked toward the house, a young man on horseback came forward, recognizing me. It was the dead girl's older brother. We greeted each other, and I handed up the photograph. He looked at the image for a long time. The young man swallowed hard and slipped the photograph inside his shirt.

"Gracias, amigo," was all he said.

Holding his hand to his shirt, he turned his horse and rode away.

Chili: Too Much Can Make You Crazy

THE YEAR WAS 1968. I had been looking around for some new adventures in the Big Bend when news of the Second Annual Chili Appreciation Society Cookoff competition came to me. The previous year's competition between Wick Fowler and humorist H. Allen Smith was declared a draw when Hallie Stillwell voted for "Soupy Smith"; Floyd Schneider, Lone Star Beer's representative from San Antonio, voted for Wick; and the self-proclaimed mayor of Terlingua, Dave Witts, claimed his mouth was seared tasteless by an initial sampling of the pungent chili and he was unable to make a decision to break the tie. Needless to say, fraud was suspected.

This first competition came about when Frank X. Tolbert and one of his friends, publicist Tom Tierney, asked Californian Dave Chasen, a self-appointed chili maker for the stars (notably Elizabeth Taylor), to compete against Texas' own Wick Fowler. He selected the no-man's-land of Terlingua as the site of the competition. Chasen got sick (probably from eating his own chili) and declined the invitation, but by this time humorist H. Allen Smith had joined the fray. He had written a magazine article titled "Nobody Knows More About Chili Than I Do," challenging Tolbert's expertise in chili matters. Slurs were slung between the two, and more and more people got into the act. The crowning insult to all Texans came when Smith claimed that *NO* Texan really knew how to cook chili and that Tolbert's recipes were trash. A line was drawn in the Terlingua dirt with a chili pot, and the now famous Terlingua Chili Cookoff was begun.

Advance information indicated that this year's judging was to be on the up-and-up, with an unbiased panel of judges, including astronaut Scott Carpenter and racing champion Caroll Shelby. I enlisted the support of two of my close friends, State Representative Frank Calhoun and Abilene attorney (now judge) Bob Dickenson. The day before the activities were to begin, we all traveled to Alpine, where we joined our longtime friend Johnny Newell to make the scenic drive south.

Johnny himself was an unusual character. Short by Texas-myth standards, he was a five-foot-seven-inch bundle of energy that seemed always in motion. He graduated with a degree in geology from Princeton at the very beginning of the Great Depression and couldn't find a job in geology. He did find his way down to Houston, where, with two other geologists, he began operating a service station for the Gulf Oil Company. Soon he owned the Gulf oil distributorship in Alpine.

Johnny was one of the first people to recognize tourism as an important force, not only for the development of the region but also as a developing market for his gasoline business. One day he happened to be at a service station in Del Rio, and he overheard another traveler talk about his trip through the Big Bend area. "The most desolate, godforsaken part of the world I've ever seen," the traveler said. Johnny thought, "No! No!" This guy didn't know what he was seeing.

Johnny went home and considered the problem: how to let the thousands of people traveling these Big Bend–area highways know something of the geology, the colorful history, and the recreational resources available. He developed a travel guide, keyed to highway odometer readings, that explained the geological and historical points of interest in all directions from Alpine, and he gave it away free at his service stations. Word spread, and pretty soon travelers were requesting "Johnny Newell Road Logs."

Arriving in Terlingua just at sunset, we followed the road to the little Terlingua airstrip, essentially a graded hillside cut out of the desert scrub at the foot of a small peak. As we approached the meeting place, the cars gathered there turned on their headlights, marking the runway for a small plane that was attempting a night landing. We picked up a friend from Dallas; then we all made the trek to Terlingua Ranch, which was Caroll Shelby's headquarters, for several hours of poker, good Texas barbecue, and fellowship with other "chili heads" who had come for the competition. Later that night we drove to the Basin in the national park and checked into our rooms. It was a short night! We returned to Terlingua the next morning for the competition. The big contender was from California. Woodruff De Silva, architect and former director of the Los Angeles airport, had been brought in to take the place of Smith, who had withdrawn, claiming to be suffering from hives.

"Wino Woody," as he was called, landed on the gravel strip in a DC-3 loaded with several cases of California champagne with which he intended to wash down his chili. "Texas beer tastes terrible," he said. In addition, he brought an enormous Chinese wok in which to prepare his chili concoction with exotic components, undescribed. By noon hundreds of people had arrived, and the various pots of chili were prepared. The competition was under way. Everyone added special ingredients, including secret herbs, mystery meats, and unmentionables. Tigua Indian dancers performed to add a spiritual dimension to the Texas chili. Just as the judges cast their votes,

Cosmic Oilfield Chili, Terlingua, Texas, 1968.

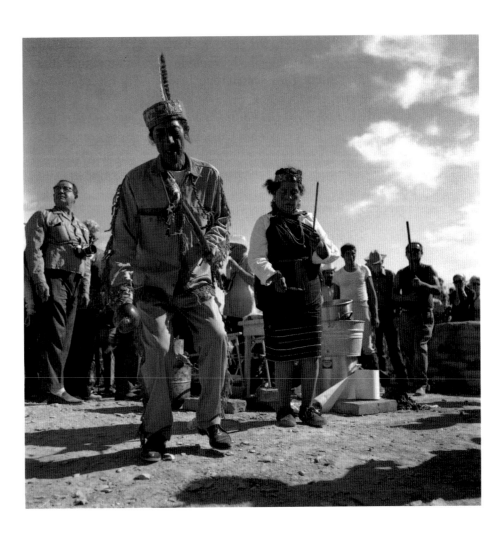

Tigua Dancers at the Terlingua Chili Cookoff, 1968.

a volley of shots rang out, and three masked bandits forcibly took the
unopened ballot box and fled into the countryside. Rumors later circulated
that the ballot box was thrown down the hole in the seat of an outhouse
that had been constructed over the shaft of the deepest mine at Terlingua.
According to Frank X. Tolbert's analysis, Wick was cheated of a clear win.
The judges were all buddies of De Silva's from California, and if the box had
not been snatched the inferior chili would have won. So, again, the verdict
was a draw.

 While all the judging was going on, I noticed a Mexican family cook-
ing meat on a makeshift grill nearby, laughing at the antics of the gringos.

Calhoun and I had already sampled the various offerings of the contestants, so we sat in the shade of an abandoned adobe and had a real lunch of barbecued *cabrito,* while Bob and Johnny seared their insides with multiple samplings of the competition chili.

My next trip to the Terlingua Chili Cookoff came several years later, in 1971. My friend from Abilene, Amber Cree, had crashed the competition the year before along with two classy women from Midland/Odessa. Pat Beck was from Odessa. Janice Constatine, from Midland, came in a chauffeur-driven car with four miniskirted good-time gals to stir the chili pot. "Their dresses wouldn't even cover their imagination," observed Amber. Janice also brought a violinist from the Midland orchestra to provide a high-class cultural ambience.

Amber came looking pretty spiffy. She was outfitted in a white cowgirl jumpsuit with two six-guns filled with champagne strapped to her side. Despite their colorful appearance, the girls were prohibited from preparing their chili on the porch, which had already been staked out by the men. Still, they were allowed to compete even though they had not been invited.

Amber's secret ingredient was camel meat imported from Egypt, and she brought an "Egyptian holy man" to proffer incantations over the simmering pot. The holy man was later revealed to be Venezuelan brain surgeon Marco Eugenio, who, dressed in a black-and-white-striped *jabala,* constantly muttered incomprehensible waarks and groans over the chili.

Amber had some initial encouragement when H. Allen Smith, openly disdainful of the women's offerings, came to officially sample her pot. He was supported by two starlets, one on each arm, as he was clearly in need of balance. Amber leveled one of her champagne-loaded revolvers and let him have a full load right in the mouth. "He licked his chops and said, 'To hell with your chili, I'll have some more of that!'" Amber reported.

It was to be a hopeless cause. The anti-female judges regarded all the girls' chili as being of low quality and wound up throwing the scantily clad good-time girls into the Terlingua jail. The charge, best I could determine: indecent exposure.

Hearing of the machinations of the judges and determined to support Amber if she decided to compete again, I decided to attend the 1971 competition. We gathered a representative group from Abilene, including my wife, Alice; my sister and her then husband, Owen Cook; and our good friends Bob and Peggy Trotter, who were making their second trip with me to the Big Bend. My college roommate Mitch Martin and his wife, Floy, from San

Crowds at the Terlingua Chili Cookoff, 1968.

Antonio, also agreed to rendezvous with us at Terlingua. It was November and the weather forecast suggested a cold front, but nothing could keep us from the action.

When we arrived, we found an enormous crowd; it was later estimated to have been more than five thousand persons. Owen and I were driving a large motor home, while Mitch and his wife had brought a camper. The dust was thick enough to make mud had it rained, and loudspeakers were blaring, women screaming, kids crying . . . the place was in a total uproar. Wick Fowler came roaring through the crowded parking area in an old red fire truck, sirens blasting. A motorcycle group from California pulled to a stop near our bus. An elderly leather-clad couple slid off the bike and smiled at Trotter. The woman had removed her false teeth prior to the motorcycle ride, and her toothless grin prompted Trotter to remark, "This deal really is an old man's Woodstock."

The action lasted all night. Revelers with their bellies full of Lone Star and their grip on the controls of all-terrain vehicles roared across the desert, miraculously avoiding the open shafts of old mercury mines. Every now and then someone would try to sing when he left his tent to take a piss.

The next morning C. V. Wood arrived with a giant hot-air balloon that sagged like a month-old pumpkin. The wind had picked up, and he had been unable to get it launched as planned. The ceremonies began to get under way. "Wino Woody" was carried to the microphone on a litter, unable to walk or, as it turned out, talk. All that could be heard were unintelligible grumps and gurgles.

The challenger from the Alabama-Coushatta Indian tribe, Fulton Battise, was dressed in tribal clothing and sported a buffalo-horn headpiece. He was stirring his pot and muttering Indian sounds when Trotter walked up and asked for a sample. "Help yourself" was the generous reply. Just as Trotter reached for a cup, Fulton dropped in a full-grown, adult armadillo, shell and all. Trotter just gagged and turned away.

Mitch and Floy had had difficulty getting their two young girls to sleep the night before, and they were running out of water. Their camper held only fifty gallons, and it quickly became evident that with more and more people pouring in, we would all be frozen in place, unable to leave. There were campers, welding trucks, and motorcycles in every direction, packed like sardines, with plenty of sauce from cooler boxes in every vehicle.

Before the judging took place, we all decided we couldn't stand it anymore and, with great caution, navigated the motor home and camper

through the melee and drove to the Chisos Basin to camp for the night. It wasn't long before the "norther" hit, and the wind began to rock our vehicles. Owen and I had thrown our bedrolls on top of picnic tables to make more room in the motor home, and the quick chill almost froze us to the table. The next morning, Floy and Mitch decided they had had enough of Big Bend hospitality and returned to San Antonio.

It began to warm a bit toward midday, and the unfrozen decided to hike the Lost Mine Trail. We drove to the trailhead and, braving the elements, started up the three-mile trail to the overlook of Pine Canyon and the mountains across the river in Mexico. The wind whistled, and a light sleet began to fall. We all turned back, chilled to the bone, loaded into the motor home, and headed back to Abilene. It was our last trip to the Big Bend for the chili cookoff.

The chili cookoffs have attracted thousands of visitors and have become firmly established as a Texas institution. For me, the large crowds have destroyed the magic of place, and the event has taken on too much of a commercial cast. In many respects the crowds now coming to the chili cookoff are symbolic of the problem facing all our national parks and wilderness areas: too many people in too little space to have an authentic outdoor experience.

Capote: The Inaccessible Wonder

THE YEAR WAS 1967, and Bob Dickenson and I decided to check out the tallest waterfall in Texas, Capote Falls. I was not surprised that when we talked about our trip, few persons knew of Capote and fewer still knew of its remote location in the Big Bend country of Texas. Imagine Texas' tallest waterfall hidden in the desert. So inaccessible that only a few hundred people have seen the sparkling spring-fresh water tumble over the rhyolite escarpment of Capote Rim and fall one hundred sixty feet to the canyon floor below. The falls and the canyon are probably the least well known of Texas' scenic "brags." Only visitors with the tenacity to ferret out Capote's beauty hike the two-mile-long canyon hidden in the rugged desert mountains of the Trans-Pecos' Sierra Viejas.

Marfa is the jump-off town to Capote country, but West Texan Gene Corder once estimated that fewer than 50 percent of the local people in the Big Bend area know of the falls' location. With the home folks unaware, it is not likely that others across the state have ever heard of the canyon, the falls, and its pied piper call to a desert filled with animals and flowers.

Capote is more than beauty. The painted desert-blue mountain country along the Big Bend's western edge has a historic heritage as well as a colorful present. More than four centuries ago, in 1535, forty-three years after Columbus "discovered" America, Alvar Núñez Cabeza de Vaca, the black Moorish slave Estebanico, and two other Spaniards penetrated the Trans-Pecos area. They were survivors of Pánfilo de Narváez's ill-fated expedition to Florida, begun in 1528. At the confluence of the Rio Grande and the mighty Rio Conchos from Mexico, the survivors saw their first permanent houses built by New World Indians, the friendly Jumanos. Later, others came, drawn by the tales of Quivira's gold, beyond the northern fringe of New Spain. After Vázquez de Coronado's expedition, others came bringing the cross, and in the years of 1683 and 1684 nine missions were established in the vicinity of what is now Presidio. They called the settlement there La Junta because of the joining of the two great rivers. In later times Presidio became a trade center linking developing industry north of the Rio Grande with Chihuahua and other cities to the south. Throughout its history the wild, unsettled country along the river has been the scene of countless raids and counterraids by Indians and U.S. cavalry, Texas Rangers, and renegades from both sides of the border.

In 1885, Luke C. Brite drove a herd of Longhorn cattle to the open rangeland at the foot of Capote Mountain and established a headquarters there. For many years his only shelter was in a cave, his only neighbors

miles away. The location was excellent for ranching. Behind Capote Peak to the south was a spring-fed *ciénaga,* or marsh, which had flowing water year-round. It forms the source of Capote Falls as the water spills from the rim-rock to the plain below and finally, at flood, through the desert to the Rio Grande.

Bob and I headed south from Marfa after gaining permission to enter the ranch below the rimrock and photograph the falls. Ahead of us was the majestic Sierra Vieja range. After a while the pavement ends and the gravel road begins. The desert here is full of cholla, lechuguilla, and dagger plants. As we dropped into colorful Pinto Canyon, we saw the top of Chinati Peak to the south. On the right side of the road is an abandoned adobe building, used as a set for the 1950 movie *High Lonesome,* which starred John Barrymore, Jr.

At the little settlement of Ruidosa we turned onto FM 170, which parallels the Rio Grande. At the fork of the road, traveling left takes one to Chinati and Presidio. We turned right and drove toward Candelaria and Capote Falls. The road passed by a deserted military outpost established with other border forts for protection of the settlements along the river.

The main road in Ruidosa is powdered white dust; the principal landmark is the deserted Mission of the Sacred Heart Catholic Church. Its adobe walls are crumbling, and it now serves only bats and swallows.

As we moved north along the river road, we felt the heat of the river valley. Beyond, the mountains rise abruptly on either side of the floodplain. Closer to Candelaria the cotton fields spread out from the road with green luxuriance. The first bale of Big Bend cotton was produced here in 1913 when J. J. Kilpatrick mined the river for water and built a gin. Some of the irrigation ditches were the same ones used by Indians centuries before.

Candelaria is as far from the mainstream of Texas as a town can get. You would never know it, however, by talking with the granddaughters of Kilpatrick, Mrs. J. E. Walker and Miss Frances Howard, who still operated the family store. "It cost too much to fix the gin after Daddy died, and we just shipped the cotton to Presidio," Mrs. Walker said.

At Candelaria the Rio Grande is almost dry, the result of dams north of El Paso. Once, when Candelaria supported an army post, the river ran full and provided plenty of water for the army and the various villages. Now the farmers are gone, adobe homes are deserted, and the only customers for the Howard and Walker store are their own employees, a few neighboring ranch-

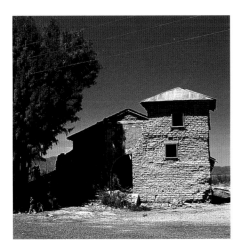

Abandoned church, Ruidosa, 1994.

ers, and the few Mexican families who walk across the trickle of the Rio Grande from San Antonio, the village across the border.

Bob and I entered the store and waited until Mrs. Walker was free. She was somewhat busy with Mexican farmers and Texas ranch hands buying supplies. I struck up a conversation with a patron who introduced himself as Glen Godsey. He asked where I was from. When I told him Abilene, he was surprised and asked if I knew his good friend Joe Alcorta, who taught Spanish at Hardin-Simmons University. I told him that Joe and I were good friends.

Glen was a Baptist missionary to the Mexican people on both sides of the border. He made trips to the area on a regular basis to hold services and bring supplies needed by the poor families who were barely scraping out a subsistence. He gave me a brief version of the history of the Baptist mission effort in the area, how it had been started by a traveling minister from Arizona, Joe Lee, who came each year, and how the church in Marfa had extended its care to the area when Joe was no longer physically able to make the long drive to the Big Bend. "I came down here in 1967," he said. "The first official work that I did was in the Porvenir community, where the First Baptist Church of Marfa built the first Protestant church building along the river. Lloyd Conner, the pastor of the Marfa church, got a call one day from a Mexican family named Jacques who had heard the gospel over the radio and said they would like to have somebody come down and preach to them.

"This part of the country grows on you. I love it. My wife comes with me sometimes and loves to be at the church at Porvenir and different places like that. After we began our work here, many Baptist people from Texas came to see how the people lived. Many of them had to drink water out of the sump holes in the river because for about nine months of the year the river is dry here. People would have to dig down into the riverbed and get a sump hole of water, which was very polluted. So our Baptist people saw the need for cleanliness and water, for ways to plant, and ways to breed their cattle, goats, et cetera. I know of one farmer in East Texas who went down and artificially inseminated cattle to bring in a new strain. Very few of them had any goats, so we brought rabbits to furnish them with some protein.

"It was a challenge for those of us on the Texas side of the river to go across and help the people on the other side. The openness of the people was magnificent. The welcome you got when you crossed the river meant so much to everyone."

Glen began to tell us more about Mrs. Walker and Miss Howard. "They have been here for years and years. When I first started coming down here, they had a gasoline pump, but since that time they have turned it off," he said. "They had a real general store. It was also a mail station for the folks who lived across the river because it was more dependable for people to send mail through Marfa to the Walker store than to send it by way of Mexico. They provided a livelihood for a lot of the people who live in Mexico because they would come over here and work and could buy groceries from the store and clothes and medicines and things like that. The sisters were good to the people and had good rapport."

Finally, we were able to visit with Mrs. Walker and learned that Candelaria does have some tourist trade. Entered in the register kept for guests are visitors from as far away as China and Spain, including such notables as Supreme Court justice William O. Douglas, who was so struck with the beauty of the region that he included a chapter on Capote Falls in his 1967 book, *Farewell to Texas.*

The Howard and Walker store is the "Tourist Information Center" for Capote Falls because beyond Candelaria the roads are not maintained and are traveled mostly by ranch vehicles and horseback. Capote Falls lies some sixteen miles from Candelaria and is approached through the Bill Middleton Ranch. The ranch gates are usually locked, and permission must be secured in advance to enter.

We had already secured our permission, and we left Candelaria and soon came to the Middleton gate. The ride from the Middleton gate to the base of the escarpment and the head of Capote Creek can only be described as fantastic. If the trip is made in the early evening when the setting sun brings out the full range of colors in the desert stone, the landscape is painted every possible color. Ocotillo, with its showy flowers, dominates the desert floor along with the strongly scented creosote bush. (Creosote was once used in making an antiseptic lotion for treating cuts and bruises. It is also still brewed by some of the locals as a medicinal tea to ease intestinal disturbances.) In the crisp, dry air, getting cooler with the setting sun, the trip is an unsurpassable experience. The desert floor is dotted with black lava boulders, the erosional remnants of a flow from eons ago. The surrealistic setting caused Gene Corder and others to name the area Moon Valley.

The road ends at the mouth of the canyon. At the bottom trickles Capote Creek. Except in flood, Capote Creek sinks into the desert not far from this place. At the canyon mouth are the ruins of an old assay house,

used when attempts were made years ago to mine the abundant nitrates in the area. It now serves as a good campsite for those exploring the falls. We unloaded our bedrolls and spent the night below the stars, thinking about our two-mile hike to the falls the next morning.

We followed Capote Creek up the main canyon. There is no trail but the stream. The pitch is easy; clumps of Arizona ash and cottonwood dot the streambed. Along the sides of the canyon are prickly pear and other cacti of several varieties. The strawberry cactus found here has a delicious edible fruit. All carry beautiful flowers at varying times of the year.

According to wildlife biologist Harry Ohlendorf, who made a study of the area, mule deer frequent the canyon, although they are not as common here as elsewhere in the Big Bend. He finds the canyon and falls area prolific in plant and animal life and has cataloged many varieties and new species.

As we walked toward the falls, we could hear the song of the Canyon Wren almost everywhere and occasionally sighted it as the birds flew from the foliage in the bottom of the canyon to the nesting sites along the canyon's walls. In the fall the Rock Wren is more common. We had heard that the Water Thrush was also found in the area, and we were on the lookout for this songful bird.

In the desert year-round water is a siren's call for all kinds of wildlife. Raccoon and ringtail had left abundant tracks along the stream. Ohlendorf has found signs of porcupines. Bobcats and even the now rare mountain lion, or cougar, range the area. The rocks along the way shelter the white-tailed antelope squirrel, and we saw many black rock squirrels as we made our way toward the falls.

The water was very cool and clear. It rushes along so swiftly that good-sized pebbles tumble down its course. Along the streambed are massive conglomerate slabs polished by the flowing water. In some of the softer rock, potholes have been scoured out, leaving the stone pocked with a spongelike surface. Even in the morning the shade of the ash and cottonwood trees is welcome. The parapet cliffs on either side could conceal a thousand Indians, and I could imagine John Wayne riding into this cinematic scene at any moment. Roots of the willow trees along the bank have surfaced mossy red from below the water.

The temperature was about sixty-five degrees as we continued up the creek. Occasionally, we saw a two- or three-foot-high leafless shrub appearing as a tangle of sharp-pointed green thorns. It was the allthorn

plant. Mexican legends say that from it came Jesus' "crown of thorns" and that only Butcher Birds will perch on its spiny branches.

As we walked deeper into the narrowing canyon, toward a rim of towering rock, the stream suddenly hooked to the right. We had no warning, no crashing sound of running water. Capote unfolds its grandeur with surprising abruptness. We found ourselves standing at the bottom of a cylinder of stone, a room of mineral-plated rock with silver cords of water hanging drapelike over the mineralized travertine cape of Capote. A windblown plume of spray at the very top seemed to evaporate into the dry desert air. Greenish-blue rocks under the waterfall shone in a colorful display contrasting with the black-stained white rhyolite on either side of the grotto.

The trees along the side of the pool were magnificent. Vines clung to the sides of the falls, straining for water and light. The floor of the box canyon was mostly in shadow, even as noon approached. Only the afternoon sun penetrates the shade at the bottom of the falls. It is a place of quiet beauty.

Above the falls, on top of the escarpment toward Valentine, is the headquarters of the Brite Ranch and the source of spring water that gives life to Capote.

As I stood at the base of the falls, legends of hidden gold and treasure came to mind. Not long before, University of Texas geology students on a field trip to the area had stumbled across a scattering of silver nuggets, possibly jostled from some packsaddle as they were being transported along an early trail.

Stories abound of hidden Indian mines and caches of gold and silver. Mrs. Walker remembered a pair of eager prospectors from California who called at her store. They inquired about the location of a certain cave and upon receiving directions hurriedly left the store. They came back shortly, requesting guidance. Mrs. Walker sent two Mexicans to show them the way. The Californians, before they reached the cave, became suspicious of the Mexicans and vice versa. The four soon parted company, and the prospectors were left to find their own way forward or backward, as they desired. Mrs. Walker says she has been in the cave herself, but there was no gold to be found.

Another famous story of the area concerns a hidden mine with a door across the shaft. The mine has been lost and found and lost again for many years. About ten years ago three men were driving along the road, and

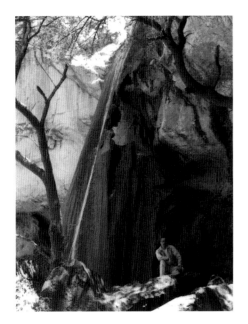

Bob Dickenson at Capote Falls, 1967.

one spotted the door high on a mountainside, but, after a long search, they were not able to find the mine.

The arid land of the Trans-Pecos offers a variety of minerals in quantities large enough to generate excitement but, so far, not great profits. An exception was the famous silver mine at Shafter. This mine was presumably discovered by an army lieutenant named Bullis, but it was John W. Spencer who took samples of the silver ore to General W. R. Shafter. As a result of the assay reports, the Shafter Mining Company was organized in 1885, and, until the mines were closed in 1942, more than $18 million in silver was produced. Other mining operations were started in the Trans-Pecos area for coal and nitrates. The Terlingua area became famous for its cinnabar production.

These thoughts were in my mind as we started the long hike back to the end of the canyon and civilization. What would be the future of Capote Falls? Today the land may be entering a new phase. Wild lands like Capote may find their true value as scenic wonders for beauty-hungry people. With great cities polluting the atmosphere at an ever-increasing rate, the cool, clean air of the Trans-Pecos has an irresistible call.

Many people, including the late Justice Douglas, have called for federal action to protect Capote Falls as a national wilderness area, to be opened up to the public. Douglas criticizes the Brite family, who owns the spring-fed *ciénaga* above the rimrock, for overstocking the area with cattle during the long drought of the fifties. In his book *Farewell to Texas,* Douglas observed: "A waterfall in the desert is a miracle. Man's act in destroying it is a depredation. Capote Falls must have a protective arm about it, either state or federal. The free enterprise of the cattle business is too capricious, too irresponsible, to be entrusted with the preservation of this, a great wonder of America."

Douglas's concern for conservation was well founded, but I personally feel his approach to the problem was too extreme. The Brites and the newer generation of ranchers are good businesspeople who would never knowingly ruin their land. They know that land is their capital, and most will not abuse it. There are also personal reasons for land conservation. We can look back to the days of young Luke Brite shivering in his limestone cave at the foot of Capote Mountain. New-timers can only guess at the hardships he encountered protecting his herd of iron-mouthed Longhorns from Indians and bandits, as well as the ravages of nature.

Land owned by people like Luke Brite has special meaning. It is not a mere element of production. It is a living thing, a part of their being. Most would die before they would desecrate it. The question remains: Should Capote Falls be made more accessible to the general public? There has been talk of a new park. Like the Guadalupe Mountains National Park, it may be too big for the state alone to handle. "We thought about talking to the Department of the Interior," former state representative Gene Hendryx said. "The Texas Highway Department agreed to build a highway there."

Bob and I agreed that we hoped no highway will ever be built. The fragile beauty that calls to Douglas and others might well crumble under the onslaught of large masses of tourists. Capote Falls is a private place. The stillness is a part of its heritage and its magic. Though the area could be policed, large numbers of tourists with their chewing gum wrappers and flip-top cans would destroy the vision. The deer might drift away. The black-necked garter snake would hesitate to sun himself on the rocks in the crystal water, and the eagle with his suspicious eye would move his range. This great natural treasure must be protected. I feel it is better that Capote remains the private property of conscientious people who follow in the footsteps of the Brites and Middletons, who will guard the hidden beauty but make it accessible to responsible visitors. Whatever fate awaits Capote Falls, I hope it will always remain remote and inaccessible. Those who are willing to make the physical effort to inhale its beauty surely also share a lasting concern for its protection.

I HAVE OFTEN THOUGHT about making another trip to photograph Capote Falls. Things kept getting in the way, but in 1995 I decided to carve out the time to visit with Jim White, the present operator of the Brite Ranch. I discussed with him my interest in interviewing him for this book and in making another trip to the falls to see what time had done to the environment. He would not see me. Not hostile, just firm. "No," he said. He wanted no publicity. I understand his feelings.

In the time between then and now, much has changed in the political landscape, giving landowners concern that the State of Texas and the United States government will intrude into the management of their private lands. With an increasingly rigid interpretation of the Endangered Species Act, landowners no longer welcome biologists and other scientists onto their property, for fear of onerous regulations that might be imposed. If archaeological sites are found, many landowners fear federal or state inter-

vention. David Alloway, a member of the Texas Parks and Wildlife staff, observes, "This is an unfortunate misconception that is perpetuated by conservation groups who throw archaeology in with natural resources without the permission of archaeologists, which causes landowners to regard them suspiciously. To the contrary, a significant archaeological site in Texas can be registered as a State Archaeological Landmark if the owner is willing to protect it. In this case the owner is given a tax break, and the designation restricts the site from being disturbed without complete negotiation with the owner. This prohibits even professional archaeologists from digging into the site."

There was a time when many landowners welcomed cooperation with the government to protect species and historical sites. Ranchers and farmers have generally welcomed governmental support in other areas such as soil conservation and range improvement. These projects were offered and done at the election of the landowner. It could have been the same partnership with the biological environment. Now, at the close of the twentieth century, the overzealousness of some federal and state authorities has caused landowners to be more than wary of such endeavors. No regulation can be written to deal justly with every individual case. Successful application of a regulation requires authorities who have demonstrated sound judgment. When laws as potentially complex and disruptive as those dealing with the use of private property and the environment are implemented with regulations that reflect no "wiggle room" for legitimate special cases, there is certain to be trouble. Then the environment, the landowner, and the public are the losers.

Largely because of landowner fears, the privilege of visiting and enjoying the wonder of many of Texas' private places like Capote has been taken away, even from responsible visitors who would not dream of damaging their beauty. Some landowners have even been so extreme as to threaten destruction of delicate environments just to keep people out and preclude the government from controlling their land.

To compound the problem, there is a movement to create another national park in the Big Bend. The Davis Mountains offer such spectacular recreational opportunities that feelers have been put out by the Nature Conservancy and other groups to purchase land and convert it to a new Davis Mountains National Park or wilderness area. Angry landowners have banded together to organize against such an effort. Other landowners are quietly supporting it. As Fort Davis resident CPA Lineaus Lorette observes, the tax

laws, unless changed, will force disposal of the land over time. The recre-
ational and conservation value of this mountain island in the Chihuahuan
Desert far exceeds its value as ranch land, and with the inheritance taxes
mandated by Congress, heirs receiving it would have no recourse but to sell.
The breakup is already beginning. Large holdings are being purchased and
subdivided into small acreages for retirement and vacation homes. In the
process yard lights from new development are increasing the light pollution
surrounding McDonald Observatory. Additional environmental concerns
stem from the new coal-fired electric generating plants across the Texas bor-
der in Coahuila, Mexico, that are spewing sulfates into the air and gener-
ating acid rain and lowered visibilities. The government would be another
willing purchaser. So along with the rare snakes and plants, the West Texas
rancher might turn out to be an endangered species as well.

In a sense, however, these are short-term problems—important to us
because we have short-term lives. In the long term, much of what we do will
have little effect. Climatological changes, stray asteroids, and subterranean
pressures will ultimately determine the shape of the earth and the nature of
its inhabitants. For now, I will hope for a better understanding to develop
between landowners and the government, and for hikers, photographers, and
other lovers of the land once again to be permitted access to Texas' most
beautiful places.

A Minimalist Conversation

THE ALARM IN MY EL PASO hotel room was like a bee in my dreams, stinging me awake. It was 4:00 A.M. and I had promised to fly to Marfa for a meeting with artist Donald Judd early that morning. Several weeks before, I had received at my office in Abilene a letter from his assistant, Ellie Meyer, inviting me to Marfa to visit with him.

I had come to El Paso several days earlier to complete some photography on my Tigua Indian book and was expected in Austin that night for a dinner meeting. I would be flying near Marfa and thought it would be a good opportunity to stop and meet the famous artist. I hoped to learn more of the vision that had brought him to the Big Bend, where he created one of the largest installations of a single artist's work anywhere in the world.

I dressed quickly. The wind was brisk, and a front was forecast. The complimentary hotel coffee was hours from being brewed. Ellie had suggested we meet at 7:00, and I needed to leave the airport by 5:30 to arrive on schedule. I left immediately and performed the pre-flight safety procedures for 888TT, my Beechcraft Bonanza. All was in order, and I lifted off exactly at 5:30 A.M. with full fuel and a strong tailwind.

It was a clear West Texas night, plenty of stars; the ride was bumpy from the wind, and I arrived over the Marfa airport just as a faint pink appeared in the eastern sky.

The place was deserted. Ellie wasn't there to greet me. I wandered around for about forty-five minutes, wondering if she had forgotten the meeting or if I had misunderstood the plans. Finally, headlights appeared with the dawn, and Ellie's pickup pulled up in front of the small airport office building.

Ellie was a wiry woman with a sun-beaten West Texas complexion. She was brisk and efficient-sounding as she said that we would stop by the office for some needed papers before heading for the ranch.

Judd was controversial in Marfa, to say the least. A shy man, he quietly came to town in the late 1970s and began purchasing real estate. He had visited Marfa once before, on his way to the West Coast during the Korean War. Impressed with the prospect of a town with no visible opportunity for development and with the openness and light peculiar to the Texas Big Bend, he filed the rugged ranch country in his mind. Later in his career, disgusted with the New York art scene, he searched for a permanent home for his artistic installations. He settled on Marfa, the town that had thrust its image into his mind so long before.

One of Donald Judd's aluminum boxes,
Chinati Foundation, Marfa, 1992.

In 1978 the old military post Fort D. A. Russell in Marfa was avail-
able for purchase. It consisted of a variety of structures on a large piece of
ground south of town. Working through people at the Dia Foundation who
had become interested in supporting his work, Judd acquired the property
and remodeled the gymnasium, leaving the great cavernous volume but
remaking the floor into an example of perspective and texture. He added a
conference table on one end, lonely and insignificant in the vastness of the
space, and behind a wall, a kitchen and a small bedroom. He converted the
artillery sheds to glass-sided showcases for his installation of one hundred
aluminum boxes, each of the same exterior dimensions, but each unique
with different panels and openings.

He purchased other buildings as well, more than thirty-two in all.
He transformed a former bank into a gallery for an unknown muralist who
had painted the walls many years before and whose work was rediscovered
when Judd stripped away the old wall covering from a previous remodeling
job. He used the old railroad depot to showcase the sculpture of a friend,
John Chamberlain. Twisted shapes of compacted car bodies stand silently in
the otherwise empty building. At the fort he installed a sculpture by Claes

Sculptor John Chamberlain's permanent installation at the Chinati Foundation, Marfa, 1994.

Oldenburg, another friend. Somewhere along the way, he purchased the old Crews Hotel, once owned by my uncle, Billy Crews. That seemed to give me a remote and tenuous connection to the Judd project. The Dia Foundation finally withdrew from the project, and Judd created his own organization, the Chinati Foundation, named for the mountains south of Marfa, to carry on the work.

The pickup pulled to a stop before a downtown building, and Ellie disappeared inside. I waited. Finally she reappeared, and we headed for the south edge of town. As we passed several cafes, I wondered if we were going to stop for coffee, but she made no indication that food or drink was in her plans. I settled back for the ride to the ranch, which she earlier said was a short distance from town. I presumed that coffee would be available shortly.

We drove south on Texas Highway 2810, continuing past the end of the pavement toward Pinto Canyon, one of the most beautiful areas of the state. It was, however, farther from Marfa than I had thought the ranch would be. The road wound between canyon walls, following a clear, spring-fed stream that descended through the rugged Chinati Mountains. When the road was first constructed, it served the pioneer ranchers and their wagons.

Later, it was a supply route for the army during the Pancho Villa days of border disturbances with Mexico. Wagon trains of military freight passed from Fort D. A. Russell in Marfa, south to Ruidosa on the Rio Grande.

As we drove, we talked of Judd and his work. Ellie said Judd passionately believed that his art deserved a place designed specifically for it. It wasn't conceit, just a firm belief that his art should not be placed cheek by jowl with other artists' work inside some sterile museum. Judd despised the bureaucracy of institutions. He believed that his art deserved its own space, absorbing and reflecting the light and his minimalist vision.

We continued on the main road. "Don decided to go to the Hot Springs Ranch," she said. "It's down near Ruidosa."

"Down near Ruidosa" was a two-hour drive from Marfa! I settled back, calculating the time we would be traveling and the time I might be spending with Don, and it seemed that I would miss the evening meeting in Austin. This was more exciting, though, so I relaxed and went with the flow.

Ellie was talkative and interested in my photography and projects. "Tell me about the photographic exhibitions you have exchanged with other countries," she said. "What are your interests in photographing people? By the way, Don asked that you not photograph him. He is very shy around a camera."

I was disappointed in this news. Although I would honor his request, I hoped that I could convince him to let me photograph him with his sculpture. I figured that as we got better acquainted, permission to photograph him would come.

We descended from the top of the escarpment, winding down through the canyon on the twisting road toward the floodplain of the Rio Grande. Mountain juniper and bear grass were replaced by ocotillo, lechuguilla, and prickly pear. Anonymous ranch gates appeared before us, then disappeared in the dust as we passed. I was really getting hungry and wanted a cup of coffee. Ellie was serene and relaxed. I wondered if she was on a diet.

We pulled into Ruidosa and turned toward the county road that led to the ranch, which was located at the bottom of the escarpment, another hour's drive! Since the possibility of reaching Austin before late in the evening was already blown, I suggested a quick diversion. "Let's drive on up to Candelaria and let me photograph the Howard sisters before we continue," I proposed. "I might not get back here before something happens to them." Ellie agreed. We continued up the river road toward Candelaria.

*Mrs. J. E. Walker and Miss Frances
Howard, 1991.*

The Howard sisters were legendary. They had run the little store in Candelaria for many years and were known on both sides of the river as benefactors of the region's poor. Mexicans brought them handcrafts for sale in the store and purchased hard-to-get supplies there. For years there was no electricity or telephone. It is not a tourist destination.

I saw that the sisters were unoccupied, and I introduced myself. They had forgotten that I had met them on an earlier trip to photograph Capote Falls. "I would appreciate it if you would let me take your picture," I said. "You are famous for your life here in Candelaria, and I want to record it for historical purposes." A long discussion ensued, and the sisters finally, though reluctantly, agreed to pose briefly. I had scarcely time to raise the camera before they scurried off to other matters.

Ellie and I climbed back into the pickup and headed for the ranch and the meeting with Judd. We had gone only about five miles when I realized that I had been in the presence of food and had failed to make a purchase.

The road to the ranch, doubling back north to the bottom edge of the escarpment, was unpaved, sending a fine layer of dust drifting into the cab of the pickup as a continuous geyser plumed behind us. After arriving at the bottom of the escarpment, the road climbed several hundred feet and finally terminated at a ranch house with several outbuildings and a corral. Judd was standing by a pickup as we drove up. He walked to us as we emerged, hot and sweaty, from the pickup. "Bill, this is Donald Judd," Ellie said. He nodded, and we shook hands. Don and Ellie began a conversation regarding their business affairs, and we walked into the building.

The inside was empty but for a long table with benches along the side. A fireplace remained unfinished at one end, open to the sky; a single chair rested against one wall; a table sat against the other, holding apples in a bowl; and on the floor at the end of the room opposite the fireplace, several bowls and glassware items were scattered, seemingly in an arrangement. Don took his place at one end of the long bench, and Ellie positioned herself in the middle. I politely sat at the opposite end.

They continued their conversation, and I strained to hear. Don spoke so softly. I inched toward the center of the bench, trying to get in on the discussion. I was catching every second or third word, and it wasn't making much sense. Finally, Ellie rose and excused herself. "You all have a good visit," she said. Ellie departed through a rear door. Since it was nearly noon, I hoped she was going to the kitchen to arrange lunch.

Don rose from his position at the end of the bench and moved to the chair on the wall facing me. No one said anything. Since I was the one summoned, I thought it appropriate for Don to begin the conversation. I waited. Nothing happened. I was determined not to talk first. I tried to be casual. I looked about the room, examining every nook and cranny. I smiled at Judd. He smiled. Nothing was said.

Finally, I surrendered. The silence was too uncomfortable. "When will you finish your fireplace?" I asked lamely, beaten at the first-to-speak game.

"I haven't decided how I want to wind it up," he said.

"Sure is a nice place," I said.

"Yup," he said.

There was another long silence. I was beginning to think that the situation was ridiculous. I began to ask him about his building purchases in Marfa. "I understand you purchased the old Crews Hotel. It used to belong to my uncle, Billy Crews." Judd seemed interested. "I'll try and get you some of the history of the place if you are interested," I offered.

He said, "Thank you."

"I have some new work in the building out there," Judd said, indicating a building near the corrals. "It's full of saddles and boxes, but you can see the work." I eagerly agreed. Perhaps I was about to learn something about his work and philosophy. We rose and walked toward the door. "Just go on out, the building's open," he said. I realized he was not going with me. I would have to figure it all out by myself.

By this time I was beginning to wonder why he had invited me to come and see him and when we were going to get to it. I walked to the building and looked in the open door. There in the space was one of Judd's aluminum creations; around the sides of the tack room were boxes tossed helter-skelter, saddles, and sacks of grain. It formed an improbable backdrop for the shiny, modernistic piece of sculpture. I walked inside and behind the piece. Framed by the open double sliding doors, it was magnificent and anachronistic in the desert setting. Beyond, through the doorway, you could see the sweep of the desert down toward the green tamarisk border of river and, in the distance, the blue hazy form of mountains in Mexico. I stood, immobile and meditative. The shimmering expanse of the vista framed in the open doors, and the sparkle of light reflecting from the sculpture, helped me begin to understand Judd's preoccupation with light and space. It was all coming together in a way no museum could hope to replicate. This was his

Judd's bedroom in the remodeled gymnasium in Marfa, 1994.

dream: to create art that resonated with space and light, to place it where space and light would never be tamed and distorted with development and pollution. It was a grand design.

I walked back to the house and thought that perhaps over lunch we would get down to business. Judd and Ellie were standing in front by the pickups. "Well, I suppose it is about time we got back to Marfa," she said.

Was this what it was all about? What about lunch? I was desperate for conversation and food. "It was nice to meet you," said Judd. "I hope that we can spend some time together in the future."

We loaded into the pickup, Ellie and I, and lurched off down the road. As we drove back to Marfa, I thought about the event. Actually, it was a magnificent experience. The image of the piece of sculpture in the tack room, framed by the Chihuahuan Desert, will be with me forever. That was what it was all about.

When we got to Marfa, I took Ellie to dinner. Mexican food had never tasted so good.

Claes Oldenburg's Monument to the Last Horse, Marfa, 1992.

Tragedy

THE HORSE WRANGLER CAME toward us at a gallop from the front of our column of riders. He asked for Dr. Mendenhall and, when Elliott identified himself, the wrangler asked us all to wait where we were, and the two of them rode past our fellow riders and out of sight in the trees toward the front of the line. We wondered what the problem was and if someone was injured.

ONE OF THE PREMIER EXCURSIONS in Big Bend National Park is the South Rim Trail. After my first experience in 1950, I did not do the trail again until 1968 when my friend Elliott Mendenhall and his wife, Nancy, my wife, Alice, two of their children, and two of ours decided to make a vacation trip to the park. It was over Easter vacation, and consequently the housing was tight. Elliott, Nancy, and their children Craig and Catherine, stayed in motel rooms in the Basin, while Alice and I prevailed on our friend Buck Newsome, who owned the horse concession in the park. He let us stay in a spare room in his house above the stables.

Elliott was a tall, lanky vascular surgeon. Somewhat stooped in the shoulders, and pale from an indoor life, he had an introspective nature that belied a fine mind and a growing reputation. Nancy, in contrast, had been a ranch hand from birth. Born in Sanderson, Texas, she had been riding horses and enjoying the outdoors all her life. Elliott was quiet, Nancy was gregarious. Craig and Catherine were the ages of our two kids, and we had urged them to join us in the Big Bend. Elliott perhaps would have preferred a night at the opera, but Nancy, loving the West Texas land of her childhood, prevailed.

We had arranged with Buck for a horseback tour to the South Rim the following morning. After dinner the Mendenhalls retired to their room, and Alice and I returned to Buck's and relaxed with a drink and some conversation.

Buck was a man who should have worked for Marlboro. He held himself erect and was all muscle. His pale blue eyes could look through you to China, stripping away all pretense, a visual undressing. Buck wore his Stetson at just the right angle, his moustache trimmed precisely. He walked with the unaffected gait of a man who had spent lots of time on horseback. His work boots were scarred in just the right places to differentiate him from those who scuffed their boots getting in and out of cars.

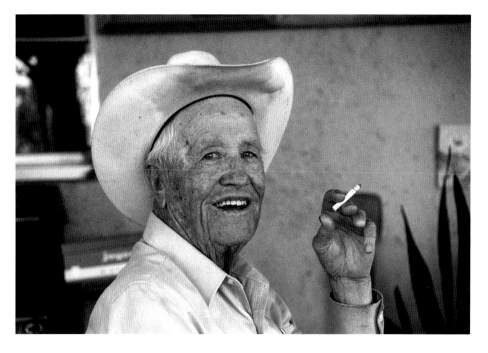

Buck Newsome, 1995.

 That evening was magnificent. We stepped out on the porch to see the full moon being eclipsed by the Earth's shadow. I remember thinking at the time how, in ancient times, people looked at eclipses of the sun and moon as foreshadowings of evil. It was hard to imagine in the beautiful, star-studded sky of the Big Bend how anyone could interpret that celestial event in a negative way.

 Buck brought out a bottle of whiskey and poured us a drink. He was a hospitable man. I asked him about running the horse concession.

 "I came here with the Border Patrol," he said, easing back into his chair and savoring the whiskey. "I was born in Lake Whitney. My dad was born there, and my grandaddy was born there. But my great-grandaddy wasn't. On his tombstone it says he was born in Jones County, Georgia, in 1820. I worked with the Border Patrol for eighteen years. I quit in 1959 and bought the horse outfit here in the park. Carried lots of folks to the South Rim and most every place in the park.

 "Lots of people can't walk it. I've carried a little girl three years and two months old up to that South Rim on a horse and a woman that was stone blind. Yeah, she had never seen the light of day. Born that way. But she

wanted to go. Then I had a woman from Horton, Texas, that came and brought her grandchildren. She was eighty-six years old, and those kind of people can't walk up there, you know."

Buck had a hundred stories about his life as a border patrolman and his other occupations. The conversation got around to a recent guest of his, Justice William O. Douglas.

"Yeah, I had him," Buck said. "I got his picture right up there." He gestured to a photo on the wall. "Judge Douglas of the Supreme Court. He was a good ol' fella. He's a free thinker, you know; I liked him. He had his wife, Joanie, with him. She was about twenty-two years old, and he was about sixty-six. We got to talking, and I said, 'I know you've been there longer than anybody in that Supreme Court, but I have read some of your opinions and I don't like some of 'em. I guess your judgment is bound to be all right or you couldn't stay there, but now your judgment on this matrimony, I think you got your pasture overstocked.' The judge just laughed.

"We were down there on the river; rode to Castolon on horseback. We set up a little table under a mesquite tree. The judge drank a lot of whiskey and we ran out. I said, 'Judge, we're out of whiskey.' 'Well,' he said, 'by gosh, Mexico's right over there.' I said, 'Well, you sit down here and make the ruling and I'll do the smuggling.' Well, he sat down there and had a little ceremony, and I went across the river and got a bottle of sotol. He drank it like rainwater. He said, 'Whoo!' I said, 'Yeah, it don't taste too good, but after two drinks of it, it'll taste about like Kool-aid.' He said all right and so we drank a little there."

Buck continued: "I had Jerry Mays, the Kansas City Chiefs linebacker, and Buck Hannon and Curly Johnson and Joe Namath. I had astronauts. My horse bucked one of 'em off. He was Scott Carpenter. We got up there to Laguna Meadow and I carried a slicker on my saddle, and I told Carpenter that ol' horse is all right if you 'tell him the business,' but he won't put up with no fooling. If it starts showering, get down off your horse, put your slicker on and button it up, and get back on him; and he'll put up with it. But don't try to put it on while you're mounted. Well, he didn't listen to me. He got up there and it commenced showering a little bit and he reached back and untied his slicker and ran his arm through a sleeve and pulled the tail of it around that ol' horse's head, and by God, he unloaded him.

"He hit the ground, knocked the wind out, but didn't hurt him. I told him, 'Now get up.' He said, 'How'd you know that horse was going to

do that?' I said, 'I know these horses better than you know your kids if you got any. Now button it up and put the slicker on and get on like I told you and he won't do another thing.' And he did, and we went on.

"Once I carried a woman up to the South Rim. She came down to the corral, and she had a big pillow and a umbrella. We get all kinds. She was going to put that pillow in the saddle and then hold her umbrella. I told her that ol' horse will take her down with that ol' umbrella. She paid attention to me and folded up the umbrella. I can't remember what she did with the pillow.

"I had to put up with the Sierra Club. They don't want you to do nothing. One woman wrote a letter, said that I was polluting the trails with my horses, and we're going to kill every bird down in that old mountain. She wrote the superintendent a letter, and, well, he knew better. Such stuff as that happened all the time."

I asked Buck if he had a lot of arguments with these people.

"No," he said. "I didn't argue with 'em, I just told 'em what I thought. I had a wrangler named Jim Johnson. He was a Will Rogers type. He had something to say to everybody. We had some fat woman come down here, and she was about five foot two inches tall, just about as tall laying down as she was standing up, you know. Jim was trying to get her on the horse and he'd get her nearly up there and her leg would give way and down she'd come. He pushed his hat back, and he said, 'Lady, that ol' horse weighs twelve hundred and that's as big a saddle as they make. But there just ain't no way I can wad all that up and git it up there.' She said, 'I know it's big, but don't tell me about it.' She said, 'I want my money back.' 'Yes, ma'am,' Jim said. 'I'm going to give you your money back.' He was reaching to get her money out of his pocket and she said, 'Well, I guess all that's left for me to do is haul ass.' He said, 'Yes, ma'am, I think it'll take two trips.'"

Buck was on a roll. The stories came one after another. "Was Luna still living down on the Maverick Road when you first came here?" I asked.

"Yeah, he was there, living in his *jacal.* I rode up to his place there one day, and he was sitting on a rock. We got talking, you know. I said, 'Gilberto, how old are you?' He said he was one hundred and something, which I don't think he was. 'How many kids you got?' He said, 'Thirty-three, Señor.' 'Well, hell,' I said. 'I heard you had fifty or sixty.' 'Well,' he said, 'I ain't countin' them girls.' The old-time Mexicans, you know, didn't count the girls."

Luna's jacal, 1994.

The next morning dawned clear, and we got an early start. Elliott and Nancy and their two children met us at the horse concession, and we all saddled up with the other guests who were making the trip that day. Nancy rode in front with the wrangler who was leading the group, talking horses and swapping stories about her early life in West Texas, and Elliott, Alice, the kids, and I brought up the rear. I wanted to be able to pause and photograph without holding up the entire group. We rode up the trail, past Laguna Meadow, and on to the South Rim. We photographed and had lunch at a particularly nice viewing spot. On the way down we passed through Boot Canyon, where I had camped on my first trip to the park, many years before. As we were filing down the trail, Elliott and I were still riding back with Alice and the kids, while Nancy was still talking with the horse wrangler, at the head of the procession of twenty or so other tourists.

Our column came to a halt, and we waited for four or five minutes wondering why we had stopped. When one of the wranglers came riding back and asked Dr. Mendenhall to come to the front of the column, I figured someone had been hurt. High on the South Rim Trail any injury requiring evacuation would be difficult and time-consuming. It was getting late in

the evening, and nightfall would make it even more difficult. Our column of horses continued waiting for what seemed an interminable time. Finally we began to move again. Alice was as anxious as I because she was nervous about horses to begin with and had only reluctantly come along on the horseback trip.

We made a turn in the trail and as we silently passed by, I could see Elliott beside Nancy by the side of the trail, gently rocking her in his arms. I wanted to stop, but the wrangler, standing by Elliott's side, waved us on. Nancy appeared to be unconscious. I tried to reassure Craig and Catherine, but I had a sinking feeling, recognizing Elliott's despair as he silently held his wife.

After about thirty minutes, as we continued down the trail toward the Basin, we met a rescue team coming up the mountain carrying a metal stretcher. We arrived at the horse barn and went immediately to the ranger station, where they informed us that Nancy had apparently been thrown from the horse and was unconscious. They were evacuating her to the hospital in Alpine. For hours we waited for the phone call.

Finally it came. Nancy had died instantly, there on the trail. It was a freak occurrence. It was incomprehensible. She was an experienced horsewoman. Raised on a ranch, she had ridden all her life. She was on a plug horse that never walked faster than the horses in front, and they were slow. What could have gone wrong?

When Elliott called, he asked Alice and me to take his children and stop by Nancy's parents' place in Sanderson and convey the sad news to Nancy's mother, then pick up their younger daughter, Cheryl, and take them all back to Abilene.

We packed quickly and drove to Sanderson. We picked up Cheryl, broke the news to Nancy's mother, and continued the sad trip home.

Of course we were consumed by "what ifs." What if Alice and I had decided to go somewhere else that Easter . . . if we had invited someone else who had not been interested in horseback riding . . . if we had gone rafting instead. Thinking back to the night before, when I had watched the eclipse, I wondered if perhaps the ancients were not so far wrong in thinking that there is some power that foretells our fate by signs in the skies. I have never walked the South Rim Trail since that I haven't thought of Nancy.

Mules and Metaphysics

IN 1973 I WAS A MEMBER of the board of the Texas Outward Bound School, which ran wilderness survival and personal growth courses in the Big Bend area. They were headquartered in abandoned buildings near Fresno Creek, north of Lajitas on the Anderson Ranch. Locals called the area Buena Suerte. It was once part of the now inoperative Fresno cinnabar mine. The Outward Bound program consisted of twenty-three-day courses in the rugged terrain—climbing on ropes up and down the smooth, water-worn walls of the canyons, doing map and compass work, identifying native plants, and learning methods of backpacking and camp selection.

One of the course instructors was a young man named David Sleeper. His job was to teach the students wilderness skills interspersed with activities that promoted self-confidence and inner growth. With his easygoing style and friendly manner, David was a popular instructor.

In 1974 there was a tragedy. A group of students camping in Arroyo Segundo near Fresno Creek awoke to find water swirling through their tents. A sudden storm in the mountains to the north had sent tons of water roaring through the canyon, and their campsite, thought to be safely above the high-water mark, was inundated. In the panic that followed, all but one of the students found trees or high ground. The other, a young woman, was swept away. Sleeper, who had an encyclopedic knowledge of the rugged area, was asked to join the search for her body. The next morning, he found it.

Not long after the death, the Outward Bound program moved its operations to Santa Fe. Sleeper founded, and operated for five years, a program called Desert Dance, Expeditions for the Spirit, consisting of twenty-eight-day mountaineering trips into Mexico. In 1978 he began the purchase of Fresno Ranch from Rex Ivey and moved his operations from Buena Suerte. The ranch is located at the junction of the Fresno Canyon and the Rio Grande, six miles upriver from Lajitas.

On occasion since then I have contacted Sleeper, and he has been kind enough to allow me and my students to come onto his land to photograph. One winter I was traveling with my friend Bryce Jordan, who was always looking for a good photographic opportunity and an interesting story. We decided to find David and photograph him with his stock of trained mules. The ranch gate was locked, but a few inquiries directed us to the area where the movie *Streets of Laredo* was being filmed. David had secured a part-time job working security for the movie location, a portion of which was on his land.

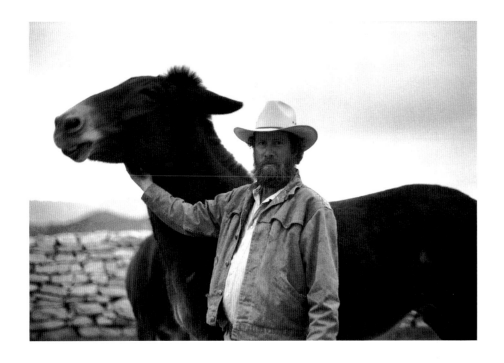

David Sleeper and Angelina,
Fresno Ranch, 1995.

I found him eating supper in the big supply tent, surrounded by movie types. He had gained a bit of weight since I had last seen him but was still fit and trim. His luxuriant reddish beard was new to me, and I greeted him with some hesitation, not remembering his face with all the growth. We shook hands, and I told him that when he finished work I would like to talk about his mule business and make some photographs. He was agreeable and gave me the keys to the ranch gate, asking me to close a specific inner gate to secure the mules and then to meet him there at the ranch house after 6:00 P.M.

Bryce and I went to the ranch, closed the gate, and made some photographs of the mules. When we returned in the evening, we honked the car horn as we entered the gate, as instructed, and Sleeper came out of the house when the guard dogs began barking. He presented us with cold soft drinks and invited us to the corral to be formally introduced to the mules.

I asked David how he got started in the mule business.

"I've been putting it together ever since I signed the papers on the ranch," he told me. "I first started raising horses. Well, I raised horses and the horse market wasn't any good and I'd always been impressed by this one Mexican mule I knew. It was embarrassing being out on your best rock

horse, accompanied by a Mexican on a mule, and you finally get up to the top of a pass where he's been waiting for you for a long time and his mule is dry and your horse is soaking wet and breathing real hard and, then, off you go again and just like that he's skipping over those stones and way ahead of you. It kind of gets your attention. So I started raising mules."

David walked into the corral and slipped a halter on a large, very handsome animal and led her toward us. "I want to introduce you to Angelina," he said. "I brought her in here because she is the second-spookiest, high-strung mule I've got, just to demonstrate a few things."

Bryce and I began to get educated on mule etiquette. David told us how important it is to respect a mule's space as the way to establish trust.

"When I approach a mule, I get close," he said, "maybe three feet away, depending on the mule and the situation, and I stop. Then, I take a tiny step backwards, or even a big one. I'm showing that I'm not going to just walk up and stick my hand in her face. Not going to invade her space."

He continued, stroking Angelina all the time. "Mules are careful, and they don't want to get hurt. If you rush in, to them that's danger. Once the danger is not rushing at them, they get curious and want to investigate. Stepping back is like an invite for them to move a little closer. I move closer and closer and, then, I might take another step back, depending on the situation. I am showing them right off that I respect them very much, and I will not just throw my reality on them. I show them I won't invade their space without asking. This helps build a foundation of mutual respect and trust."

David gently drew the halter rope in toward him. Angelina was wary of Bryce and me and eyed us nervously, her ears pricked up and focused. David continued, "Mules are a very interesting gift from the Creator. You can't take two other species and make a third like you can with the burro and the horse. You can't take a mallard duck and a wood duck and make something else. You can't take a sheep and a goat and make something else. It just don't work. But you can with these guys."

I began to see mules in a new light as David proceeded. "When you get really good mares and a really good burro, you've got something that a horse can't hold a candle to. Except for doing things that are stupid. Of course, sometimes it's real nice to have a horse that doesn't think and will do whatever you tell it to do."

David was just getting up to speed. "There are times, especially for the way us humans are put together, when humans would rather be on an animal that's *not* thinking, just responding as it's been trained. That

doesn't happen much with the mule. The mule is going to always be think-ing; the mule likes routines and the mule likes to trust and it doesn't want to get hurt. The horse's instinct is to run from its problems. Say you had a horse that got its foot caught in a net fence. Its first instinct is to get the hell out of there, and thereby tear up its foot, tear up the fence, and be afraid to ever go near it again. If a mule got caught in a fence the first time, her natural reaction is to use her mind, to figure out how not to get hurt; she figures it out, and then she gets her foot out. She understands the dan-ger, and then can get right next to the fence, because now she understands fences."

For David, mules were a way of life, a part of his worldview. It was a mule philosophy. I moved closer and tentatively began to stroke Angelina's muzzle and run my hands over her ears as I saw David do. Angelina began to nuzzle me and breathe heavy-like. I felt that I was making progress.

"Like I was saying," David went on, "you go to put a mule in the trailer for the first time, and a typical human is going to try to force her in there, and the mule looks at the trailer and says, 'That trailer looks pretty dangerous.' Then the humans become dangerous themselves. They lose their patience, they lose their temper; the mule reads the human's mind and thinks: 'This human is getting dangerous. Why should I jump in a dangerous trailer with a dangerous human? I don't want to get hurt, I'll go on strike.' Then the human takes the whip out and proves to the mule the human can't be trusted at all and actually wants to hurt her. So she certainly isn't going to go in that dangerous trailer with a dangerous human, and she goes on strike, and so mules are called stubborn.

"Conversely, the horse gets hit in the butt by an angry human and runs from its problems and jumps in the trailer. This dangerous place with this dangerous human. But us humans are so used to this kind of behavior that it's real hard to get a lot of people not to try to treat a mule like it had a horse's brain. Mules are a hybrid, and they think in a much more humanlike manner. What often happens is when mules get ruined, they get dangerous. They realize that humans are not to be trusted, and they do various things to try to convince the humans to leave them alone. Like kicking or what-ever. 'Don't put that saddle on me . . . don't do this or that.' Whap! 'I don't trust you. Leave me alone.'"

Was it just my imagination that the other mules in the corral seemed to be interested in our conversation? I felt that they were beginning to crowd around, big long ears twitching, and each one pushing for a front-

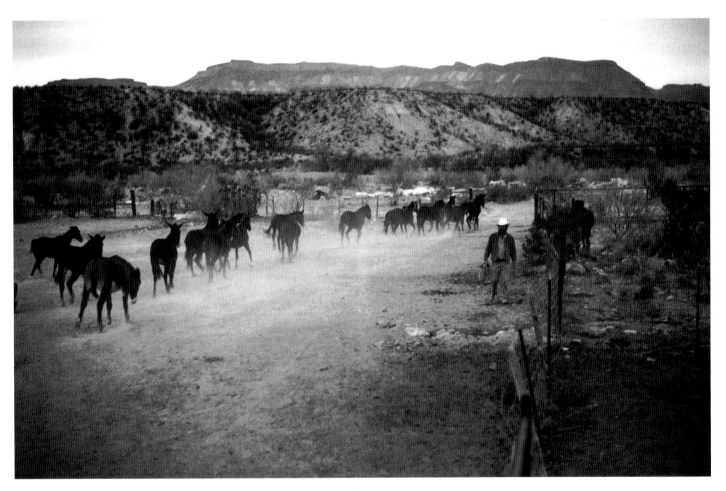

Fresno Ranch mules, 1995.

row seat. "What would happen if you used the same approach on horses that you use on mules?" I asked.

David responded, "It doesn't seem to be as necessary. That's kind of a tricky question because since I've been so involved in mules, I have not taken a horse colt up all the way. I would have to really do that to answer that. You are dealing with a whole different kind of intelligence. Pretty much the way horses are raised is the best way to deal with horses. They really do respond well to that master/slave kind of relationship. The 'I'm going to hit you in the butt, you better get in there' type thing.

"On a mule, if you try to do this master/slave sort of thing, 'I'm the boss, jump off the cliff into the lake,' the mule goes on strike because he

looks in your brain and says, 'You don't know what you're talking about, and I don't want to get hurt. The only way I'm going to jump in that lake is 'cause I trust you. When I get in that trailer, it's 'cause I trust you.' It is a much greater challenge for the human to not abuse that trust and to develop a relationship. A mule takes a bit longer to train than a horse."

"How long does it take to train a mule?" I asked.

David mused over the question. "If I just had one mule and time . . . say you had a four-year-old that had never had a saddle blanket on or a saddle on or anything like that, but like these mules of mine, was bonded to humans from birth . . . by spending an hour a day for a month, I would have a trained, broke mule and be going for rides with other animals. She wouldn't be ready to go out on her own just yet. I don't push that process because I want them to have a good time. I would end up forcing them if they left all their friends and were all by themselves. I don't want to force; I want everything to be darned fun. I want them begging to have that saddle put on. 'Let's go do something new and different and fun.' I want them to really learn to like to work, to do things. I don't break mules, I melt them."

"Do you use a bit?" I asked.

"Yeah," David replied.

"Spurs?"

"Not initially. Later on I'll use spurs just because they're an extension of your heel. You can do a little more fine-tuning. The heel is a little short. If you've got an extension, it makes it a little easier to do the turns and corrections and stuff like that. If you're roping or something and really do need to turn that hind end around real quick, you can poke her in there and it works out."

Bryce and I were about convinced at this point that David knew something about mules. The three of us walked from the corral up toward the house—make that the *four* of us, because Angelina came right along with David. He ushered us into the living room, and sure enough, Angelina came right in behind him.

"Excuse me a minute," David said. "Angelina hasn't been in here before, and I want to get her acquainted with the house." Bryce and I watched in amazement as the man and the mule made a circuit of the living room, then through the kitchen, into the bedroom, another room, finally returning to the living room. Angelina stood beside David with her head on his shoulder as he continued talking.

"One of the mules we saw out there today, her name is Hugger. That's because she would 'wrap' people and give them these hugs when she was younger. We had to teach her not to do it because she was trapping people. They couldn't get away. She got so big, we called her Huggasaurus. The first time I took her roping cattle was on a Mexican ranch that I had leased for ten years. I had one hundred twenty head of Longhorns, and we spent the whole day on five thousand acres rounding up the herd. The next day, I went over there with Hugger and my roping horse. I just turned Hugger loose in this big pen with the one hundred twenty Longhorns and ignored her.

"With mules, this is a great training method. Bring them to a certain point and then ignore them. They start feeling left out. Mules want to be part of whatever you are doing. Just like bringing Angelina into the house. If I had left her outside, it would have been like, 'Hey, do I get to be a part of this or not?' She may have even come in on her own.

"So I had this mule loose in the corral, and she was off in the corner thinking, 'Wow, where is my human? What is going on here?' I just ignored her and went to work roping these calves, and pretty soon she's over here. We've got a calf tumbled and we're vaccinating and castrating and branding, and Hugger, she's right over here, her nose right in everybody's business, trying to figure out what are we doing. She's trying to understand how she can be a part of it. She was lonely over there in the corner.

"Before long, when I roped a calf, she'd be over there trying to tumble the calf. The story gets better yet . . . pretty soon she starts shadowing my horse; whatever my horse does, she's doing. Like a dance partner.

"I roped this calf, and it's on the end of my rope flopping like a fish, a pretty big one. Hugger wedges her chest up so the rope is going across my saddlehorn and across her chest (she's paralleling my horse) and back to the calf. She braces her feet and has her back arched way up and it's like she's saying, 'I got him, I got him.'"

About this time I noticed that Angelina was getting a little fidgety. She sort of shook like she had a little tremor all over. David excused the two of them, "Got to take her outside for a minute . . . we'll be right back." Man and mule walked out the door and in a few minutes back they came. Angelina was quiet and settled again. "I rushed her coming over to the house. She just had to go outside and do her business."

"You mean this mule is house-trained?" Bryce asked.

"Some can get that way pretty good," replied Sleeper.

"Mules are very possessive," he continued. "I had a mule once named Rosalia that went over to Mexico to steal a baby. She found a six-month-old colt over there that was ready to be weaned anyway and stole it. So I had to go fetch that mule. Now Rosie is real tame, but the colt was extremely wild, and when the colt would run away from me, the mule would say, 'Ah, that's my baby, I've got to go with it.'

"I was riding ol' Hugger, and I ended up having to rope the mule in a big mesquite thicket, in a box canyon, after dark. Rosalia, who wanted to go with her stolen colt, gave us a good ol' tussle, but Hugger had seen this all happen before. Even though she had no practice, her moves were perfect. We had quite a rough-and-tumble deal there for a while. She was real nervous and scared, but her intelligence took over. She was thinking, 'I know what this is about, and I want to do it right.' She did incredibly well. Normally, with her total lack of experience, other than that one day watching cattle being roped and wanting to participate, the situation would have just been a giant wreck waiting to happen. It was all in the dark, in this canyon, in Mexico. It was pretty darn interesting.

"When I've got critters to shoe, I'll take this same mule, old Hugger, and turn her loose in the pen and just ignore her. I'll be putting shoes on horses or mules, and she will come over and try to see what we are doing. Then, up goes those feet. She'll come over and actually beg to have shoes put on. I'll have to go over and hammer on her feet a little while so she'll leave us alone. She wants to be part of what's going on. Horses just aren't like that."

By now it was clear that Sleeper was not a typical rancher. He had certainly developed an unusual attitude toward animals, and it seemed to be working. No one could deny that. The Outward Bound experience and his life in the desert had shaped his feelings toward the land and animals, giving him a sensitivity that most people never develop.

I figured now was the time to ask about something Bryce and I had seen earlier when we went to close the gate. "David," I asked, "what are those large stones standing in a circle that you can see from the corrals?"

"Well, I'll tell you about them," he said. "It is nothing I want to advertise, but for people who are sincere, I am glad to explain them." He continued with the explanation that he had built this as a site where people of all persuasions could come and meditate. The site was constructed to rep-

resent the solar system at one level and to create an awareness of life's stages at another.

"There are twelve large stones set in a circle," he explained. "The very center of this thing is where the fire pit is, and the diameter of that, which is maybe twenty-two inches, represents the diameter of the sun. I'm going to represent the solar system here." He spoke of his plan to place various sizes of spheres at distances proportional to the distance from the sun of the various planets. "If the sun is about twenty-two inches in diameter, it puts the Earth about nine hundred feet away," he explained. "Some of the far-out planets might be situated on some of these neighboring mountains! I'll put a little ball bearing on a big rock to represent the Earth. I'll place large rocks to represent the nearby planets. The close ones I'll put on some big rocks at their ratio to that twenty-two-inch sun, and then the far-out planets will be going on places like Fresno Peak or Mount Emory. They'll just be little dinky ball bearings."

"But what does the rock circle represent?" I asked. "It looks a lot like Stonehenge."

"I'll have to explain that out there." David asked us to wait until he could prepare the site for our visit. Bryce and I walked outside, and David and Angelina left for the stone circle. By now it was completely dark. Bryce and I sat in the Land Cruiser and reviewed the day's events. The full moon had risen over the eastern horizon, and I fumbled around for a flashlight even though the moonlight illuminated the surrounding area in the clean Trans-Pecos air. We didn't have to wait long. David returned, still leading Angelina, and invited us to follow. We drove the Land Cruiser as far as we could go, gathered our cameras, and followed single file through the honey mesquite thicket to a large bowl-shaped depression with the giant standing stones in the center. David had built a fire in the fire pit, and sparks were flying and the flames were casting flickering shadows on the circle of stones.

A pathway led into the circle of stones from the rim of the bowl, descending in spirals until it passed through a small gap between the stones, where a person could enter and face the fire pit. With the full moon and the flickering flames, deep in the Chihuahuan Desert, it was just a bit spooky.

David suggested we walk the spiral, saying that he and Angelina would follow. He urged us to meditate along the way. Bryce was having some problems with his knees and said he would just remain on the rim. I took the lead, and David and Angelina followed behind. It was a memorable

experience. The giant megaliths . . . I could imagine some ancient Celtic rites being played out in this desert theater.

We continued around the spiral and finally entered the circle of stones—that is, David and I entered, and Angelina stood outside, nervously eyeing the fire and trembling. "She's afraid of the fire," David said. "This is her first trip to the circle. It will be a chance to demonstrate the trust we share." He began talking to the mule, stroking her nose and ears and whispering that it would be okay to enter. Slowly, Angelina moved forward to the narrow gap in the stones. David took a step backward, gently pulling on the halter. With a few more words of encouragement, Angelina was standing inside the circle of stones, in the midst of the flying sparks and darting shadows. We walked the inner circle, and David explained the meaning of each stone:

"This is called the Chalice Flower Medicine Wheel. The chalice is like the Cup of Christ, the Holy Grail. We are in the center of an earthen bowl, and these stones in the very center here are like a very tall, petaled flower opening up. This forms the outside of the medicine wheel, which is patterned after the Indian medicine wheel. A way of tying some of the two traditions together in terms of the Christ thing and then the Native American tradition of being in touch with the earth sort of thing. The firelight from the center of the medicine wheel passes between the stones and fans out to the bowl, or chalice, and forms petals of flickering light and creates the chalice flower."

I asked him if there was any reason for the resemblance of the stones to Stonehenge, and he believed that there was really not much similarity. He described his monument as more of a medicine wheel than a Stonehenge with all its mathematical intricacies. The interesting thing about his circle, he believed, was the way to get to the center by descending the spiral path, making seven revolutions around the upright stones. It was 1,600 feet of a walking, contemplative, spiritual journey, a cleansing sort of adventure to prepare oneself to enter the sacred space in the center . . . an art piece with a spiritual function.

"It is very beautiful," I said.

"It's not like an ornate cathedral," David observed. "It's using the native materials here to make an outdoor temple of sorts. There's no rules or restrictions or doctrines or anything like that.

"I would like to explain a way to look at the stones," he continued. "We start over here in the north. This is kind of similar to Indian stuff and

Fire in the Chalice, 1995.

some of it is just local Fresno Ranch stuff here . . . a combination of various things. But many tribes have different ways of interpreting their creation of sacred space. Those that use the medicine wheel have various traditions, and this is a combination of some of those, with a lot of local flavor."

We walked to the north side of the circle and examined the tall standing stone. David talked about the north as a place of death and conception. "If you look at this rock, it is all beat up and it's been around the block, the color is white. If you look on the other side, you will see it is pink, like

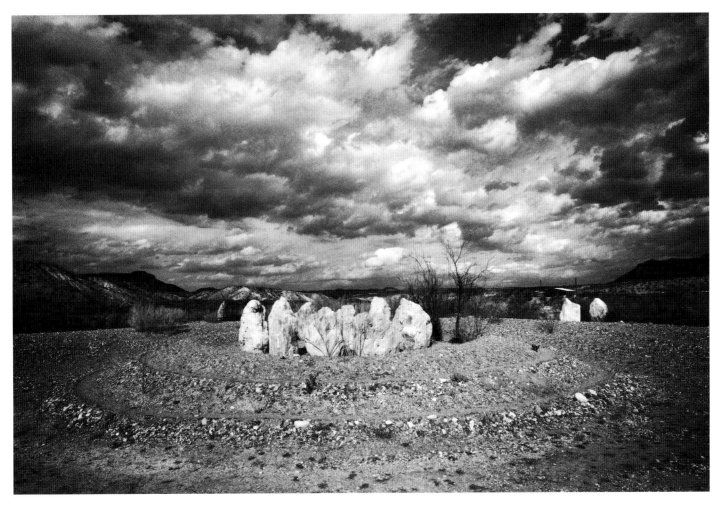

The Chalice Flower Medicine Wheel Sleeper
created on his ranch using local stones, 1995.

fresh blood. It's pregnant . . . it's got a big ol' bulge on it. Death and concep-
tion," he said.

David, Angelina, and I walked to the next stone. "We are going
around the wheel, and the wheel is like a cycle, like a cycle of life, or the
cycle of a marriage, or a career, or whatever. In this rock you see the kind
of face on it there . . . like a baby frog. Or Casper the Friendly Ghost . . . or
a fetus. . . . This is a child rock. The next step after conception. There is an
innocence here . . . like being a small child, wide open. See the big eyes?
Ready to jump out into life, this baby frog."

We continued around. The next stone he connected with children
growing up. He explained that youths have a tendency to believe themselves
the center of the universe and that the whole world revolved around them.
He believed that this rock had that kind of feeling. "Then along comes the
next stage," he said. "Life comes along and knocks us down to size.

"This is a short little squatty rock here; this is kind of going through
the humbling experience," he said. "If in that humbling experience, we
really touch the Creator . . . like this tree molds around this rock . . . things
can really solidify and crystallize. You step over here and look up at the top,
it's all full of crystals up there. Things can really solidify and crystallize."

Leading me to the next rock, David explained that it represented
adulthood and pointed out that the red stain on the surface represented
action. It was also the place of the coyote, or trickster, in American Indian
lore. "You see how this rock has got a kind of wizard's cap on it and two
shoulders and one is down low and it's like he is looking at you, fixing to
trick you, fool you," he said. My eyes strained to see the stone metaphor. He
suggested that the coyote "medicine" is supposed to turn your world upside
down and backwards. "We have to learn how to laugh and see the humor in
our human foibles, and that is what the coyote is about."

The religious rock that David called the Monk came next. He said
that after the coyote is through with us, we have a tendency to get religious.
The rock, in the vague shape of the hood on a monk's robe, represented
the cycle in our life where we pursue ceremony and look for some religious
experience. We moved around past the angelic rock that was to represent
this core spirituality as separate from religion and came to the rock that
represented the feminine place. He termed it the rock of "middle age" and
wisdom. A place like a stone womb that you can slip inside and be intro-
spective. I was tempted to try it, but the cleft in the standing stone seemed
small for my over-six-foot frame. David asked me to give this rock a big hug

because the feminine side of life is very important, symbolizing the sensitivity required to be a complete person.

Another rock in the circle was to honor the elders. It was a massive upright stone with seven prominent faces. David pointed out an eye and a nose and a mouth and then more noses and mouths and eyes, seven faces in all; one like Jimmy Durante. There was a Neanderthal and an American Indian. They all pointed forward. David said, "If you were to weave between the rocks and think about your life or a marriage, you might get to this point where you are stuck between these two rocks, looking backward at your past, and you've got seven faces staring at you and they are all saying: 'Turn around, quit being in the past.' To turn around is very difficult. It is very tight here. It is not easy to turn around and join them looking forward." We continued past more rocks, each with its own metaphor, until we came to the final stone.

The death rock. He told me that by embracing this rock we are embracing death, or the death of a part of ourselves—like the death of the part of us that smokes cigarettes. When we embrace that death, we are also embracing conception, and then there is a sort of rebirth. Then we become that innocent child again. We are to take very good care of that innocent child so it doesn't get badly hurt and send us backward. The child keeps on growing, and we start going around the cycle again.

I was almost hypnotized by the tour of the rocks and the flames and the moon. We stood in silence for a while, and then David walked over to the fire and began to kick it out. We walked the spiral upward toward Bryce, the Land Cruiser, and dinner at Lajitas after a drive to town. We walked the spiral . . . just David and Angelina and me.

Big Bend National Park, 1993.

Socialist Art Has Gone to the Dogs

CHAPTER 13

HERPETOLOGIST DAVID HAYNES, my traveling companion, and I planned to meet our Albany friend, Clifton Caldwell, at 5:00 P.M. at the Limpia Hotel in Fort Davis, where Clifton's daughter worked in a gift shop. We could never have dreamed where this visit would lead us. From the shop, we planned to visit a friend formerly from Abilene—Joe Williams, an architect now living in Austin, who had built a clever vacation house on the point of a mountain overlooking the Fort Davis area. David and I were ready for some refreshments after a long week of hunting snakes for David's census, making photographs, and camping out in the summer heat.

Clifton was waiting for us in the open doorway of the gift shop, which is across the street from the Limpia. What used to be curio shops have changed over the years—no more coffee cups with clever sayings. This shop was politically correct. It was nature to the hilt. There was an enchanting collection of insects in plastic boxes, plastic snakes, toads, and lizards. There were also scientifically designed bouncing rubber balls, children's paint books, a harmonica lesson on cassette for travelers, and all sorts of other interesting things. After checking out the store, David, Clifton, and I climbed into Ole Grey and headed up to Joe's house. We drove toward Alpine for a short while and then turned right off the highway onto a dirt road that snaked up the mountain, went past the vineyards, and passed a number of different homes that had been built there on the lower slopes. Joe's house was on top, at the tip of a ledge overlooking the town. We stopped at the unusual and seemingly self-constructed house, with its solid but not quite polished exterior, and Joe came out and met us. While he hustled up refreshments, we looked at a comprehensive map he had constructed with all the area ranches marked on it.

Talk turned to the interesting people in the Fort Davis area. Joe mentioned that there was a political radical by the name of Lineaus Hooper Lorette that we should certainly meet. He collected leftist art. The situation seemed interesting enough for us to attempt a liaison, so Joe looked up the phone number and we gave Lineaus a call.

I introduced myself on the telephone, and he was very pleasant, though surprised that a stranger would know of his art collection. We got permission to come by and visit. He gave us directions to the house and, since we were running short of time, we thanked Joe for his hospitality and started immediately for Lineaus's house. Clifton was very apprehensive. Visiting people that he did not know suddenly made him nervous. He stopped at the gift shop to give his daughter information about where we were going

and, perhaps, instructions about what to do in case we didn't come back. We continued north on the Balmorhea highway and turned right at the taxidermist's shop. We proceeded up the unpaved road, passed the medicine ball factory that Lineaus operated, and turned south into his driveway.

We could see that he had a fenced yard and that a vehicle was parked in front. As we drove up, a hundred dogs (I may be exaggerating slightly) came barking, snarling, jumping, and leaping out toward the fence, and, to our amazement, many of them clawed their way over the top of the gate; others squeezed through gaps in the wire; others came under. They were like lemmings running pell-mell to the sea.

They surrounded our car, yapping, barking, and snarling. Lineaus had prepared me for the dogs, assuring me during our telephone conversation that they were harmless. I got out and began to let them know I was not a threat. David and Clifton, after an initial hesitation during the snarling phase, got out also, and we, accompanied by our dog friends, all proceeded through the gate in a jumping, yipping pack.

Lineaus came out to meet us, reassuring us about the dogs and directing us to the main room of the house. Lineaus was an imposing figure, a tall, friendly bear of a man with a body that showed evidence of weight lifting. He wore rimless glasses with the left lens tied to the frame with a string, giving him a decidedly casual appearance, emphasized by his muscle shirt and gym shorts. He also wore hiking boots. He had a reassuring smile.

Lineaus came straight to the point. "My politics are probably a lot different than yours," he said with a grin. "I'm a Communist."

This did not come as a shock, as we had already been briefed on his political interests. "I'm a conservative Republican," I said. He was not startled either. "Most of the folks out here are pretty conservative," he said. He was very friendly and didn't seem to mind that he was being invaded by conservatives.

We continued into the main room of the house, which was cluttered with paintings, sculpture, and memorabilia. The art covered a wide range of genres and techniques. There were classical and impressionistic portraits, bronze statues, and paintings of revolutionary heroes. Much was folk art— or perhaps you could say the entire room was a strange hybrid of classical art, folk art, and maybe junk. Clifton considered it junk. David, somewhat more liberally, conceded that it did have some redeeming value. He felt the early work was better than the later.

Lineaus Lorette, 1995.

Then we paused before a series of portraits that showed sensitivity and great talent. Lineaus said that they had been done by his mother, Richey, while she was a college student.

Richey Hooper Lorette was born in Oklahoma and received a degree in art from the University of Oklahoma. She met Lineaus's father, Jack, while both were in East Texas, where he was working and she was visiting a sister. A year later they were married and moved around Louisiana and Texas while Jack worked in the oil fields. They ended up in Odessa, Texas, in 1951, where he went into the well-servicing business.

Richey secured a job teaching art in the Odessa public schools and painting. Lineaus grew up there. I asked him about his life before Fort Davis.

"Odessa was probably the best place in the world to grow up," Lineaus said. "Everybody was middle class. If you really thought you were better than anybody, you moved to Midland.

"Still to this day I ask people where they are from. In Odessa you didn't ask kids you went to school with, 'What does your father do?' You asked, 'Where are you from?' Because everybody was from someplace else. There was a level playing field. Odessa was the most god-awful place in the world, so anyplace was better. Your baseline of comparison was astronomically positive. But it was wonderful to grow up in Odessa. The rules were fair to everybody and everybody was on the same level and it was really very pleasant. We never knew it was as miserable as it was.

"I can remember being in Austin when I first got a car. I was going to school at the University of Texas, and I threw a piece of trash out of the [car] window and someone honked at me. I didn't think I had done anything wrong because in Odessa, why would you care? It's such a trashy place. I understand from time to time they have programs to clean up the place, but they always fail."

"How was it that you went to the University of Texas and became a certified public accountant?" I asked.

"It happened this way," Lineaus said. "In my senior year in high school, you were required to write a paper on what you were going to do in life, and I was going to be a physicist. While doing the term paper, I found out you had to have a Ph.D., and I decided that this was just outrageous. So I got out the newspaper and looked in the want ads for jobs, and there were all these jobs for accountants. So, I said, I'll just be an accountant. Once I said it my parents thought that was great, and I was never allowed to change. They

were paying most of the bills for me to go to school, and so, yes, I ended up being an accountant.

"I worked in Dallas after I graduated, worked in Dallas for fourteen months and came back to Austin because I loved it so much. I was probably the youngest person ever to be a partner in an accounting firm at the time in Austin. I became the CPA for the second bishop of Austin."

Lineaus worked for the bishop for a time and then, after completing some specific projects the bishop needed, returned to private practice. He changed the way he had been working, preferring to be a one-man shop rather than doing business with everyone in town.

"Why did you get interested in revolutionary art?" I asked. "What shaped your political perspective?" I really thought it was somewhat bizarre for a West Texan to be an admitted Communist.

"I got my politics from my mother," Lineaus said. "My mother's father was a Marxist and a Socialist, and I was never told it because of the red scare. I was only told later in life when my politics manifested. I can remember being seven years old and my mother telling me that there was no devil and folks only said that there was a devil to scare people. From that time on, I never thought there was a devil.

"I have a dog named Madame DeFarge and I clearly remember there was this wonderful movie, *A Tale of Two Cities,* with Agnes Moorehead as Madame DeFarge. She portrayed this vile woman and while we were watching it, I said something about how terrible she was. My mother said, 'Well, Lin, I don't know if you know the story of what happened to Madame DeFarge. She was raped at the age of sixteen and she had this little girl. The duke who raped her took the child away from her and had her killed. She could never have children again. Because of this, her hatred of this family was totally consuming. *A Tale of Two Cities* is a tale not of two cities, but of consuming hatred and consuming love.' My mother said things happen to people, and it changes their lives. They get consumed by this, and you should try to understand the source of their feelings. Since then, I believed Madame DeFarge was the hero of the piece. My politics come from this very progressive family of my mother's.

"She had seven sisters and one brother, and to this day it's given me trouble. Their father (my grandfather) said, 'You gotta go to a church.' They were all different. They became Presbyterian and Methodists and Baptists and Lutherans. At family reunions they'd start poking fun at each other's denominational quirks. To this day I think denominationalism in Christian-

Lineaus's mother, Richey Lorette, Midland, Texas, 1995.

ity is one of the real things that's kind of humorous. People take this too seriously. In my family it was humor.

"In 1980 my politics really manifested. I quit the Catholic Church, and I got into politics. I ran for the United States Senate on the Citizens Party ticket in 1982."

"Are we talking about the same thing as the Libertarian Party?" I asked.

"No," he said. "When people think of third parties, they always think there must only be one, and that's the Libertarian. The Libertarians

are simply Republicans. The Citizens Party was an environmental leftist third party founded basically around Barry Commoner, who was an environmental scientist.

"In Austin we were really dedicated, and we did the work to get on the ballot in 1982. It was a disaster. The left has an identity crisis. I am a libertarian leftist, a decentralist leftist. I believe, for example, that I have the right to health care, but I think it's the obligation of the community of Fort Davis to provide me with that health care, not the state, or not the national government. The authoritarian leftists believe we need a national program . . . a socialized medicine national program. In this sense of the word, 'libertarian' really means anarchist. The word was invented by anarchists after the Paris Commune when it became illegal to use the terms 'anarchism' and 'anarchist.'"

"That's the reason you have some anarchist art?" I asked.

"Yes. I really like the anarchists."

"You separated yourself from the Communist Party of the United States?"

"Yes," he said. "That's Marxist/Leninist."

"So you're not a Marxist/Leninist?"

"That's right. I do consider myself a Communist, but I am a decentralist communist. In the history of the Communist Party there was a First International. The First International was run by the anarchists. The anarchists are the opposite extreme of Marxist/Leninists. The Second International was taken over by Marx and the authoritarian leftists. When Emma Goldman, who's an anarchist, met Lenin and was asked if she was a Communist, she replied, 'Yes, but of the anarchist school.' See, Bill, you have to understand that the goal of communism is for the commune to rule. The community. The commune is to rule. Marx thought the way you got there was to first create the state and then the state would dissolve itself. The anarchists believe you shouldn't trust giving the power to the state, because it will never give it back. This is correct. Anarchists believed in immediately giving the power to the community. The goal of all Communists is the same thing: community rule. How we get there is what differentiates Marxist/Leninist and the anarchist schools."

I said, "I don't know, but you are sounding more like a Republican to me—moving government back to the local level!"

"Oh, I'm not that scary," Lineaus replied. "What I believe is that our economic rights should be in the Constitution and that the community

should be responsible for providing health care, retirement security, and a job . . . training. It will happen that way ultimately. You have communities that are unique and, because Texas is so big, any time you try to create programs, you run into difficulty. The problems of Beaumont are very different from the problems of El Paso. It is difficult to design a program for both Beaumont and El Paso that is flexible enough to meet each of their needs."

"How do you deal with the problem of a community like Fort Davis that is not big enough to have economic surplus enough to be able to purchase the expensive modern requirements of medicine or education or production?" I had him here, I thought.

"Out here, we would have to combine several communities. It would cover the three big counties out here, perhaps more," Lineaus explained.

"What you're saying is: Rather than individual communities, you recognize the need for a critical mass that's big enough to support a working situation. Would this be a different number of people or area depending on the industry, smaller for education, perhaps, than for medical treatment?"

"Texas has a wonderful historical tradition," Lineaus said. "We believed that you should be able to go to the county seat in a day's horse ride. That's the reason there's all these little counties. Texas is easy to conceptualize because it's basically county as a community, except, once you get past the Trans-Pecos we're deserted. The crisis we face is in the cities, and Dallas is the best example of all because it is totally surrounded by bedroom communities. You really have a 'community of Dallas' that should be one governmental agency. If the external cities continue to develop, the inner cities will become violent and worse than they are now. The population is fleeing the cities and moving out in the countryside because it is safer.

"I've read Mao, and to be a Maoist you really have to be a Marxist/Leninist/Maoist. Mao talked about the contradictions and how you should always focus on the contradictions. One of the big contradictions of our time is that inner cities don't have the power to deal with their problems because the money has fled to the suburbs. But it is still one town, it's still one city. They need to have one governmental agency. What we have is a system of government that was created to settle the West. We need to move on, to get past our history. The real problem I see in American democracy is that our structures of government at the national level were created, if you read the *Federalist Papers,* to slow the process down, not to speed it up. But now we need to speed up."

Lineaus continued his discussion of the federal government, saying that it had done nothing for us in the last twenty years. He talked about the disaster of the last big tax reform bill, which screwed up the continuity of the business world. I thought this a curious perspective for a Communist.

Lineaus kept talking as we made our way through his house looking at the art. On one wall was a series of masks, done by Patty Manning, a Texas artist living in Alpine. They were fashioned from various animal bones and papier-mâché, and many were grotesque.

Along the other walls and on the tables were portraits of revolutionary heroes: Sacco and Vanzetti, Chairman Mao, and others. "Who painted these revolutionary portraits?" I asked.

"A Marathon artist, Abby Levine," he said. "She came down from New Jersey, but she is getting well known now, and I don't know how many more paintings of hers I can afford. She is getting expensive. We have talked about several things. One is a painting of a famous Russian filmmaker, a real people's hero, named Sergei Eisenstein. I would like her to do Sergei because he's very photogenic, a very handsome young man. I've only seen pictures of him; I think he died young. I have occasionally gone to the library to find books for her. She does the research."

"Does she share your political opinions?" I asked.

"I think, yes, she does. She's got great leftist sensibilities."

I wanted to know more about his art collection and asked him to tell me about the work of Abby and Patty as well as that of his mother.

"Well, I'm a real fan of my mother's art," he said. "Her gift was in portrait painting. When you see an impressionist portrait, you need to know the person and know the portrait, and then you think, 'Oh, God, that's really great.'

"I've got a closet full of Mother's paintings that aren't up. Every time I am home I bring back more and more of it because I think she's just a great artist. I would really love to see my mother honored in her lifetime, and that may not happen. Her art is in a lot of different media—she made dolls, she made these pillows, she made papier-mâché fruit for the Christmas trees, and she did bronze sculptures. I wish she'd know that she was honored and that people appreciated it.

"I never thought of myself as an art collector, never in a million years. I came out to Fort Davis and started buying Abby's art. I'd buy a little thing and it was so nice and then I bought another little thing and then I got

another and I got a little bigger thing, and . . . it's wonderful, and this is a wonderful house for art."

Below, along the wall, sat a long wooden bench with leather pillows that Lineaus made out of scrap from the medicine ball factory. Lineaus told me that he gave them away as gifts to customers.

We went on into the great room and there on the table, under a large clear plastic box, was an ornate chess set made by his mother. The pieces were nontraditional, representing cowboys and other Western figures. Each of the individual chess pieces stood about four or five inches high, cast in bronze. "All of the casting was done by my father," Lineaus said. "He is an incredibly talented man. He and my mother built this house.

"My father's very smart about this sort of stuff. People have problems out here because they contract with someone to build a house and then they go back to their hometown. The contractor then does a bad job. My parents first built the two bedrooms. Then they had the adobes made. They found a guy here in Fort Davis to lay the adobes. They came out after the wall was half up, and my father said it looked like the waves of an ocean. The lines of the desert. So he fired the man, and he decided at that point that he would never do any work on this house unless he was here. And so my father and mother were here when every bit of work was done on this house. My mother would get out there and screen the mud, the dirt, to make the mortar. They both worked and while they didn't actually plaster the walls, they were here helping with it until it was done. I helped them put the roof on. My father laid the floor and redid all the windows. These windows came out of a post office. My father can do anything."

Amid the sculpture and paintings there were two old dogs lying on the floor. Lineaus explained that the three-legged dog has had cancer for thirteen of her sixteen years of life. She has had eleven operations.

The three-legged dog was, nevertheless, showing some signs of activity. As we watched, she rose, shaking on three legs, and slurped a little water. She wobbled to the doorway and lay down again. The other dog was taking his ease under a table.

"Why are these two dogs allowed in the house?" I asked.

Lineaus replied, "They are my old friends. They just can't quite take the stimulation of all the other dogs outside."

I wanted to know more about the dogs. "Where do you get them? Are you the Fort Davis pound?"

Lineaus laughed. "I get them from everywhere. People call me all the time. I have Donald Judd's dog!"

"Now how is it you happen to have Donald Judd's dog?" I asked.

"Well, Judd died, and they were going to put her to sleep if somebody wouldn't take her. They heard that I had a bunch of dogs and so the people at the Chinati Foundation called and said, 'We have Judd's dog, and we're going to put it to sleep if you don't want it.' I said that I would come over and look at her. She's the huge, beautiful black Belgian shepherd. She had been neglected and had body sores, really in bad shape, but she was a good dog. Next week I'm going to take Judd's dog to the shindig at the Chinati Foundation in Marfa. I'm sure they're going to get excited about somebody showing up with a really big dog, but I don't care. Why not—I mean, it's his dog. And it's his place."

"Tell me about your other dogs," I said.

"I'll go through the names," he said. "Lucy Parsons is the oldest dog. I was reading Emma Goldman's autobiography and Emma, who says tacky things about all women, only said nice things about Lucy Parsons. So I named her Lucy Parsons. Emma didn't tell us that Lucy Parsons, who was Albert Parsons's wife, was a black woman. Albert Parsons was hung for the Haymarket Massacre in Chicago. Lucy Parsons was tried along with her husband, but since she was a woman, they didn't hang her.

"There's Theodora, who was Justinian's wife. We learned from her life that if you're a self-made woman, after you die and can no longer defend yourself, men will write books about you and call you a slut.

"There's Jiang Qing, who is Mao's widow. There is Zhu De, who was Mao's general. He was largely responsible for the people's victory over the reactionary forces in 1948. There is Ten Bears, who is named for a Comanche Indian chief. I have Alma Mahler, who was Gustav Mahler's wife. She is considered one of the examples of female genius that goes unrecognized. This is because female genius has a tendency to be in a broad spectrum and male genius has a tendency to focus.

"I have Pasionaria. She was named after a famous Spanish Communist who said things like 'Better to die on your feet than live on your knees.' Her real name was Dolores Ibarruri. She was Basque. Okay, other names: I have a dog named Solidad Sosa. Solidad was a Mexican woman who was the first woman ever elected to a leadership position in a union. It really caused a lot of controversy in Mexico. The males didn't like that at all. There's

Fannie Lou. Fannie Lou Hamer was this big, huge black woman in the civil rights movement who was a cotton picker. She picked cotton all her life. She went down to register to vote one day when she was sixty years old, and they wouldn't let her register to vote. She became a woman a lot like Barbara Jordan. Very eloquent speaker.

"I have a dog named Buffalo Woman. I am a vegetarian, even though I use leather in making my medicine balls. The myth of the Buffalo Woman is that you're supposed to use all of the buffalo and not let any go to waste. It's an Indian folklore myth of a beautiful maiden who was changed into a buffalo.

"I've got a lot of dogs: Cuauhtemoc, who was the last Aztec emperor. I have a dog named Julius Rosenberg."

"Do they all have names?"

"Absolutely," said Lineaus. "I have named them all after revolutionary heroes."

He took us through all the rooms. In his bedroom there was a very nice drawing by a modern artist. He said this was probably his most valuable piece. Along the top of the wall, Lineaus had hung framed portraits of the presidents of the United States that had impressed him as a child. The guest bedroom had a crazy quilt on the bed made out of all sorts of fabric and a very extravagant nude on the wall. The bathroom was done in the style of the late 1920s and had a footed tub. Some of the cushions on his couch had been made by his mother from discarded silk ties. They were actually very beautiful. "She made these while she sat watching television," Lineaus said.

I knew that Lineaus had a medicine ball factory, and I was curious about how that worked and why it was in Fort Davis. Lineaus led us out of the house and across the yard toward the separate building that housed the manufacturing equipment.

"I got in the medicine ball business because I was a runner," he said. "I was one of the first runners in Austin, probably the first person to ever run around Town Lake. If I wasn't first, I was second. I think I was first. I used to run a mile a day in 1970, and people thought I was crazy. I ran through my knees and began looking for something else to do. The director of the YMCA knew some medicine ball exercises and taught me, and I started teaching a class. More and more people wanted to come down to the class, so I went down to the sporting goods store to buy a medicine ball and

there weren't any and I was kinda shocked. And so I decided to make medi-cine balls.

"All accountants want to do something honest for a living," Lineaus said with a laugh. "We are leeches on society! My mother believed she could do anything if she wanted to. I guess I do too. I got that from her: If you want to do something, just do it.

"I make a real high-quality product, and I have a great reputation in the trade. I've sold my medicine balls to almost every national football championship team in the last ten years. I was at the right place at the right time. I've never made a lot of money at it. The most sales in one year were about twenty-five thousand dollars. That was a good year. I make too high quality a product. I sold Harvard all their medicine balls, and when I saw them again, a few years ago, they said, 'We're still using those balls.'

"Medicine ball exercises are a real leftist thing. It's a cooperative exercise, not a competitive one. The reason we're doing medicine balls is because in the sixties the Russian sports industry did radar analysis of people running and exercising to see what was actually going on. They found that each person has a dominant side and a weak side to their body. If you're right-handed, you're right-side dominant. When you run, you run bal-anced. The strength of the weak side limits the available power from the dominant side. The Russians were looking for something to build the weak side. They started using the medicine ball for this purpose.

"The East German track training manual, which is legendary in sports, has all these obscure references to using a medicine ball to train ath-letes, to build up coordination. That's where the director of the YMCA got his ideas.

"So, I came out of the YMCA at the same time the colleges and uni-versities like UT found out that medicine ball training built speed and quickness in athletes. They lift a lot of weights, and weight training has an adverse effect on speed and quickness, so they need to counteract that nega-tive effect of weight training. What matters in professional sports is who's the quickest, not the strongest. And so medicine ball exercises are quickness exercises. It's the greatest exercise in the world."

The long building was an exercise facility, a storage room for materi-als, a factory full of sewing and cutting equipment, and an office for Lin-eaus's CPA work. The door to the building opened into the office, which was cluttered with books and equipment. A computer with a modem stood on a table.

"I do all of my accounting practice by a telephone connection with my clients," Lineaus said. "I try to get to Austin to see them once a year."

The north wall was covered with a selection of books worthy of any small community library. There was all of Gibbon and Plutarch, a scattering of Southwestern history, and much of everything in between. We left the office and continued through the manufacturing area, examining the equipment and the balls in various stages of construction.

It was interesting to speculate on what Plutarch might think about the journey of his biographies from ancient Greece to the Davis Mountains of Texas and how they have influenced the thinking of a person almost two thousand years later. The wonderful quality of the light in the Big Bend was about the same as Greece, but what an incredible trip from the writing to the reading.

We said our good-byes and drove away, followed by dozens of yapping dogs. Yes, I thought, the Big Bend is changing.

Mitre Peak, 1993.

Doctor Bug
and the Boxcar Laboratory

CHAPTER 14 MARILYN CALDWELL RUNS a gift shop in Fort Davis, and David Haynes and I stopped by to say hello. I wanted to purchase something for my grandchildren, and Haynes was along for the ride. His real interest on this trip was snakes and turtles. He had been organizing the photographic collection of the Marfa and Presidio County Museum and decided to take a day off and do some exploring with me.

When we entered the shop, Marilyn was sitting cross-legged on the floor, sorting books. I picked up some T-shirts, children's books, and toys, and as I was walking to the front of the store to check out, I saw the bugs. Dozens and dozens of them, all packaged neatly in small plastic boxes with their scientific names on the back. Each box contained a single insect, and they reverberated with every color of the rainbow. The labels revealed their origins: Brazil, Costa Rica, Uganda, Indonesia, Philippines, and many other locations. I was fascinated, having been a collector of insects during my high school biology days, and I selected a particularly nice specimen for Chase, the oldest of my four grandsons.

As I was checking out, Marilyn said, "The guy that sells us these lives here in Fort Davis."

That was enough to set my curiosity in gear. "How can I contact him?" I asked. Marilyn dug out an old invoice with his letterhead, and I borrowed her phone and punched in his telephone number. Terry Taylor answered.

I explained that I was interested in what he was doing and would like to come out to his office, meet him, and see his operation. He was somewhat surprised. "Why would you want to do that?" he asked. I could tell he didn't expect to have much company. After a whispered conversation with his wife, he agreed to the visit and gave me directions.

The directions proved to be complex, as he lived twenty miles or so out of town, in the heart of the Davis Mountains in an area called the Davis Mountains Resort. He suggested we meet him at a convenience store along the way. From there he would guide us up the mountain.

We set the odometer and started out, looking for the dirt road that led from the Valentine highway. Finally we came to the road, made our turn, and soon arrived at the store, where Terry and his wife, Diana, were waiting in their four-wheel-drive pickup. We all got out and shook hands and introduced around. Terry eyed Ole Grey and agreed that it could make the trip.

Terry was about sixty, with a husky build and salt-and-pepper hair. Diana was attractive and sparky. She radiated good humor and pleasantness.

They returned to their pickup and started up the unpaved road through a juniper forest.

Haynes and I fell in behind the pickup. The road wound and branched. We crossed streams with no bridges and bridges with no streams. We gradually made our way into the interior of the Davis Mountains' Upper Limpia Basin. I was glad that he was leading us, as there was no way we could have followed verbal directions. The trees grew higher and denser, and finally we came to a clearing where two red railroad boxcars stood side by side, welded together. It was an incongruous sight.

Terry and Diana got out of the pickup and mounted a few stairs leading to a wooden deck in front of the sliding boxcar door, which they unlocked and pulled back for us to enter. Inside was a well-appointed office. The walls of the boxcar were lined with fitted drawers, all with labels indicating their contents. A small desk and computer and a wall of artifacts from Terry and Diana's travels completed the interior. In the middle of the boxcar, an opening led to the adjacent car, which was outfitted in a similar manner.

"How was it possible to get these two boxcars this far up the mountain?" I asked. Terry laughed. "We bought them at Odessa Metals and had 'em hauled in here on lowboy trucks with lots of curses. We had to have a bulldozer do some work to get them in here."

Diana chimed in. "They were the first trains through Fort Davis," she said.

"We have about sixty acres here," Terry explained. "All the canyon from the top down to this location. This boxcar contains all our butterflies. We have them organized in these drawers and respond to orders by mail."

"So you put them all on a spreading board and pin them and everything to present them?" I asked.

"No," Terry replied. "We send them unmounted." He indicated a tray containing a number of envelopes with clear cellophane sides with folded butterflies inside. "This is an order Diana is filling now. It's for the entomology section at National Taiwan University. It's up to them to mount them or to do whatever they're going to do to them."

I asked him how it was possible to catch all these insects. "Do you have help?" I asked.

"That's correct," Terry replied. "I travel to an area where I need specimens and where it is legal to collect, and I will teach people how to

Terry Taylor in his boxcar insect archive, 1995.

collect and how to ship. We identify the specimens, catalog them, and then fill orders from all over the world."

I caught the emphasis in his voice on the word "legal." "Is it *illegal* to collect insects?" I asked.

"Yes, sir," Terry said. "You must have a permit to collect. Most countries now require a permit for the collection, a permit to export, and I must have a permit to receive. It's getting really legalistic."

I asked the obvious question. "How did you get into this business? And how did you wind up in the Texas Big Bend?"

"I went to school at the University of California in Pomona and wound up becoming an entomologist. I wanted to work for myself, and I wanted to travel. This business has allowed me to travel all over the world and live where I want to live. In this area we found the people to be very conservative, and here we are."

"How did you find this area?" I asked.

"My daughter, Lisa, and I found this area. Diana wasn't with us. Lisa and I had been in the tropics for a couple months. She was nine years old at the time and we were driving back through this area. It was late and we stopped at the office, and, of course, they wanted to sell property. I said I

wanted a stream and I wanted a meadow and I wanted cliffs, and they said, 'We got just the place.' We came up here, and we bought. Then I went home and told Diana we were moving to Texas. It was really wild. Lisa went running around the house, 'Momma, Momma, we're moving to *Texas!*'

"It was becoming so dangerous just to live in Southern California at that time, and it hasn't gotten any better. It's even worse now. Here we enjoy the safety, the people . . . being able to relax. There's not much crime out here, and people leave you alone. You'll find the people in this area are high-intensity people. We're a different lot. We have our own way out here.

"There is every type of person you can think of here. That makes for an interesting mix. Lots of politics. It took me a long time, a couple decades, but I learned just to mind my own business and go on."

We walked down the aisle, and Terry began to pull out drawers. There were butterflies of every shape, color, size, and country of origin: Belize, Brazil, the Philippines, Indonesia. They were all packaged on cardboard with a transparent cellophane cover stapled over them and tossed into the drawers like rainbow-colored playing cards. We moved from butterflies to beetles. There were gigantic rhinoceros beetles from Brazil and scarabs from Egypt. The colors were drab to iridescent. We riffled our fingers through cockroaches, water bugs, and the like. I could imagine my wife, Alice, seized by a spontaneous convulsion after seeing a giant Gromphadorhina cockroach from Madagascar scuttle out from under a chair.

There were walking sticks from Sumatra, tiny supella from Wyoming, and sow bugs from California. "There are some nice beetles from right here in the Davis Mountains," Terry observed. He radiated an aura of pleasure as the drawers were opened and closed. "I have the largest insect business in the world," he said. "Right here in Fort Davis, Texas. Probably have more than a million insects in these two boxcars from perhaps ten thousand different species."

As we walked down the aisle, we came to a picture window that had been installed in the side of the second boxcar. It opened to a quiet meadow surrounded by trees. "See those bones out there by the fence?" Terry asked.

I looked where he pointed and saw a few whitish objects scattered about. "Mountain lion," he said. "It ate my dog. Had to shoot it. In fact, we had a real problem here for a while. I saw five lions in a two-week period. They were getting pretty aggressive. Normally, I just see them and we leave each other alone."

As we said our good-byes and prepared to leave, Terry paused by a beautiful photograph that was on the wall near his desk. "See if you can guess what that is a picture of," he said. I looked at the green and yellow impressionistic image and decided to make an educated guess. "A butterfly wing, close up."

"No," he said.

"How about pond algae?" I thought I might be getting close.

"You'll never guess," he replied. "That is the frame I shot when my Jeep in Vietnam hit a land mine and I was thrown through the air and landed in a sugarcane field. Every time I have a bad hair day, I look at that photo and thank God I am in Fort Davis, Texas."

Haynes and I were glad that he and Diana were here as well.

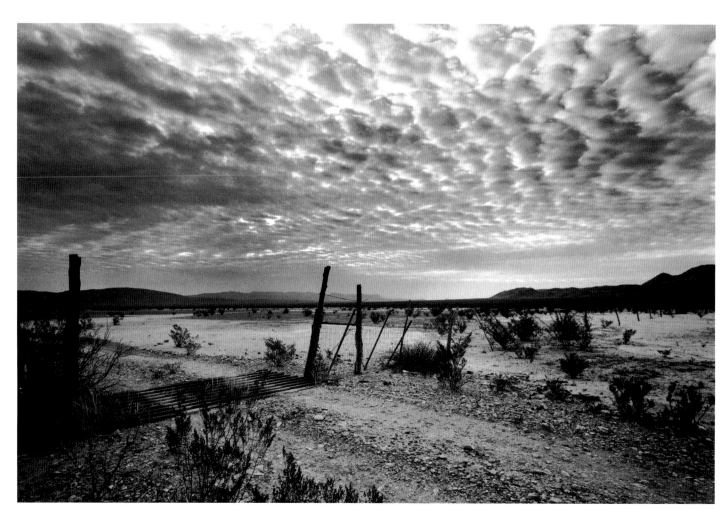

Ranch gate, 1994.

Legends Then and Now

BILL AND LISA IVEY were hospitable as always and invited me to dinner when I called to let them know I was in town. Bill was the owner of the Terlingua Ghost Town and had grown up along the river. His dad, Rex Ivey, owned and operated the trading post at Lajitas for many years, and Bill had taken over the management after graduating from Texas A&M University. As I drove through the ghost town on my way to Bill and Lisa's house, I saw "Crazy" Angie walking on the porch of her restaurant, the Starlight Theater. Now, Angie is anything but crazy, and she knows everything that is happening in Terlingua. Angie got the appellation "Crazy" from the kite store that she once ran in Lajitas called Crazy Angie's Flying Circus, and it seems to have stuck. I was about thirty minutes early, so I decided to pull Ole Grey up to the Starlight hitching post and visit for a while.

Angie is a fine-looking woman of indeterminate age and of a strongly independent orientation. She recognized Ole Grey and walked forward to give me a welcome hug. We sat together on the wooden bench on the veranda in front of the restaurant and looked out over the ghost town toward the Chisos Mountains, which were settled in a bluish haze as the sun illuminated the very tops of the peaks. "It's beautiful here," I observed. "But so many changes in the past few years! The Big Bend has become a growing tourist destination. Air pollution is increasing. The chili cookoff is now bringing thousands, and it seems that people are all over the place all the time."

Angie was philosophical. "Like someone once said," she reminded me, "the only thing constant is change! More people, more business. More business and people, more people move here to get a piece of it."

As we sat there on the porch, a few customers began to drift in for beers and a little frontier networking before they went home for dinner. The bulk of the tourists would show up a little later. The Starlight was where the river country residents met to swap information and catch up on things.

"I think it is the commercial development that I hate," I said. "Pizza places along the road with neon signs, new motels going up, the increased air pollution from the Mexican power plants . . . just seems like the whole character of the place is changing from the way it used to be . . . when there was the sense of the frontier, you could see for two hundred miles on a clear day, and people had to work to get here. That's what I loved."

"Yes," Angie replied. "That goes with it. But a new frontier is being created. Different, yes, but with its own unique character. No place like this anywhere I know about. The desert is still here, and it draws a certain kind

of folk. Independent in thought and action. People who enjoy getting good water to drink and a comfortable bed at night with a good meal and some entertainment. But also the kind of person who likes to take off in a four-wheel-drive truck and bird-watch in some isolated draw or cross over the river to horseback-ride in Mexico. People like you. You used to camp out when you came here, but now I see you a lot around the motel at Lajitas."

I confessed that it was true. I did like a good bed at night and a meal that someone else prepared. I was agreeing more with the old photographer's aphorism that anything more than fifty yards from a vehicle is not worth photographing. Yes, and I enjoyed a little entertainment from time to time.

As we sat there in the gathering dusk and people began to arrive, I thought about the legends: frontier ranch woman Hallie Stillwell, still going strong at ninety-eight; Buck Newsome, former border patrolman and horse concessionaire at the park for many years; Ross Maxwell, the first National Park superintendent. I thought about Robert O. Anderson and the Big Bend Ranch, which now belongs to the State of Texas, botanist Barton Warnock, archaeologist J. Charles Kelly, and the other scientists that studied the area. These folks, and others like them, helped create the legends of the Texas Big Bend.

But new people were becoming legendary Big Bend characters themselves—Angie herself, sitting beside me; David Sleeper, his mules, and the Fresno Creek Ranch; J. P. Bryan and the Gage Hotel; artist Donald Judd. There was also Bill Ivey, with whom I would be talking shortly, building his own reputation after taking over from his father, an early pioneer of the area. All kinds of stories revolved around lots of different folks. Some were shrewd businessmen, others were drifters or artists. Some came to stay, others to gather themselves together and then move on to other climes.

I remember reading the theories of the astronomer Fred Hoyle, who advanced the concept of "continuous creation," suggesting that the universe is being created all the time. It was the same with legends and the personalities that make the oral and written history of an area. As new folks come, the old pass from the scene, leaving the sometimes wacky, always interesting evidence of their passage in the folklore of the region, the stories of their lives becoming living monuments to the courage, the humor, and the frailty of the human condition.

Angie rose to attend her customers and Ole Grey and I started moving toward dinner.

Bill and Lisa Ivey's house is at the top of the hill overlooking the old Perry mansion, built by the autocratic owner of the cinnabar mines, which when they closed created a ghost town of what had been Terlingua. Beyond the mansion stretched the wrinkled arroyos of the Chihuahuan Desert, lying like some enormous flattened brain below the now darkening mass of the Chisos. We sat on the screened porch opening toward the southeast, and I brought up the conversation I had started with Angie. We talked of Big Bend National Park and tourism.

Bill believed that the park's policy was now directed toward conservation of the natural resources rather than providing for the tourists in the area. He reported that there had been a two- or threefold increase in tourism in the past three or four years. The feeling of these visitors was that the Big Bend was the last frontier in America, and they wanted to see it before it changed and the magic was gone. But these present-day explorers wanted to have their adventure soft, not hard. They wanted more services.

"It's still rugged," Bill said. "The electricity still goes out; the telephones quit. I cringe to think we'll become a Sedona or a Santa Fe or a Taos. But I think it's possible."

I had felt for some time that the very success of the Big Bend experience is destroying it. I hated to see it go. Bill and I agreed that the Big Bend was experiencing the same kind of development that is occurring in Santa Fe and that while it is still an interesting place to go because of the cultural attractions, the old Santa Fe is gone, supplanted by new homeowners from Texas and California, leaving the city a stranger to itself.

Towns are so much like organisms, I thought. They have appetites. They feed on money. If there is plenty around, they grow. If the diet gets meager, they wind up like Terlingua.

Bill leaned his chair back and twirled his glass of red wine, musing, "The increased number of visitors has brought changes here. I can remember when we didn't have electricity. Now we take all those things for granted. It wasn't that many years ago that we didn't have telephone or TV. When I was a kid, there was a dirt road from here to Alpine. Now we complain about the bumpy pavement. We've become more accessible. The people that have lived in this area for a long time have made a really big push to say, 'Hey, this is a wonderful place, come on down.' At the same time most of those same people are saying, 'I wish they'd go away and leave us alone so we can enjoy our community.'"

I felt like a traitor to my own desires when I thought about how many persons I had introduced to the Big Bend over the years. I knew they would come back and bring their friends. I wanted the isolation, but I also understood the need for the Bill Iveys and the Angie Deans of Terlingua to make a living. They couldn't make it from jackrabbits and javelinas. It had to come from tourism.

I knew that the potential for large increases in tourism was limited by the available water. The Rio Grande is really polluted now, and to expand the supply of water, an extensive treatment facility would be required. Terlingua got its supply from wells that required less expensive treatment, but the supply was limited. This would keep development to a minimum for the near future. There were other factors too, such as schools and medical facilities. Plans for a new high school are being advanced, and the area just got a new clinic.

Yes, things were changing. Bill's father, Rex Ivey, had come to the area for the first time in the late 1920s. He left for a while, then came back to stay in the 1930s. Originally, he was a trapper. Then he began buying furs, gradually expanding his buying to the entire area. Big Bend National Park was not here then, and his furs came from the entire open country. Bill told me that his father knew all the old-timers of the area, names you read about in the books now, like Bobcat Carter and Elmo Johnson. He knew them, and he bought furs from them. Then he got into the wax business and stayed in the wax business for many years, finally turning it over to Bill, who was still carrying it on.

Rex established an outpost to buy wax at what Bill called "the rock house," which is upriver from Lajitas about two or three miles. A fellow by the name of Loenthal was running the Lajitas trading post at that time. It had been originally established by a man named Scaggs in the early 1900s.

Loenthal attempted to drive Rex out of the wax business by paying more for the unrefined wax than he sold it for. He told Rex once, "You young whippersnapper. I've been in the wax business a long time. I'm going to starve you out." Rex told him to do what he wanted to do and then crossed the Rio Grande and leased all the land that bordered the river across from Lajitas and fenced it off so the Mexican gatherers couldn't cross at Lajitas. It was easier to sell to Rex upriver at the stone house. Rex ended up with the store, and Loenthal was out.

"Are you still in the wax business today?" I asked Bill.

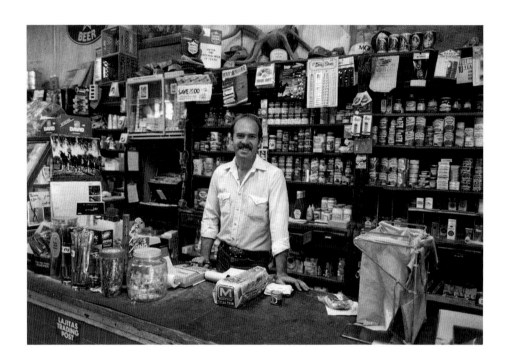

The Lajitas Trading Post, where Bill Ivey continues to buy candelilla wax, the production of which has been a local industry since the early 1900s.

"Yes," he responded. "I get almost all my wax today from across the river. It's more legal, I guess. I still don't know, and no one's ever been able to tell me where we stand in the wax business. But we are getting wax out of Mexico, and I'm proud to say, at the very first part of this month I bought my first load from the Mexican government, and it was delivered to me right there in Alpine. I bought the Casner refinery three or four years back. I've been working on this deal with Mexico for a long, long time. It's really unusual, because now I'm trying to make deals with the Mexican government. In the past, at one point, they had a Wanted poster on me. I wish more than anything that I had a copy of it. They passed it around the area wanting to know if anybody knew who I was."

"So you were a persona non grata in the interior of Mexico," I said.

"That's right. That was before the big devaluation of the peso. I had taken control of the wax market, and they got their feathers ruffled over that. They started coming down hard and heavy and kidnapped some of my guys. They sent word to me to come down to Saltillo and get my men. It was pretty interesting there for a while. After the devaluation I guess they figured out we were putting food in a lot of stomachs in rural Mexico and

maybe it wasn't as big of a problem as they thought. But it's interesting to go from being wanted to negotiating in the same business."

I had been interested in the strange-looking candelilla since I first came to the Big Bend, and I'd explored the processing plants along the river when floating the canyons. Years ago I had visited the Casner refinery and still had the chunk of raw candelilla wax they gave me there. Bill told me that it hadn't changed at all in the intervening years. The same man, now seventy-seven years old, was still refining the wax, and Bill was still selling to the same wax broker who had been buying the wax all along, blending it to industry specifications, and then selling to Johnson Wax and other purchasers.

I asked Bill about the possibility of the Mexican government continuing with their onetime plan for a national park on the Mexican side of the river. His feeling was that even though there was more talk about a "mirror park," it would be economically unfeasible for Mexico, given the country's present financial condition. There was also the problem of what to do with the people who lived off the land in the area. "If they can't have livestock and they can't harvest candelilla," Bill said, "the drug business is all that's left, and that's already got most of my workers anyway. It's hard to find anybody to work because so many are in the drug business."

The wax business had taken Bill into parts of Mexico where the lack of development shocked even him. That is part of the charm, part of the romance of living in Lajitas. He comes into contact with people who can still be surprised by such conveniences as telephones. Often, someone will hear a notice on the Ojinaga radio station, which is the only means of communication in that rural part of Mexico, that a relative has died in the States. The radio station will ask the person to go to the Lajitas trading post and "call your family in Odessa." Showing up at the trading post, they present a number that was given them over the radio station and ask Bill to make a phone call for them. They have no idea what a telephone is and no idea what to do with it. When Bill explains that, through the telephone, they can speak to someone in Odessa, it is simply magic.

"I have many wonderful memories of Lajitas," Bill told me. "I basically grew up in the trading post. When I graduated from college and came back in 1979, people asked me, 'What was it like, living in Lajitas and running that old store?' They were surprised to hear that to me it was one of the most exciting things I've done in my life. It was a pioneering thing. When I

took over the trading post, it was the hub of the community. Everything revolved around it. I had to become a little bit of everything, whether that was the doctor, the minister, the veterinarian, the psychiatrist, or the referee. It was a challenge that Texas A&M had only partially prepared me for. I don't remember any courses that told me how to deal with all of this kind of life. It was really exciting."

When Bill returned, it was a new time for Lajitas. Walter Mischer had bought the town and was pumping in a lot of money, turning it into "a resort." Bill worked a year for Mischer as his administrative coordinator. They were restoring the church and building condominiums, and the motel was brand-new. He did this for a year, and when the opportunity to take over the trading post came, he took it.

Bill's mother loved Lajitas tremendously, he remembered. She loved to go fishing. She loved to be a part of what was going on, just as Bill's wife, Lisa, loves to be a part of it today, running the store in Terlingua. When his mother was living, it was definitely a man's world. In many respects, at least in Terlingua, it still is. Just five years ago Lisa was not even allowed in the wax room. It was tradition. Even if the Mexican candelilla gatherers bring women with them, the women don't come in. They sit in the pickup. Bill said it was just one of those things about the culture of the border.

"Was this the Anglo culture or the Mexican culture or both?" I asked.

"I think the Mexican culture," Bill told me. "In the Mexican culture you don't let the public see your wife working. Now, it was different when Maggie Smith ran the store in Lajitas. She was a single woman. When it's a wife situation, you don't do that. Many times guys would sell me wax, and they might have their wife or girlfriend with them. They never got out of the pickup. They never even looked into the room. That was a hard thing for Lisa to understand."

Lisa was raised on a ranch, and she was used to doing what work was needed. It was difficult for her to understand why Bill's dad, Rex, objected to her being out with the guys loading horse feed or whatever needed to be done while she was working the store. She said, "I'd run out and start unloading feed, and Bill's dad would run over there and grab me and say, 'That's what these men are for. You go back up there and run the cash register.'"

Bill told me about going to social events in Mexico. "They're very

restricted," he said. "The women are in one room, and all the men are in another. In fact, all the men are in one room with all the beer. The women are in the other room with all the children."

The first time Bill took Lisa over to a party in San Carlos, he explained all of this protocol to her—that when they arrived, it would be segregated. The men would go off and they'd talk and have a beer, and she would have to sit with her hands in her lap in the other room with the Mexican women. He told her it would be somewhat difficult since she didn't speak Spanish, but it was protocol. He said it would be nice if she would offer to help prepare the meal. Bill waited until just before they arrived at the party to tell her the rest. "When it comes time for us to eat," Bill told her, "you have to fix my plate and bring it to me."

Lisa boiled up. "That was just too much," she said.

When Bill first began running the store, the days still had an element of danger. Everyone was armed. They still checked guns when they came in the trading post. Certain guys would come in that Bill knew were heavily armed, and they would hand over their weapons until they left. It was his policy for everyone, and he never had a problem.

"There was always a tradition in the wax business, back in those days, that everyone carried guns," Bill told me. He carried a gun himself. There were even times when he had a gunman stationed on the roof. There was never any direct threat; it was just part of the whole system. It was a respect thing, tradition.

"One night I received a shipment of wax about three in the morning," Bill related. "Back in those days I got most of my wax between two and five in the morning because the Mexican government was hot and heavy after me. I was always armed, and I usually had someone there with me who was armed also. We always had a shotgun right outside the door. These guys showed up, and I didn't know them. They were from Santa Elena, and they had smuggled the wax through the park in big cardboard canisters, which was very unusual. Everything was just really odd. My policy was you can drink after business is done. I'll even buy you a beer, but you don't show up drunk. They'd already had a few beers. It was just real edgy. A kind of an uncomfortable feel to the whole thing, and I was there by myself, didn't have any help. They kept asking, 'Don't you have any help to unload?' And I'd say, 'Oh, they'll be here in a minute, I had to go wake them up. They'll be here in a minute.' Since they kept asking, it made me more nervous. The whole scene was kinda creepy.

"We were going along just fine until it began thundering, and lightning began to strike around. Then the power went out. We were in the wax room. These guys don't know me; this is their first time in Lajitas. I don't know them. All of a sudden every light went out, and it was pitch-black. You could not see your hand in front of your eyes. All you heard were about ten or twelve guns cocking. I knew my way around, and I didn't say a word. I slipped out the door and got the shotgun. I figured if somebody was going to get shot, they're going to shoot each other, 'cause I wasn't staying in there. I got the Coleman lantern and came back in and explained to them that the power had gone out.

"Everybody had a gun so there was an element of suspicion. They bring wax and they're pretty vulnerable because they're not supposed to be in the country. If I wanted to do something underhanded, I could cheat them out of their commodity. On the other hand, all my dealings were in cash. If somebody shows up with twenty thousand pounds of wax and I'm counting out sixteen or seventeen thousand dollars of cash, it makes me very vulnerable too. It's changed a lot now. It's not exciting as it used to be."

One of the scariest times at the trading post came not from bandits from across the river but from American law enforcement officers. Bill was running the store, and the director for the United States Border Patrol was in the area to do a raft trip. Bill said, "They had these Ninja-looking guys all over Lajitas. They were on every hilltop. I don't know what they were protecting this guy from, but he was heavily protected."

They were quite busy in the store, and Bill heard this noise outside and looked out the door to investigate. There was a helicopter right in front of the porch that the Border Patrol had brought to hover over the director as he went through Santa Elena Canyon. Suddenly, a bunch of men stormed into the trading post with every kind of assault rifle you ever saw, yelling, "What's going on here? Where is it?"

Bill was startled. "What are you talking about?" he asked. "What's going on here?"

The Ninjas said, "Some guys just dropped some bags of stuff in here."

Bill realized what had happened. He told them to go into the back room and not to bother him because he was busy. "Do what you have to do," he said. Bill had just received two or three bags of candelilla wax from across the river. The Mexicans brought it over loaded on burros, which was not uncommon. They would bring their burros across the river and unload

their bags in the back room at the trading post. The guys in the helicopter saw these burros coming over loaded with white bags filled with something. They thought they were making the big drug bust of the century, a real show for the director from Washington.

Bill heard their radio squawk: "Joe, we got these burros down here—what are we supposed to do with these burros?" All that was left was the Border Patrol with this wax, which was legal, and a bunch of burros down there at the river. They left in a hurry.

Over the years Bill learned a lot of lessons they didn't teach at A&M. One thing he learned was never to do a two-night dance, that the most dangerous times are at the dances.

They once had a party on Valentine's Day. Bill thought that just for fun they would have some cockfights, which are illegal in Texas. They planned to have the fight on an island in the middle of the river because no one knew if that area was Mexico or the United States. They did it as sort of a spoof to find out who the island belonged to. Not a soul ever said a word, from Mexico or the United States.

They had horse races, and the dance music started at seven o'clock in the evening and went on all night. On Sunday morning Bill went out and unplugged the amplifiers and announced that the dancing was over for the night. They had been dancing from sundown to sunup. All that momentum kind of built its own party from then on. Then the dance started again on Sunday night. They never sobered up. It was February and a little chilly outside, and they moved inside the store. It was packed wall to wall with people.

Bill had a firm rule, and they all knew it: no fighting in the store or on the porch. He didn't care if they went out into the street and fought, or down by the river, but he allowed no fighting in the store and no fighting on the porch.

Bill related the events of the evening, "There were two or three hundred people, mostly guys. The women had gotten sick of them and left. They were dancing with each other. Drunk! My gosh, they were drunk! Somebody called somebody's sister a bad name. They got into a little pushing match. Well, they pushed, and the whole crowd would lean one way and then the other. I realized what was going on, and I hollered, 'No fighting in the store.' Well everybody was kind of mumbling and talking. I always had a big stick behind the counter. It was a piece of old rubber canvas piping with a wooden pool cue or something.

"My nerves were on end because I was tired of dealing with these people, so I grabbed my stick and slammed it down just as hard as I could on the counter. It sounded like a gun went off. You could have heard a pin drop. Every black eye turned and looked at me because they thought I'd shot a gun. I said, 'Get outside,' and they all single-filed out in the street. They had the damndest fight out in the street you ever saw in your life. I bet there was fifty of 'em just in a big wad. But I have discovered that the Mexicans really don't want to hurt each other. They usually wanted someone to break it up. I've taken guns away; I've taken knives away. I've stood right there and seen someone put a gun in another's belly, saying, 'I'm going to kill him.' I'd take the gun and tell him that he would have to come back tomorrow to get it back. He'd say okay, and that was that. Many times we've had holes shot in the roof and things like that."

Bill told me that the border Mexicans were real good folks but very emotional. One night Ventura and Braulio got to arguing. They were always picking at each other, and he told them to shut up and go outside.

Ventura said, "I'm going to take him outside, and I'm going to kill him." Feeling it was an empty threat, Bill told him to go on outside, not to do it in the store. He didn't want any blood on his floor. They went outside, and after a while Ventura came in quiet and sheepish and sat down. Bill could tell something was wrong, and so he asked about Braulio's where-abouts. Ventura said, "Well, you told me you didn't care if I killed him." Bill was concerned. "Now, Ventura, you didn't kill him, did you?" he asked.

Ventura replied, "Well, I don't know." They went outside. Ventura had hit Braulio and knocked him backward, splitting the back of his head, and he was lying in a pool of blood. He looked dead: no movement, lots of blood. Ventura kept saying, "Now you all can't get mad. You told me it was okay to kill him." But Braulio was not dead. Bill doctored him up and cleaned off the blood. After he was able to stand, he and Ventura left the trading post arm in arm and were friends again. I thought to myself that the Big Bend was getting tamer nowadays with its hotels and golf courses, but it was still on the edge of adventure.

Recently I had been looking across the river more and more, wonder-ing about those seldom-traveled lands in northern Mexico and thinking it was the next frontier. Bill talked of the huge haciendas across the river and how incredibly remote and difficult to traverse the area was. "One day I was on a wax deal," he recalled. "I had to make contact with some folks over there. It was during a time when I was not supposed to be in Mexico, but I

needed to go down there and talk to some guys. I had bought a motorcycle, and one of the boys that worked for me had a motorcycle. We spent half the day getting there and getting back. It was a long, long day. We went through communities I had no idea existed. I had on a helmet and gloves, and we went through more than one village that had never seen a motorcycle. In one little village all the school kids ran out of the school and chased us down the street. They had never seen anything like it. We got lost one time. We finally found a little village at the base of a mountain. We pulled up to this house, and when we did, they started shutting the windows and doors. It finally dawned on me, with this helmet on, I must have looked like a spaceman to these people, and if, in addition, someone has never seen a motorcycle. . . . That was in the eighties, and I was really surprised to see how many small rural ranching communities were over there. They are born there; they live there all their life; they're buried there. Probably the biggest adventure in their life is going to Ojinaga. Or going to Múzquiz if they're in Coahuila. That's something that I had to remind myself of in Lajitas. For some of those people to come to the Lajitas trading post would be like me going to Neiman Marcus in Dallas. They might do it once a year. When you consider it that way, you look at it a lot different. I mean you're no longer just selling beans and bologna. You're giving someone an experience that they look forward to once every year. It's really wonderful."

After dinner, as I left Bill and Lisa's, my mind was still on the conversation about the old-timers and their successors, about the first ones to see the country and know it was meant for them. Striking out into the unknown mountains of the Big Bend and northern Mexico was, for the early Spanish, much like the experience of the earliest migrants before them, those who crossed the land bridge between Asia and the New World. They were in search of a new life. In a way, they were akin to the first astronauts, trusting their lives to the best knowledge of the day and knowing that those who came later would be safer because of the knowledge they would share. They were adventurers to the core. So were the ones who came after them: the trappers and the cattlemen, the traders and the wax gatherers. And today, so are the motorcycle riders and hikers who venture into the back reaches of this vast land. I began to see that each of us has a bit of that little spark that led humankind to the New World, to the depths of our oceans, to the moon, and ultimately to the planets. It brings those of us with workaday lives to the Big Bend of Texas to experience a tiny fragment of the universal dream to explore, to discover, and to understand.

Window, Lajitas Trading Post, 1991.

Adobe wall, Rio Grande Village, Big Bend National Park, 1987.

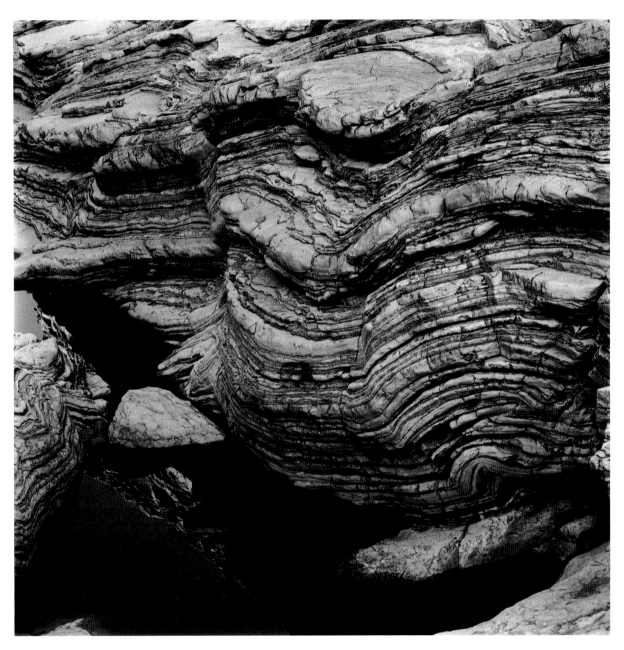

Ernst Tinaja #2, Big Bend National Park, 1987.

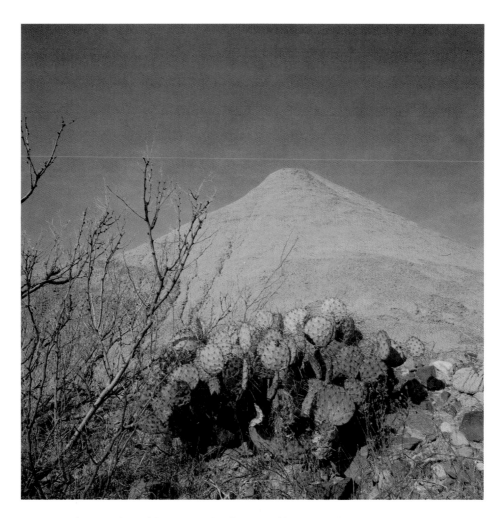

Purple-tinged prickly pear and volcanic tuff, Big Bend National Park, 1993.

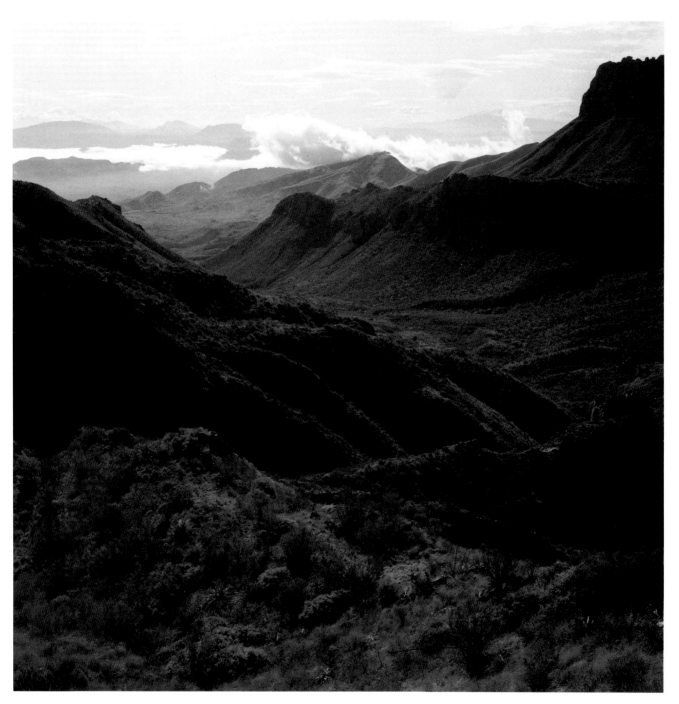

Lost Mine Trail from the saddle, Big Bend National Park, 1993.

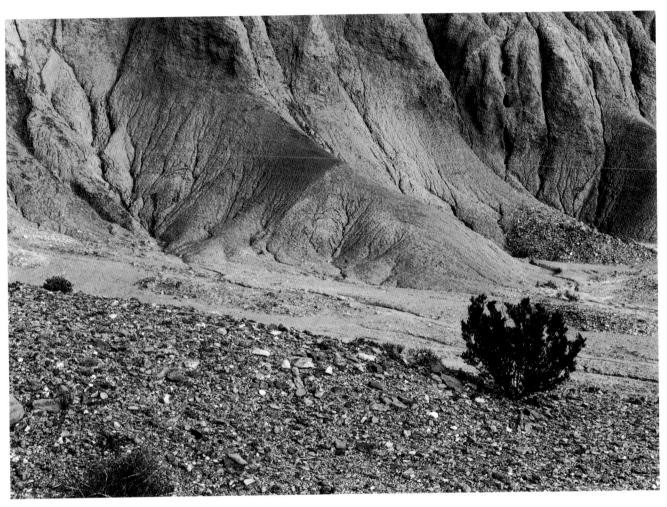

Volcanic tuff formation #1, Study Butte, 1985.

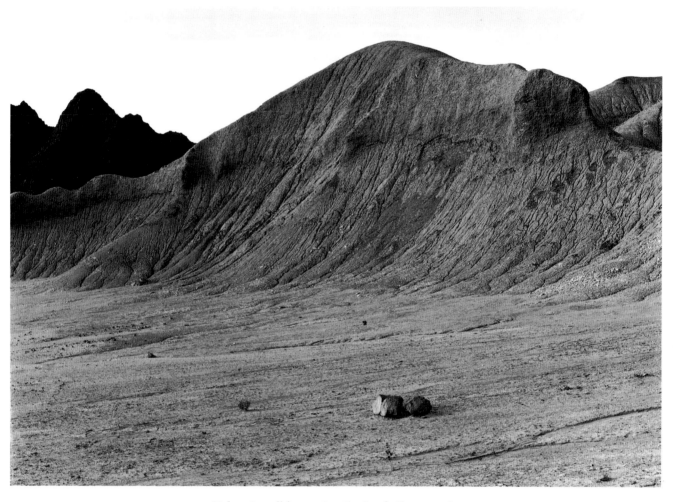

Volcanic tuff formation #2, Study Butte, 1985.

Davis Mountains, 1992.

Cattail Falls, Big Bend National Park, 1992.

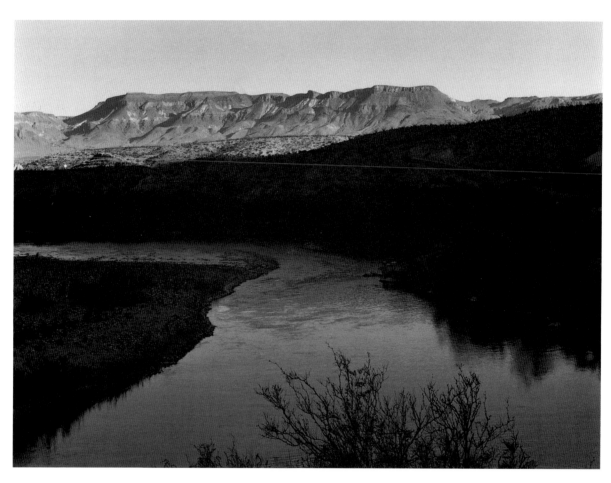

Rio Grande River north of Lajitas, 1985.

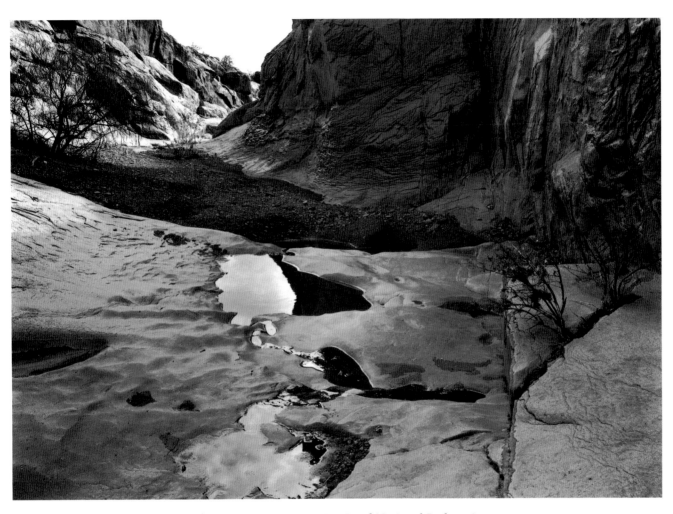

Glenn Springs Draw #1, Big Bend National Park, 1987.

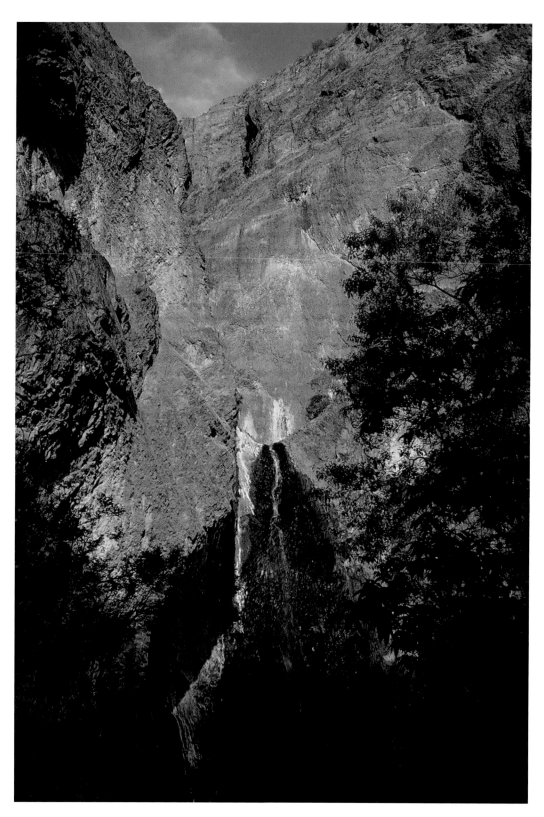

Cattail Falls, Big Bend National Park, 1997.

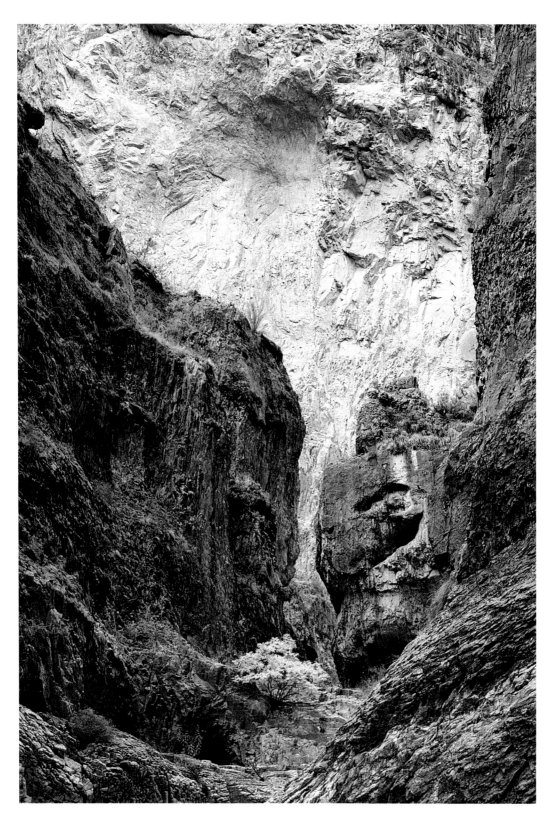

Fern Canyon, Chihuahua, Mexico, 1987.

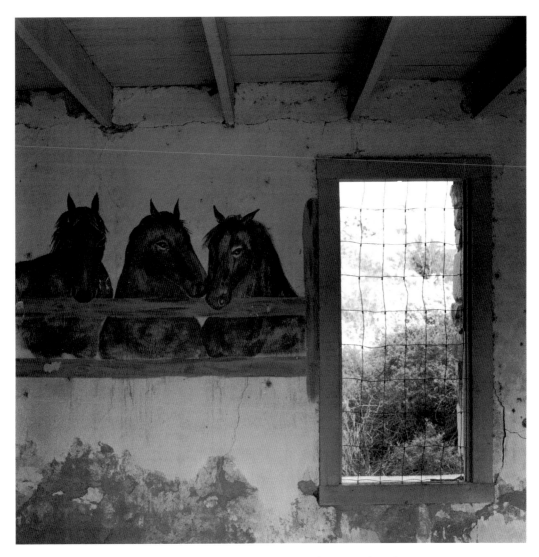

Horsehead fresco, Hot Springs, Big Bend National Park, 1993.

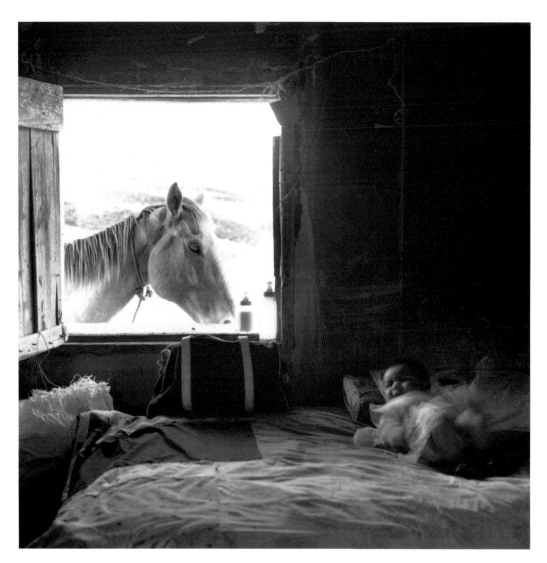

Baby and horse, Boquillas, Coahuila, Mexico, 1985.

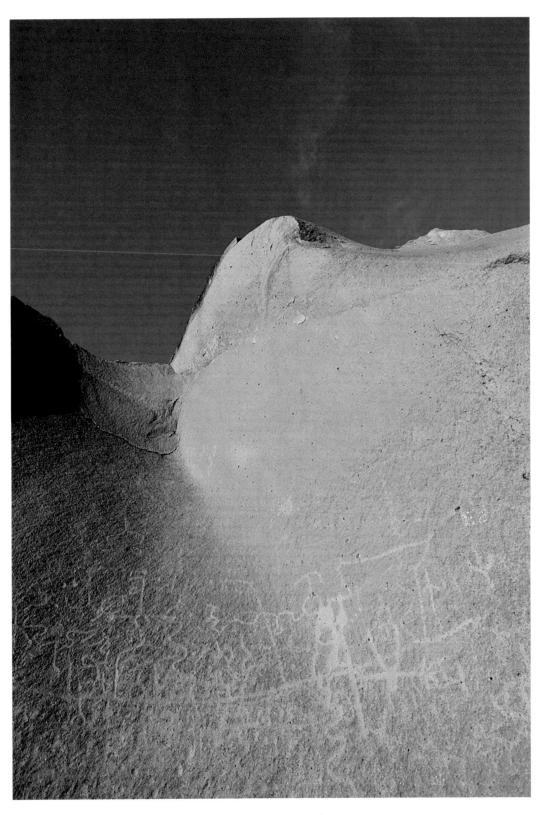

Petroglyphs at Indian Head, Study Butte, 1997.

Dune and tracks, Monahans Sand Hills State Park, 1987.

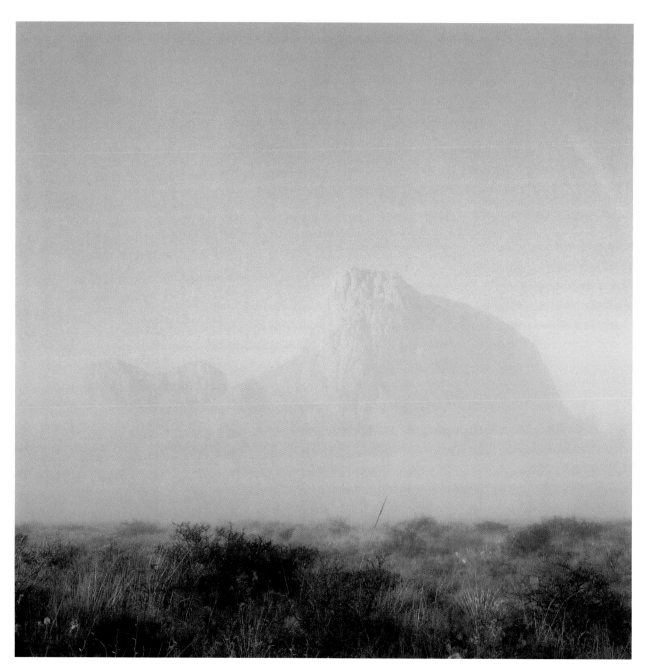

Green Gulch, Big Bend National Park, 1991.

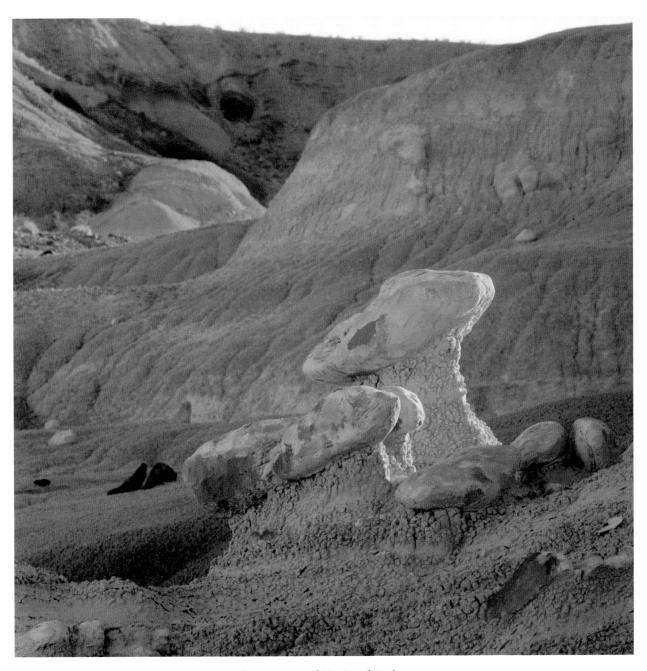

Hoodoos, Big Bend National Park, 1990.

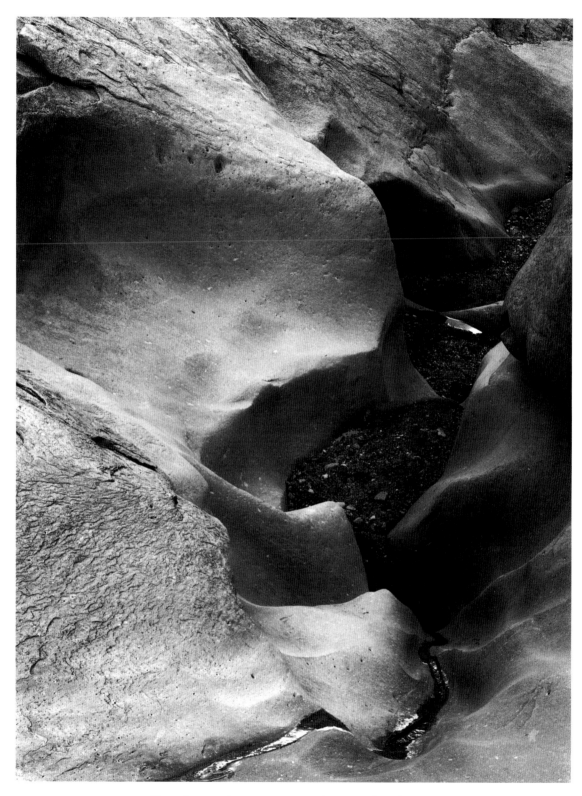

Glenn Springs Draw #2, Big Bend National Park, 1987.

Glenn Springs Draw #3, Big Bend National Park, 1987.

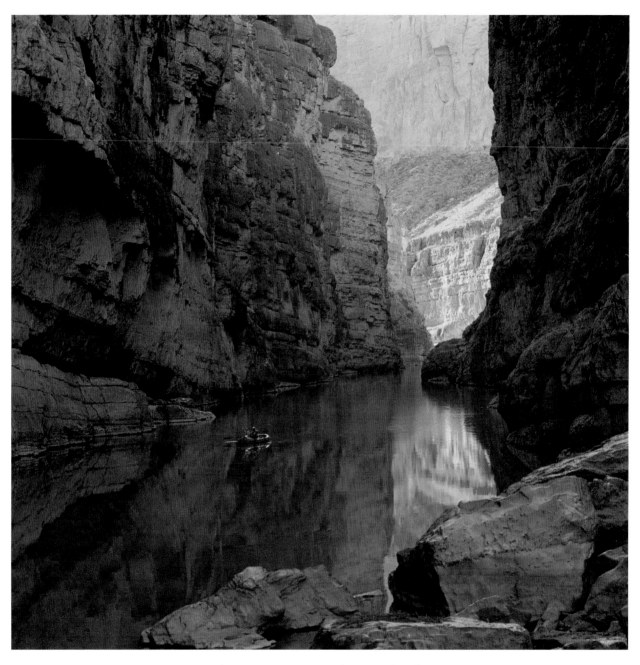

Santa Elena Canyon, Big Bend National Park, 1993.

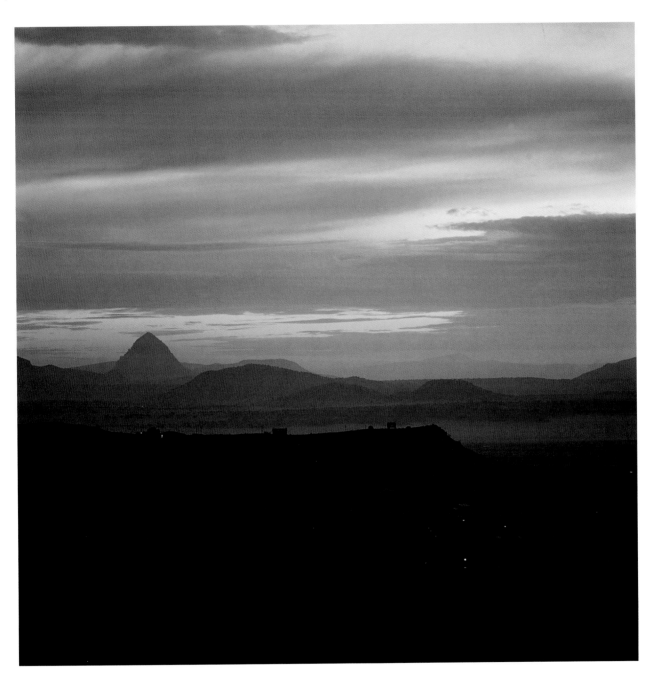

Fort Davis, 1992.

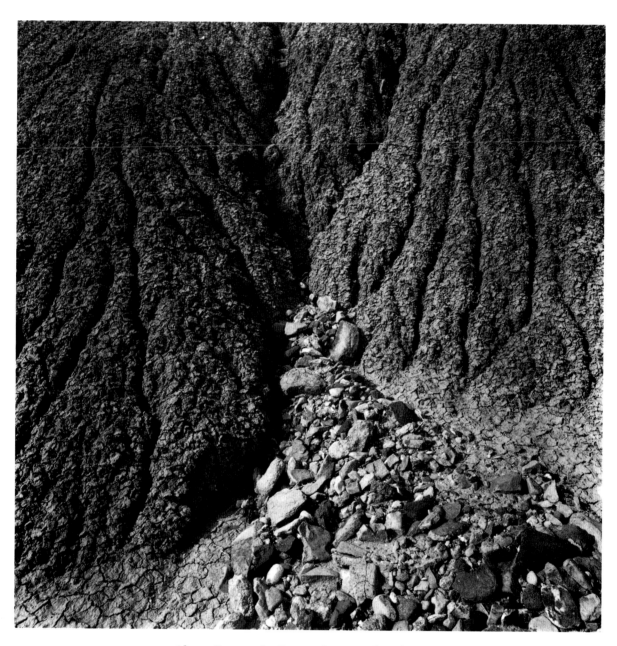

Alamo Canyon #1, Big Bend National Park, 1993.

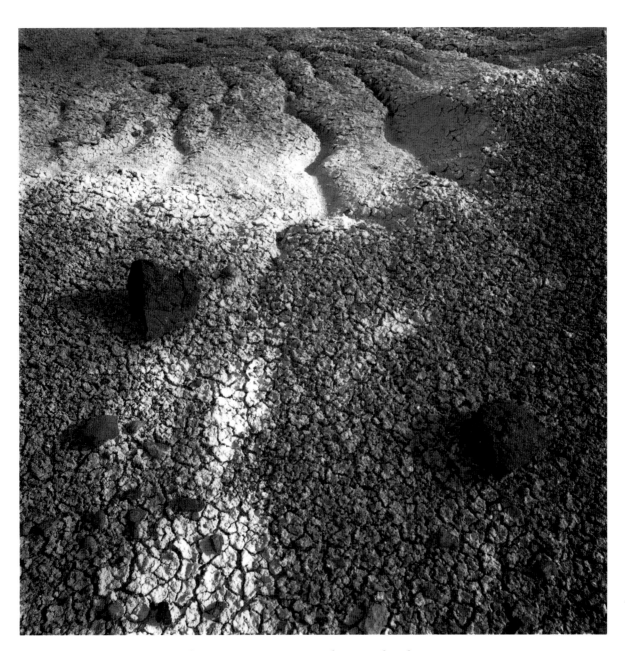

Alamo Canyon #2, Big Bend National Park, 1993.

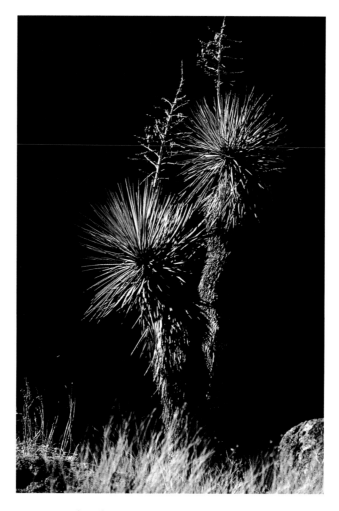

Colorado Canyon north of Lajitas, 1989.

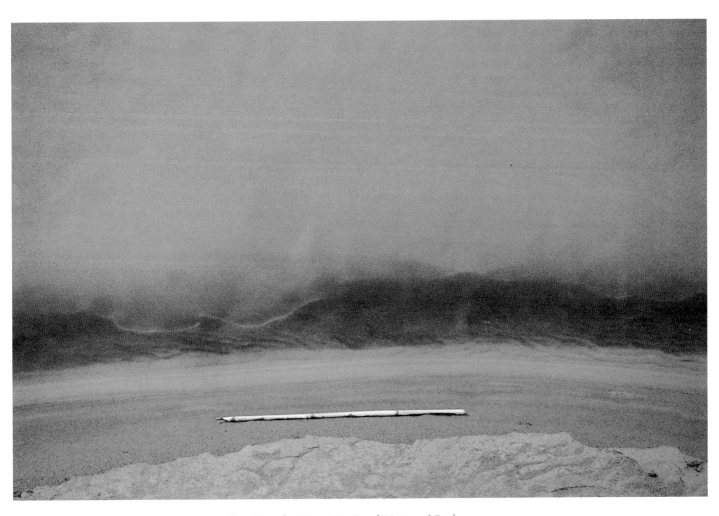

Rio Grande River, Big Bend National Park, 1991.

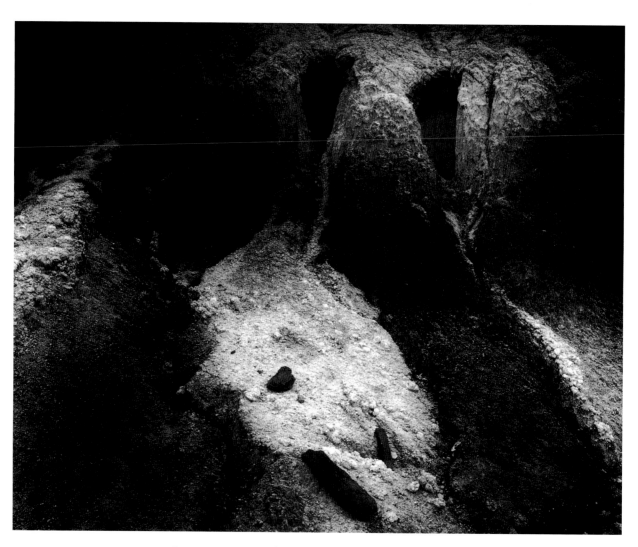

Erosion near Castolon, Big Bend National Park, 1991.

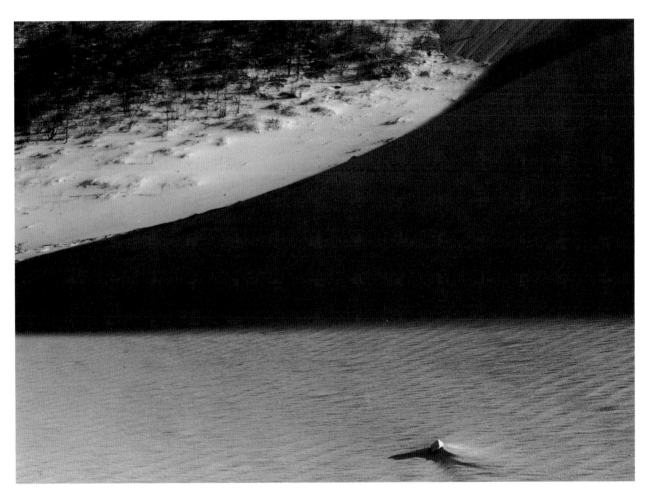

Monahans Sand Hills State Park, 1987.

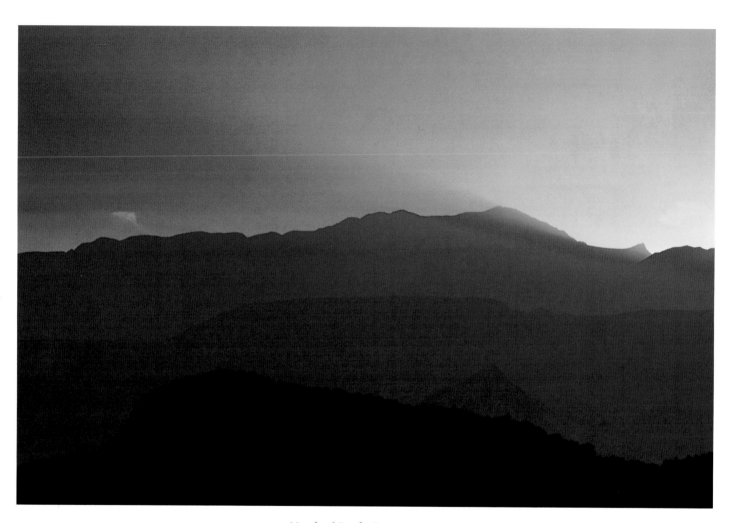

North of Study Butte, 1994.

North of Terlingua, 1995.

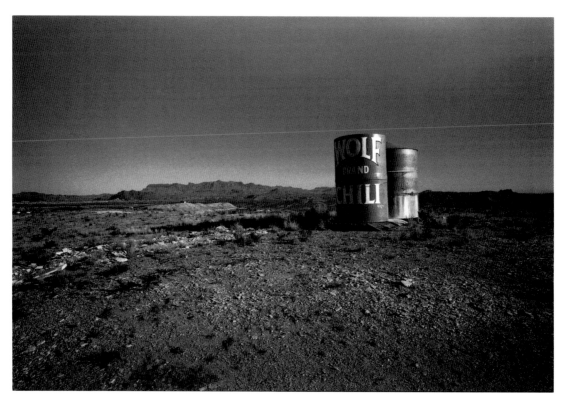

Water tanks, Terlingua, 1994.